THE
WALTER
LANTZ
STORY

Also by Joe Adamson

Groucho, Harpo, Chico, and Sometimes Zeppo
Tex Avery: King of Cartoons
Byron Haskin: A Directors Guild of America Oral History
Stuart Heisler: A Directors Guild of America Oral History

THE WALTER LANTZ STORY

with
Woody
Woodpecker
and
Friends

JOE ADAMSON

G. P. PUTNAM'S SONS / NEW YORK

G. P. Putnam's Sons
Publishers Since 1838
200 Madison Avenue
New York, NY 10016

Library of Congress Cataloging in Publication Data
Adamson, Joe.
The Walter Lantz story.
1. Lantz, Walter. 2. Cartoonists—United States—
Biography. I. Adamson, Joe. II. Title.
NC1429.L27A4 1985 791.43′092′4 [B] 85–3665
ISBN 0–399–13096–9

Designed by Helen Barrow
Printed in the United States of America
3 4 5 6 7 8 9 10

To Gracie, the voice of Woody Woodpecker

Contents

Contents

Introduction
by
Frank Capra

WALTER LANTZ, the cartoonist, has become an international asset. Millions upon millions of happy moppets (and their parents) are entertained by the antics of Lantz's creation, Woody Woodpecker. And Gracie Lantz's distinctive rendition of Woody's sassy "call" has become more famous than "Hi-yo, Silver!" Some 116 nations televise the comical adventures of Woody Woodpecker and daily give a bruised, bloody, hateful, screwed-

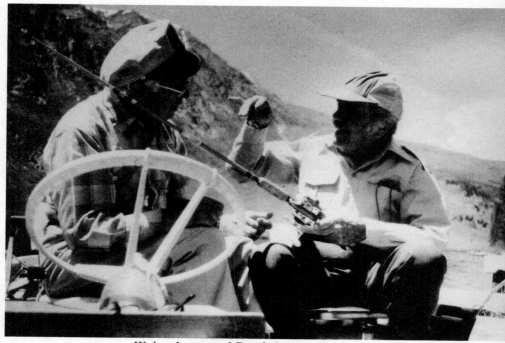

Walter Lantz and Frank Capra.

up world a half hour's entertainment to relieve the terrors of the day with the best-known curative—laughter.

But spreading joy through television, though very satisfying, was too impersonal, too mechanical, for the Lantzes. They wanted to see and to touch the unfortunates of our world. Hospitals for Vietnam wounded started them off. In 1969 (when Walter was sixty-nine and Gracie close behind) they visited military hospitals in Japan, the Philippines, Guam, Korea, and smaller Pacific outposts. Walter drew thousands of Woodys on postcards, photos, and plaster casts. Gracie did the Woody laugh at least five thousand times. Today, in distant countries, tropic or arctic, one may run into a noisy whirlpool of merrymakers—Walter Lantz, children, joy, and laughter—bringing smiles to older faces that had forgotten how to smile, while bright, perky Gracie is entertaining the bedridden.

Do the Lantzes spread joy and goodwill for money? No, they have money. For publicity? No, they go alone and are seldom written about. Are they some kind of cultists? No. Are they missionaries? No. Well, then, why *do* they go? Because they love people, because they care about the less fortunate, and they give hope to the hopeless, not with money but with their art—they make the hopeless laugh.

The art of a poet touches your heart with compassion. The art of the cartoonist Lantz gladdens your heart with laughter. Both have the same faith—a deep abiding love for all mankind.

God bless the poets. God bless the cartoonists.

FRANK CAPRA, 1985

THE
WALTER
LANTZ
STORY

PART ONE

WALTER WITHOUT WOODY

REEL 1

Chris Columbus, Jr.

"LANZA?! No, NO, you'll never get anywhere with a wop name like that! Let's call you Lantz!"

The Irishman's tact was making no impression on the two bewildered Italians in front of him. The tall, lean, mustachioed soapmaker from the very sole of the Italian boot was Giuseppe Lanza, the six-year-old with that death grip on Giuseppe's sleeve was his nephew Francesco, and neither one of them had ever seen, heard, or even imagined such noisy confusion in their entire lives.

Castle Garden, the cavernous rotunda in which they found themselves and the source of the multilingual Tower of Babble that assailed their ears, was the gateway to New York City and America. They'd always heard this was the Land of Golden Opportunity. The talk in their little hamlet in the province of Cosenza, where the Lanzas had been known for generations for their fine castile soap, played up America as a place where accidents of birth didn't doom you to a lifetime of serfitude. Relatives had written from a city called Harrisburg in a territory called Pennsylvania that money was plentiful and enclaves of Italians were neither disturbed nor persecuted.

But all Giuseppe and Francesco knew now was they'd suffered thirty days in steerage, cramped with the rest of the seasick passengers in a dingy bunk where light and oxygen were in short supply but the reek of bilge water and calcium chloride was plentiful, then were herded like sheep into this ancient fort that served as a clearinghouse for immigrants of every nationality, in the days when Ellis Island was still a storage space for naval munitions and the Statue of Liberty was hardly even a gleam in the eye of a French sculptor. The more fortunate passengers from the ship had been greeted by relatives. Giuseppe and Francesco were lucky enough only to pass the medical inspection and be given soap-and-water baths that had at least made a dent in that execrable odor of "ship" that would haunt their clothes and possessions for months.

If you'd told them at that instant that the fables of opportunity were

true, that they were the progenitors of a future movie star, and that their new name, Lantz, would forever be associated with a raucous red-crested bird with a maniacal laugh who would hover like a cloud over New York's Thanksgiving Day Parade, haunt white screens in theaters and gray ones in living rooms all over New York City, America, and the rest of the world, right down to Cosenza, and adorn comic books, storybooks, toys, games, clothes, playrooms and libraries, until he was known to every man, woman, and child in the universe—they would have counted you among the mad. And if you'd said it in any language but Italian, they would have had even less idea of what you were talking about.

They hadn't much idea of what anyone was talking about. The only red-crested maniac in the vicinity was not family in the slightest, and he was saying "No, no" to the family name.

Giuseppe and Francesco Lanza, frightened immigrants to the New World in the 1870s, became Joe and Frank Lantz, with tags around their necks proclaiming to the world their new names and the address of their relatives in Harrisburg. There were facilities at Castle Garden for turning lire into dollars and for purchasing train tickets to any destination, so before long they were on their way through the streets of the city, fortified with directions to the railroad station.

More confusion. A bigger city even than Naples, where they'd embarked—more crowded, more chaotic, more mechanized, more bustling with the American energy, and more jammed to the towering walls with endless babbling in that strange new tongue and its motley collection of dialects. Disorientation seemed to carry the day. An enormous horse-drawn expressman's cart rolled by and caught little Frank's attention. He turned to point it out to his uncle.

Uncle Joe had disappeared.

And neither Frank nor anyone else in the family ever saw or heard from him again.

■ ■ ■

Relying on the kindness of strangers—and the immigration officer's penmanship—Frank Lantz picked and pleaded his way to the station, into the train headed for Pennsylvania's mountainous green interior, and on to the home of his uncle, Guillermo Lanza (who had apparently escaped the nomenclative manipulations of his immigration officer). Guillermo was equally baffled by Joe's disappearance and offered the explanation

that the fever for Western migration had seized him, possibly with over-whelming suddenness. That gossamer conjecture has remained the ex-tent of the family's knowledge of his whereabouts to this day. Uncle Guillermo was equally baffled by the novel surname inscribed on little Frank's tag, but the family agreed that the Anglicized cognomen had a certain appeal, and before long the Lanzas of Harrisburg had all changed their names to Lantz.

As Frank grew up, it became apparent to him that an Italian working man in Pennsylvania in the late nineteenth century was faced with two major options: the railroad or the coal mines. Frank had a taste of both, and finally carried the dichotomy about as far as it could go by working as a locomotive engineer on trains hauling coal from the mines.

But eventually the family decided they'd had enough of coal mines and railroad tracks and sooty trains charging through the backyard close enough to pick apples off their trees. One day the Lantzes of Harrisburg picked up and moved to New Rochelle, an old Huguenot colony just upstate of New York City. An enclave of Italians was already there to welcome them and already included its resident Lanzas, who greeted the Lantzes with open arms and greeted the name Lantz with shock and concern—until, of course, they grew used to it and changed all *their* names from Lanza to Lantz. In New Rochelle, Frank opened a butcher shop. When a striking Italian beauty named Mary Jarvis caught his eye, he managed to catch hers, and he found himself a married man at the age of twenty-five.

In the Old Country, Mary had been born Maria Gervasi, and her father—with whom the newlyweds promptly moved in—had booked passage under the name Michelo, before undergoing the Castle Garden baptism by prejudice and having the more homogenized "Michael Jarvis" slapped on him. The Gervasis were a proud family from Italy's cultured and cultivated northern region, and their birthplace, Siena, had its medieval days of glory for its opulent, bold, and colorful artworks in the florid Italian tradition. The north of Italy, known for centers of culture like Florence, Venice, and Milan, tends to view the south of the country as "cultivated" in the agrarian sense alone. But southerners like the Lanzas pride them-selves on their tough-minded practicality just the way northerners like the Gervasis pride themselves on their aesthetic talents. In Italy, the tension between the artists in the north and the artisans in the south goes on to this day. But in New Rochelle, to all reports, the north-south alliance was going great.

The new century hadn't yet begun (though, of course, everyone had celebrated as if it had) when, on April 27, 1900, Mary Jarvis Lantz gave birth to the couple's first child, a solemn little boy they named Walter. Had they taken their *bambino* to an astrologically inclined fortune-teller, they might have been told that they had an emotionally stable Taurus with musical and artistic proclivities on their hands, and they would have found this prediction gaining more and more truth as time went by.

The art made itself apparent almost as soon as his chubby little fingers could hold a pencil—they seemed never to let go of it. Surviving relatives still recall the quiet four-year-old sitting on the windowsill of the big bay window in the front of the house, making primitive attempts at rendering the trees and birds outside the window or the early comic strip drawings that were beginning to appear in the newspapers or just about anything else that presented itself to his hungry young eyeballs. Though it was generally conceded that this was a talent derived from the northern side of the family, Walter's father was tough-minded and practical enough to be delighted at finding a prodigy among his progeny, and encouraged his son to keep trying his hand at anything that could be remotely construed as a craft.

As for music, that was all around him. The nuclear family that had accumulated at Michael Jarvis's elegant two-story house was overflowing with song, orchestrating Walter's earliest memories: "We had the happiest house in the neighborhood. Uncle Nick would bring out his clarinet, Uncle Johnny played trumpet, my aunt played the organ, Mother was a very accomplished pianist, and Uncle Charlie had a baritone voice that could be heard three blocks away. We used to have jam sessions every Sunday. The neighbors would come in for music and dancing and food and the free wine. Of course they brought their kids. Sometimes we would have fifty mothers and fathers and kids, and we'd have a heck of a time.

"When twelve Italians sit down to dinner, everyone is tallking, arguing, laughing and eating at the same time. No wonder a meal lasts three hours.

"We kiss each other, that's the lovable thing about Italians. You learn to kiss your mother, your father, your grandfather, your dog, your parrot, and everybody. You kiss them when you leave and when you come home. And it stays with you all your life."

Such a climate colored almost everything the family did. So when Walter and the younger brother who followed him a couple of years later

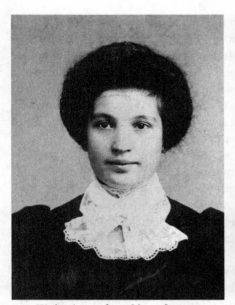

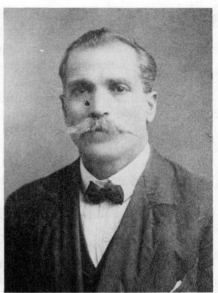

Walter's mother, Mary Lantz. *Walter's grandfather, Michael Jarvis.*

and was given the name Al got the usual nursery rhymes and fairy tales at bedtime, it never occurred to them that there was anything to object to in the ancient fables. "Now, what could be more violent than the story of Little Red Riding Hood?" Walter asks today. "The wolf has a gourmet dinner, with Granny as the main course, and he is about to eat Little Red, when a hunter hears her yelling, goes after the mean old wolf, slits his stomach open with an ax, and out comes Granny! Whoopee! These stories scared us, but we all grew up to be very normal people. Violent stories have been told to young kids for centuries. I believe kids like to be frightened."

Decades later, protest groups were to lobby in Congress against the subdued form of violence found in Walter Lantz's and other producers' slapstick versions of these same fairy tales, and no one could be more horrified at the suggestion that he was corrupting the virtues of minors than Walter Lantz. Like generations of children, he had ingested such stuff right along with mother's milk, and considered it just about as harmful. At the tender age of seven, all he knew for sure was that firmly established Italian belief that life was rosy and warm in the bosom of the family, and the world outside it was a dark and fearsome place.

But the family member who probably made the deepest impression on Walter was the least warm, least rosy, and least bosomy of the bunch: his Italian godfather of a grandfather Michael Jarvis. A cool, debonair Old World gentleman ("Aristocratic," says Walter, "if you believe his publicity"), Grandfather Jarvis cut a resplendent figure in his frock coat, ascot, gray spats, and silver-handled ebony walking stick. It seems he had found a way to cash in on his artsy background without having to pass through the coal mines or the railroad tunnels. In Italy, as Gervasi, he'd been a good shoemaker, and on his trips into New York City, as Jarvis, he had become aware that America's opera productions were gaining in splendor and its reigning stars had no particular wish to go unshod. And so Michael Jarvis became an American shoemaker, specializing— in the phrase of songwriter Tom Lehrer—in shoes for the rich. Custom, hand-made shoes, to be accurate, and fancy high-stitched boots, delicately trimmed in gold and garnished with pearl buttons. Raw materials for this kind of product tended to come at steep prices, but the returns on the work could be downright precipitous. Jarvis counted among his clientele Enrico Caruso, Ernestine Schumann-Heink, and Geraldine Farrar. He had found the key to success in the New World.

Jarvis, as Walter recalls him, was not the sort of grandfather who welcomed toddlers into his lap. In fact, minor transgressions on his sense of the meet and seemly could readily prompt a whack on the behind— or whatever location was handy. "If he'd take a swing at you," says Walter, "it didn't make much difference where he connected; he made Christians out of all of us. My brother Al was being socked every twenty minutes."

The rosy and warm Jarvis-Lantz household came unglued with a kind of shattering abruptness. In 1909, Mary gave birth to a third son, at home and attended by a midwife. She named him Michael, after her father. The peritonitis that immediately set in couldn't be handled by the midwife, and Mary was sent to the hospital for intensive care. After two weeks, the news that no one wanted to hear came back. Frank Lantz had paid a heavy price for his third boy.

The loss of his child bride when she was still something of a child had a crippling effect on a man still in love. Frank went into mourning and stayed there for what seemed like an eternity.

Not much later, Walter's family was dealt another blow in the death of Grandmother Jarvis. The crowded household was now an unconscionable burden on the grief-stricken grandfather, and Frank took his boys Walter and Al and moved in with fellow immigrant brother Tony, leaving little Michael in the care of his sister-in-law Carrie.

Walter at age four.

But Fate was not through being cruel. Frank began to complain of pain and swelling in his knees. He suspected rheumatism. His doctor sent him into New York City to a major hospital, where water on the knee was diagnosed and treated. The treatment turned out to be worse than the disease, however, since it involved tapping the fluid and draining both knees completely. Frank was unable from that point on to stand,

walk, or move his legs in any way. The crippling effect was now a physical reality.

Walter's only defense at a time when life seemed to offer nothing but tragedy was a catchphrase he'd picked up from his grandfather back in the sunny days: *Morto ogni notte, e nato ogni mattina*. We're dead every night and born every morning. Or, more loosely translated, one day at a time. You don't have to be religious to turn a simple phrase into a litany.

■ ■ ■

Frank Lantz was dressed in black and confined to a wheelchair, but he wasn't about to let that keep him down. His reach curtailed but his view of the horizon unimpaired, he began to surrender stardom in his dreams of upward mobility in the New World to his rapidly maturing first born. Smiles greeted Walter's ever more sophisticated drawings, encouragement greeted his schoolwork, and everything from biographies to Horatio Alger books greeted his interest in the lives of the great. Also determined not to be a leech for the duration of his existence, Frank set about trying to find ways of earning a living available to those without functioning legs.

Hopes for both goals were satisfied by a connection with a mining entrepreneur named Gene Bastian, a former boss on the Harrisburg mining trains. Bastian was opening up a stone quarry in an obscure outpost of Connecticut then called Beckley (now called nothing, since it seems to have vanished from the face of the earth). For this purpose, he was planning to import about fifty laborers, thereby doubling Beckley's population. He was looking first for one man to round up the personnel and run the commissary that would be needed to keep the men fed in this desolate territory, and he wrote asking Frank if he'd like the position. Frank accepted immediately, leaving to later the question of how he was going to handle that kind of work.

When Mr. Bastian met the train at the Beckley flag stop, he was startled to discover his old friend Frank Lantz on crutches and two dependents at his side with suitcases in hand. Once he had determined the cause of Frank's disability and expressed his sympathy, Bastian's first question was "How are you going to manage the job?"

"Show me what has to be done, and I'll figure it out," Frank said, smiling.

A few phone calls to every Italian neighborhood Frank knew solved problem number one: Fifty eager workers were recruited, ready to start

Walter's father, Frank Lantz.

and speaking either English or the mother tongue. This left problem number two, the old standard: Who's minding the store? There was only one answer. Al would be sent to school in nearby Middletown. Walter's schooling days were over.

Up at 5:00, into the commissary by the dim light of kerosene lamps, selling the men the food they'd cook on their own stove in the bunkhouse,

punching the amount of their purchase on their little cards, closing when their working day started at 7:00, restocking the shelves, opening again for the dinner supplies at 4:00 when the quarry's day was through, wrapping up everything by about 7:00 P.M.; on the train to Middletown or Hartford every Saturday to order new stock, stopping religiously to catch a stage show each trip, taking the men's cards to Mr. Bastian at the end of the month, exchanging them for cash, banking the money in New Britain, filling the beer bottles from giant kegs with hoses stuck in them, snapping the porcelain spring caps onto them, keeping the bottles on ice, shaking well water and buckshot in the empties to sweep the junk off the bottom: Walter was learning the sweat-per-dollar principles of business firsthand. His boss was his father, and his customers were his countrymen.

He was twelve years old.

The job offered myriad satisfactions and maximum responsibility with minimum pressure; it also left a lot of time open but shut off the supply of twelve-year-olds to fill it with. Hunting and fishing took up many of the daytime hours, but large, gaping holes of evenings yawned before him. The incessant drawings continued—usually direct copies of early comic strips like "The Yellow Kid," "The Katzenjammer Kids," and "Bringing Up Father"—but they were looking more and more childish as his mastery of the business world of Beckley, Connecticut, increased.

One idle evening an ad in a magazine caught Walter's attention. An artist named Zimmerman was offering a correspondence course in cartooning under the name of Zim. The price was a staggering thirty dollars, but Walter got that readily from his father, who was delighted to help and didn't want to see his son run a commissary in a stone mine for the rest of his life.

The Zim course consisted of a parade of bizarre cartoon figures in the broad, sketchy comic drawing style of 1913, which the budding artist was requested to re-create freehand and return to Zimmerman for correction. Walter's success in this endeavor inspired him to enroll in another course as soon as he was through. The second was run by a Mr. Landon and concerned something called animation, with the weekly lessons consisting of figures moving and faces twisting in twenty-five to thirty successive drawings to be copied and corrected. Crosshatches in each corner of the special paper Landon supplied indicated positions for inserting straight pins, to enable each drawing to be lined up precisely with the one before it.

Walter had never seen or heard of animation, but it sounded great. Unfortunately, Landon didn't know much about it either, and the results for Walter were minimal. The final drawings were never filmed, so success couldn't be measured, and the course remained academic.

The course's key contribution to Walter's advancement turned out to be its directions for the proper construction of an animator's drawing board. Enlisting the aid of one of the quarry's able-bodied men, Walter constructed a drawing board according to specifications, with an eight-by-ten-inch glass window in the center to allow light to shine through several sheets of paper. The plans called for an electric light bulb to be housed under the glass window as the primary source of light, but since electricity was a modern convenience that hadn't yet made its way to Beckley, an alternative method had to be developed. "I put a kerosene lamp on the floor between my legs," Walter recalls, "and put the drawing board over it so I could see through the paper and keep warm at the same time. It's a wonder I didn't go up in flames."

Fate, it turned out, had other things in store for him.

REEL 2

Music Hath Charms

I'm just sixty-two and I'd like to tell you
That I've always enjoyed this young life.
—Ed Boyle, "That's What I Say to Them All"

WHEN WALTER VISITED the Middletown silent-movie house to catch up on the latest in the growing art of moving pictures, he failed to notice the most intriguing element of the show: The pianist providing the musical accompaniment was wearing dark glasses and wasn't even looking at the screen. Variations in the tempo and mood of the shadow play were telegraphed to him by electric impulses carried on a wire strung from the projection booth to his ankle. It was Ed Boyle, a talented singer, songwriter, and pianist, who'd been touring as a solo act in vaudeville for years: His billing read "Ed Boyle, the Blind Singer."

But his manner was too easy, some said, as he strolled onstage in dark glasses to take his seat at the piano in front of the curtains. He failed to poke the stage with a cane as he crossed it, failed to stumble as he rounded the piano stool, failed to grope sufficiently as his fingers located the keys, failed to muff the intricate fingering once he got going, failed all the way down the line to act the part of a blind man. The guy had to be a fake.

His family knew better. Had it been an act, it's probable that all those affected gestures would have turned up in full force, right along with the fluttering eyelids and the overanxiously craned neck—the hallmarks of blindness's imitators. Boyle didn't need the act or the gestures more suited to a sighted person in a black pit. He was acquainted with blindness all too intimately and had been all of his life, not inheriting it, but contracting it contagiously from a physician half-blind himself, who put acid in Boyle's week-old eyes when he meant to reach for eye drops.

Ed did fine by himself, but vaudeville shut down in the summer, and inactivity nettled him. When he wasn't playing for the movies, he'd rent a pickup truck, hire a driver, and tour New England to sing his songs, accompany himself on the piano, and sell his sheet music at intermission.

Ed Boyle.

Soon he was taking his becoming young sprite of a daughter on these trips and noting that her effect on sales more than paid her way.

Gracie Boyle was two years ahead of Al in the early grades of Middletown and many more years away from being destined to cross paths with either Al or Walter. By the time this was to occur, she'd have logged many hours on the boards and many miles of theater circuits.

She and her father "played the parks," Grace remembers now. "It was like a picnic. We would advertise ahead and play Saturdays and Sundays mostly. Once in a while we'd be invited to come, if there was a big function like a Fourth of July celebration. When I was with him, we never had to go to restaurants. People in the town always invited us to dinner."

Ed and Grace found themselves living the life of gypsies and finding nothing in it to complain about. While five other children stayed home with mother and grandma, father and daughter toured the hinterlands as a team, first from the back of a truck, then as partners in a vaudeville act. "My brothers and my sister were always satisfied to stay at home," Grace says. "But I wanted the greener hills."

Most people would have regarded blindness as a handicap. Ed Boyle seemed to use it as an opportunity to develop his other senses and mental faculties far beyond the limits the rest of us would consider human. Chief among these, naturally, was his hearing, which became his compass, as well as the catalyst for developing a musical talent that captivated the ear of New England. Of course, Ed never learned to drive nor attempted to apply for a license. But he was not above giving driving a try, as Grace discovered when she once left him alone in the car for two minutes to dash into a train station to get a timetable. She emerged to find the car a good one hundred feet away and her father wearing a childlike grin below his noncommittal dark glasses. She knew how he'd done it—she'd already showed him how everything worked, just to assuage his endless curiosity (obviously she hadn't succeeded). What she wanted to know was why.

"That was so dangerous!" she scolded.

"Oh, no," he answered coolly. "There was nobody in front of me."

A glib statement, coming from him. "How did you know that?"

"*You* know I can always tell," he reminded her, and he was right. An object didn't have to make a sound for him to sense its presence and gauge its distance: Any *other* sound bouncing off it was enough to enable him to work it all out. His own footsteps cued him in to trees in his path, their precise distance and location. That's why he never stumbled when

he walked to the piano onstage, and that's why he could say things like "I saw that play" and "What a beautiful sunset" with a straight face. For everything he couldn't see, there were thousands of minute auditory and tactile impressions that rushed into the breach.

Like Walter, Gracie grew naturally into the world of business as a teenager, by working for her father and dealing with people like the ones she grew up with. And, like Walter, she remembers family, community, and entertainment coming together in group sing-alongs at the house and creating a kind of harmony that's become a rare thing. "Papa wouldn't take engagements during Christmas week," she explains. "Christmas Eve was a big night. We lived in a three-decker on Stafford Street; they'd move the piano out on the front porch, Mama and Grandma would make hot chocolate and cookies, and Papa would lead all the neighbors in Christmas carols. I've seen him play in the snow with gloves on."

Snow or no snow, Grace felt cozy and settled when she was at the three-decker at 203 Stafford Street in Worcester, Massachusetts, where the family eventually settled, but she saw the time coming when she'd have to head for the greener hills by herself. When she finally plucked up the courage, she and a friend took waitress jobs in New York City and made the rounds of the audition halls. She took a little bit of home with her, though, by changing her last name from Boyle to Stafford. She retained her original first name and, when the occasion warranted it, all of her three first names: Grace Theresa Veronica. "I'm named for three of the saints, that's why I've had such a lucky life."

Luck may be nothing more than point of view, but it's hard to find show people who aren't superstitious about it. Grace's point of view, as well as her luck, has always been the best, and for that she gives Ed Boyle all the credit. She claims, "He taught me that everything can be a joy."

REEL 3

Tempest in a Paint Pot

LIKE ANYONE WHO'S BEEN ABNORMALLY LUCKY, Walter Lantz doesn't believe in luck. "There is no luck," he'll say. "It's your talent that gets you over, it isn't luck." Then he'll remember that a plum contract that took talent and hard work to fulfill had come to him through a freak collision with Destiny. "There's luck again!" he'll declare, as if that had been the topic all along. "It seems that I always happen to be in the right place when opportunity comes along."

It seems that way to others in the cartoon business, too. Dick Lundy, a Disney man who later found himself working for Walter, observes, "Walter Lantz is the type that falls into a cesspool and comes out smelling like three lilies. No matter what he does, whether it's right or wrong, it seems to work out for him. You can call it what you want. I call it luck."

However Fate engineered it, the events went something like this: Gene Bastian, only one year after opening the stone quarry that put Beckley on the map, closed the quarry and took it off again. Frank, Walter, and Al Lantz went back to New Rochelle and boarded once again with reliable old Uncle Tony. "I went to work in a garage as a grease monkey," Walter says, "which was really the lucky turning point in my life. There was a lot of humor around the garage"—as there is anywhere if you know how to mine for it. Months of correspondence-school art training found its outlet in doodles of the other men at work, making fun of the way they wounded themselves with implements, argued bitterly over nothing in particular, and splattered their faces slicker than the grease-painted actors in a minstrel show. These cartoons were of sufficient quality to find their way to the shop's bulletin board, and, before long, to the attention of a customer with an eye for good doodling.

Fred Kafka, a Yale graduate and ex-athlete, was a contractor, constructing important buildings in New York City and driving a wide-open mustard-yellow Stutz Bearcat, with the duster, goggles, and scarf you needed to reach those staggering speeds like 45 m.p.h. As proud owner of this magnificent machine, he appreciated the clean work and close

attention given it by the conscientious little Italian kid and wanted to return the favor. As a man with cartooning and editing experience on the Yale newspaper, he was impressed by the funny drawings on the bulletin board. When he found out that the little Italian kid and the creator of the funny drawings were one and the same person, he hatched the plan that set Walter barreling down the road to success so fast he forgot his goggles and scarf.

"Walter, you're wasting your time in this garage," said Kafka, and though this was no surprise, the conclusion he jumped to next certainly was. "I'd like to pay your tuition to go to Art Students League in New York and get a really good art background."

And so it was that Walter Lantz found himself quitting work each night at five, washing up, downing a quick dinner, boarding the commuter train into the city just as great masses of humanity were heading the other way, and taking the forty-five-minute trip to George Bridgeman's anatomy classes on 57th Street six nights a week. All because he took good care of somebody's automobile.

The first night he attended class, wondering what advanced art training was going to be like, he encountered a pleasant surprise—so pleasant and so much of a surprise, in fact, that it came as a rude shock. "My first lesson was drawing a nude, and there was a nice plump model sitting on a stool. It was the first time I ever saw a naked woman. I wasn't quite fifteen years old. My charcoal pencil could hardly touch the paper."

A couple months of this demanding schedule and Walter was ready to throw in the dropcloth. But Kafka wasn't through. His letter of introduction to an old Yale buddy got Walter an office boy's post on the New York *American*. A room at the YMCA on 125th Street ("and the bedbugs that went with it") was secured for two dollars a week, and Walter kissed his family, New Rochelle, and his forty-five-minute train ride good-bye. He would not be living with other Lantzes again until he was able to support them.

Walter started at the *American* on a mere seven dollars a week, but that was more than pocket change in 1914. Excellent seven-course dinners were available in the Jewish, Italian, and Polish restaurants of Harlem for thirty-five cents, or he could just cook spaghetti on the gas lamp in his ten-by-twelve-foot room. In two months, his pay was raised to ten dollars a week. Clover.

"Walter was a very good artist," insists James Culhane, a friend of Michael Lantz who would be accepting employment from Walter more

Charcoal drawing by Walter Lantz, Art Students League.

than once in the days to come. "He won a couple of medals in Art Students League and was considered a very promising student. But he veered off into the cartoon."

And it's not hard to see why. The job at the *American* wasn't glamorous, consisting in the main of running copy and proofs up and down a circular three-story ladder, "rushing the growler" to keep the beer can filled, sweeping out the place, and cleaning brushes for the artists. But those were no ordinary artists: George Kerr and Willy Pogany, famous in their day for exquisite covers on the Sunday *American Weekly*, and famous to this day among connoisseurs of popular art; George McManus, creator of "Bringing Up Father"; James Swinnerton, whose "Little Jimmy" was a prominent strip and whose streamlined drawing style influenced all the strips going; Frederick Burr Opper, author of "Happy Hooligan" and "Maude the Mule"; Walt Hoban and his "Jerry on the Job"; Thomas A. Dorgan, known by his initials as "Tad" and popularizer of a parade of stick figures he called his "Daffydils"; George Herriman, whose "Krazy Kat" is still treasured as a classic in the art of the comic. To somebody

who scant months before had been content to copy the work of these masters out of the Sunday paper, this was a star-studded cast. When they took the time to critique the drawings he worked on at night and brought in the next day, or when they gave him little lettering and touch-up jobs to do, it was a better education than he could get in any school.

And that wasn't the end of it. Damon Runyon and Gene Fowler were in the city room. The *American* functioned at this time as the morning edition of the New York *Journal,* with which it shared offices, and both were owned by William Randolph Hearst, the multimillionaire newspaper baron who had revolutionized journalism and wasn't going to rest until he had revolutionized the entire business that we now call "the media." Fellow office boy on the *Journal* side of the fence was Milt Gross, then an amusing wiseguy to run up and down stairs with, by the 1920s a well-known cartoonist in his own right, and at this writing another of the immortals in the annals of the American cartoon. Editor of the *American* was Morrill Goddard, who had more or less invented the Sunday color comics section back on Joseph Pulitzer's New York *World* in 1895, when

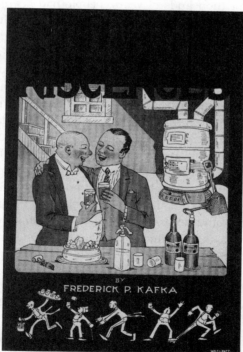

Walter's first illustrated book.

Richard Outcault drew an Alfred E. Newman-type character in a night-gown and called him The Yellow Kid. The *World* had bought a four-color press to run some fashion pages, but Goddard decided The Yellow Kid ought to be yellow, and the Sunday Rotogravure was born.

Then there was Winsor McCay, already famous for the hallucinatory Sunday strip called "Little Nemo in Slumberland," at this point toiling away, diligently, swiftly, and daily, on single-panel cartoons for the Hearst press. For all the showmanship and exhibitionism he revealed in public appearances, he was a quiet and unassuming fellow at the drawing board, giving little evidence that he was at just that moment accepting engagements on vaudeville stages all over the country with the show that was to galvanize an entire generation of comic artists and practically create an industry. When Walter saw the show, it hit him too. "I saw it at the Palace Theater in New York," he remembers, "and McCay appeared onstage and talked about it. It inspired me to want to learn the art of animation."

Animation. It was at once the world's oldest art and the world's youngest profession. For thousands of years, people had been giving it grand and vainglorious tries, but had yet to get the hang of it. Suddenly a beast had lumbered out of the Mesozoic Era and showed them how it was done.

Attempts at getting drawings to move go back further than the invention of motion pictures. Cavemen made primitive efforts to put movement into drawings before they got around to inventing the wheel. Flip-books, which succeeded in capturing the effect, preceded the invention of photography by a good two hundred years. Goddard's Sunday comic pages in the New York *American* ran successive cartoons that could be cut out and stuck together with a rubber band before Winsor McCay was even working for Hearst, and when Winsor Jr. started collecting them and trading them with his friends, he gave his imaginative father an idea.

When McCay brought out an animated reel in 1911 called *Little Nemo*, based on his strip, and another entitled *How a Mosquito Operates* in 1912, he was displaying the first genuinely fluid, imaginatively psychedelic, and wittily accurate animation. But the films had an overall experimental air that baffled people in droves. They were apparently not sure what they had just seen, but certain they couldn't have seen what they *thought* they saw; they emerged somewhat woozy, chalked up the dazzling effect to indigestion, and swore there must be a trick in it somewhere. Then McCay animated a little piece called *Gertie the Dinosaur* and appeared onstage with it, and all that changed. It was fine to give the crowds great animation in an age when even good animation was as

rare as video games, but when Gertie cavorted charmingly on the screen, people *cared*.

Walter wasn't the only one to be inspired. Others included Paul Terry, Dave Fleischer, Pat Sullivan, Otto Messmer, and men like Dick Huemer who were later to form the backbone of the Walt Disney studio. Gertie became the primogenitress of slick and furry creatures who charmed audiences the world over, the prolific antediluvian wellspring of pixie offspring by the names of Felix, Oswald, Mickey, Donald, Porky, Daffy, Andy, Woody, Grumpy, Dopey, Tom, Jerry, Bugs, Dumbo, Sylvester, Speedy, Willy, Magoo, Rocky, Bullwinkle—in other words, a major chunk of the iconography of the twentieth century.

Walter's only disappointment was that he never got the chance to share his enthusiasm with its source. McCay's vaudeville touring schedule and subsequent copyright battles with Hearst made for a poor office attendance record. By the time Walter caught up with the famous show, its creator was rarely seen at the *American,* and, soon after, Walter wasn't seen there either. "You'll never get anywhere being an office boy here," Goddard had told him. "One of these artists would have to die before you could move up, and they all look pretty healthy to me. A friend of mine, a cartoonist who used to work for me on the New York *World,* is setting up an animated cartoon studio. I think you ought to learn that business and make more money."

Among those imaginative men inspired by Gertie the Dinosaur was William Randolph Hearst. He also realized that Winsor McCay, George McManus, and Bud Fisher—three of his most famous cartoonists—were making bigger names for themselves as pioneers in this fledgling art form than they were as minions of the mammoth Hearst empire, and, in some cases, were forsaking the empire for the chance to be pioneers. Hearst loved comic strips and had been instrumental in getting them established as daily features in American newspapers; he was also fatally addicted to motion pictures. ("The movies darn near ruined the old man," one associate remarked.) The combination proved irresistible to him. He hired Gregory La Cava, Goddard's friend from the *World,* away from his current position at Raoul Barré's cartoon studio in the Bronx and told him to round up all the artists he could find who knew anything about animated cartoons and pay them whatever it took to get them. The methods that made Hearst a potentate in the newspaper business were simply transposed to the new medium. "If he wanted an artist," Walter explains, "he just doubled his pay and hired him."

Unfortunately, Lantz was too young to share in this bounty as yet.

Gregory La Cava,
animated cartoon director
for Hearst.

Goddard gave him a letter of recommendation, telling La Cava that Walter was a talented young artist, that he made ten dollars a week, and that Hearst wanted him hired at his studio. La Cava saw a fellow Italian, read the letter, and put the kid to work on the camera. ("It seems I was stuck with this ten dollars a week," Walter says.) There was only one problem. "If you're an Italian," La Cava wanted to know, "how on earth did you get a name like Lantz?" Walter told him that was a long story.

From the mad world of newspaper cartoonists to the doubly demented world of the animated cartoon, Walter was propelled as simply as that— as Harold Lloyd might have put it, feet first and safety last. Walter puts it a little differently today: "If it weren't for Hearst, I couldn't have done what I did. There's always been somebody coming along at the right time. There's a reason for these things, but I don't know what it is."

■ ■ ■

The studio was an entirely unremarkable building on the corner of 127th Street and Third Avenue in Harlem. The drawing boards were lined up in rows in the drab, sweatshoplike office. The Third Avenue El train passed its windows at least once every three minutes and rattled every board in the place.

But from 1916 to 1918 a remarkable group of men passed through its portals to make animated cartoons. John Terry, brother of the more famous Paul, had been a pioneer animator in San Francisco. Systematic, methodical Frank Moser had been animating since before *Gertie* and was to become a kingpin in Paul Terry's organization, as were John Foster and I. Klein. Foster, at thirty-five, was considered the grand old man of animation. Bill Nolan had been at it since 1910, and had invented tricks like the panorama background (putting a moving background behind a walking or running character and creating the illusion of a moving camera). Vernon Stallings, sometimes called George, was the son of the man who had made champions of the Boston Braves, and was known far and wide as the greatest animator working (outside of Winsor McCay, who was generally unavailable).

As for Gregory La Cava, it would be several years before he would become the first of a select few to graduate from animated cartoons into the front ranks of feature-film directors, bringing to the screen W. C. Fields's great silents *So's Your Old Man* and *Running Wild*, as well as those two screwball classics of the 1930s, *My Man Godfrey* and *Stage*

Hearst baseball team, 1918, Walter Lantz at bat.

Door. That last one won him the New York Film Critics Award for Best Director of 1937. He was generally considered by then to be one of the highest paid directors in Hollywood, and, along with Frank Capra, one of the best. Capra himself had enormous respect for him. "He was an artist and thought as an artist," Capra says. "He just simply objected to people telling him what to do and when to do it. He'd say, 'I'll make your picture. Keep your hands off and let me do it.' He couldn't cope with opposition."

With Hearst, La Cava didn't get any. His freedom was complete and his supervision minimal. Hearst paid him a fabulous salary weekly and asked for nothing in return but the best cartoons in the business. Other animation studios stayed afloat only by keeping a day-to-day watch on the ledger sheets. Hearst didn't care whether his cartoons paid for themselves; his newspapers showed a profit, and if animated adventures of his syndicated characters boosted circulation, that was justification enough for the fun of owning your own cartoon shop. And so Happy Hooligan, Maude the Mule, Judge Rummy, Jerry on the Job, the Katzenjammer Kids, Krazy Kat, and Tad's Daffydils found their way to the silver screen in mini-misadventures tacked on to the end of the Hearst-Vitagraph News Pictorial once a week.

"I started on camera," Lantz recalls. "Gosh, I didn't know a camera from a soap box. It *was* a wooden box, just an old newsreel camera. It looked like an oversized suitcase with a lens in it. We used to sit up on a plank and look into the lens. The only way we knew to hold a drawing down was to put pins in it; we didn't have brains enough to know you could put glass on it."

It wasn't long before he graduated to the inking desk, and not long after that to the drawing board, acting as assistant to the tyro George Stallings. Generally, an animator's assistant fills in with supplementary drawings between the animator's key positions. But the sophisticated system now in use hadn't yet evolved, so it became a more catch-as-catch-can affair, with Walter taking care of just about any drawings Stallings didn't feel like doing.

In fact, now that he was rubbing elbows with professionals, he was discovering that he and Mr. Landon weren't the only ones who didn't know much about animation in those primitive days. "It was every man for himself, and the fellow who could make the most drawings in a day got the most dough," he says. "The action was very jerky. I don't think La Cava knew any more about animation than we did. We might start

WALT-LANTZ

with the idea of having to go to the North Pole, but that was as far as we would go in working out the story. There weren't enough people in the organization to make the story department of a cartoon studio today. Bill Nolan would say, 'Walter, I'll pick up the scene with Happy Hooligan coming in from the left. When you finish your scene, be sure he goes out to the right.' That's all I had to remember. If I didn't know, I'd bring him up out of the ground. If one artist figured out how to make a character jump, he'd do a jumping sequence."

Inevitably, the Hearst cartoons of 1916 looked more like the Hearst comic strips of 1916 than anything we would even loosely call an animated cartoon today. If the animation was proceeding by trial and error (and mostly error at that), the animator's ingenuity was invested chiefly in keeping all movement to a minimum and getting it over with as quickly and surreptitiously as possible. And with the running time generally stopping short of three minutes, the stories were rarely any more involved or adventurous than the ones enacted by those same characters in the Sunday half-pages. Frank Moser's *Krazy and Ignatz Discuss the Letter "G"* was typical; the title gave the whole story away. Verbal gags and situation comedy carried the day, and the only visual humor seemed to come out of the individual animators' amusing solutions to the difficulties of getting a character from point A to point B (such as Captain Katzen-

jammer in Stallings's *Der Captain's Magic Act* tying his arm in a knot to prove he's got nothing up his sleeve, or Happy Hooligan in Moser's *Doing His Bit* jumping into a cannon by leaping in the air and then sliding *backward* into the barrel). "If a character wanted to reach three feet to pick up the telephone," Walter points out, "we'd just stretch out the arm three feet, rather than walk him over there with a natural move. We didn't go in for the slapstick and the broad humor of later years. We didn't know what a *real* gag was, or what 'topping a gag' meant."

Under La Cava's guidance, improvements came with the years. First, draftsmanship picked up when he recruited accomplished artists like Grim Natwick, a colleague from the Art Institute of Chicago, then engaged in drawing sheet-music covers. A neophyte to animation but several years older than Walter, he was impressed to find this quiet teenager holding his own in a room full of hard-core veterans.

Walter was impressed by Natwick, too: "He could draw circles all around me. He learned animation faster than anybody I knew, because he was such a wonderful draftsman. I'd give him two drawings and say, 'Make a drawing in between.' And later on: 'Put three in between,' then 'Five in between,' and that's how we learned to animate. All you had to teach him really was the spacing, because he could draw so well. He was the best artist in the plant. He could put the character in any conceivable position, in any perspective, so he didn't have to learn to draw like the rest of us."

Natwick doesn't deny that his talent for handling anatomy in different perspectives enabled him to tackle tricky movements considered impossible by more experienced hands. "I started turning characters around on the screen," he claims. "Up to that time, if they wanted to turn a character around, they'd walk him off and bring him back."

The visual qualities of the cartoons moved up another notch when Bill Nolan, in his relentless search for ways to make life easier for himself, happened on something that was soon dubbed "rubber hose" animation. Nolan found that, instead of bending an arm at the elbow and the wrist and moving it in a succession of jerks, an arm could be drawn as if it were a rubber hose and swung in a graceful, if unrealistic, arc from pose to pose. It was easier to draw, took less time, and achieved fantastic effects similar to McCay's without requiring McCay's precision artwork. Nolan went wild and proceeded to move *everything* like a rubber hose in pictures like the Happy Hooligan cartoon *The Spider and the Fly,* so that axes, bottles, and human bodies were slung about like dishrags at the slightest provocation. Audiences laughed to see such a sight, just the way they

laughed at the speeded-up action of the Keystone Kops, and La Cava drew the attention of the other animators to Nolan's discovery. "It created a new style, and it loosened up animation," Walter explains. Studio cartoons had begun to assume a look all their own.

La Cava turned his attention to the story lines, too, figuring that a little preplanning in this department could only better the impact of the finished cartoon. Rather than leave the whole business of creation to the individual animator, as was being done everywhere else, he began sketching out gags and sequences he wanted to see in the picture and talking them over with the artists involved. Informal gatherings were held, with all hands on deck, to lay out stories and possible jokes, and these resulted in more sketches for the animators to use. "This is how the stories were really written: by illustrations," Walter reminds us. Eventually this developed into the method known as storyboarding, still used on all animated cartoons and also on visually oriented live-action films that demand it.

But La Cava's greatest contribution had less to do with technique than with human nature. Later, as a feature-film director, he would say, "I have no technique. Give me a story about human behavior and I'll put it on the screen. Give me real people to work with, people like Bill Powell and Carole Lombard, and we'll give you a picture." Now he was telling Walter and the rest of his artists, "We want our characters to act like human beings. We want the audience to see them thinking. We want to put blood in their veins."

La Cava saw that absorption with the technicalities of filmmaking often got in the way of what should have been a direct connection between the human beings making the film and the human beings in the audience. He saw the amazing link between audience and screen that Charlie Chaplin was able to establish, and he became a student of Chaplin's methods. It didn't take La Cava long to realize that timing was critical to the audience's perception of a joke, and he started working with the animators on spacing the drawings closer together or farther apart for maximum impact. Across town, animators at the Pat Sullivan studio were doing Charlie Chaplin cartoons and studying films and photographs supplied by Chaplin himself. La Cava managed to get hold of prints of Chaplin's comedies for his animators to analyze frame by frame—actually tracing a sketch of action on separate sheets like an animated scene.

The gains are apparent in the few Hearst cartoons that have survived the intervening years. From 1916 to 1918, the films progress from being twitchy, jumpy re-creations of comic strips to being *animated cartoons,*

with attention clearly focused on individual characters and their inherent gestures, quirks, and problems, worked out in terms of readily perceptible action and physical comedy.

Walter had now reached the ripe old age of eighteen and was a full-fledged animator with his own series to do: Walt Hoban's *Jerry on the Job.* These pictures show off the talent responsible for his rapid advancement, and it may be a little unfair for Lantz to credit all his progress to La Cava. Certainly Walter's love for broad comedy makes itself apparent in *A Tough Pull,* when Jerry's boss at the railroad station seems to have a toothache and Jerry attempts to cure it by tying one end of a string around the tooth and the other onto a train, which he starts up in hopes of yanking out the tooth; when the thing doesn't surrender immediately, the train pulls the entire station off its moorings and begins dragging it over hill and dale, with no actual connection between the two objects but that beleaguered tooth. But even tiny gestures, wildly exaggerated and grotesquely distorted in order to register, are rendered with the draftsmanship and comic timing necessary to put them over, so that everything is at once recognizable as human action and blown out of all proportion like a good cartoon. In *Sufficiency,* little Jerry toddles around with a run conspicuously different from the manly stride of his boss—a rapid paddle in which the feet lead the body, somewhat like Chilly Willy's pace forty years later. The characters in general are doing more and talking less.

All of this was aimed at getting bigger reactions from audiences, and it worked. They were delighted with the clever effects, and, more to the point, Hearst was delighted with them. "Hearst was *insane* about animation," Natwick remarks. "He couldn't *wait* for those pictures." Progress was encouraged and stepped up.

Walter was rewarded for assimilating the new rules of the game with a salary that climbed in leaps and bounds from ten to thirty-five to seventy-five dollars a week, and still rising. He was able to get himself out of the Y and into an apartment in the Bronx that was roomy enough to rescue his father and both brothers from leaning on relatives. If he could get money enough to buy some furniture for the place, he could move them in right away.

La Cava solved his problem, first by lending him enough to buy all the furniture he wanted, then by raising him to $125 a week so he could pay it back. But after weeks went by and Walter had squirreled enough away to repay him, La Cava refused to take it. "You're going places, Walter," he insisted. "When you get there, you can buy me a dinner."

REEL 4

Making Good

THERE WAS SOMETHING UNREAL about having this much fun and getting paid for it. Walter Lantz was working hard and had his eye on better and bigger jobs, but his daily grind was made up of the kind of thing most people looked at just for kicks. When work is hard to distinguish from play, illusion and reality start getting mixed up. And when your business demands a strange combination of childlike imagination and disciplined effort, it's easy to let your diversions cross that critical line that separates them from needs.

For Walter's sunny, hard-working nature, such considerations posed few problems. But the environs were strewn with the bedraggled remains of those who didn't have such an easy time of it. It was the twenties, and things were getting a little crazy.

Walter's extracurricular cartooning was finding its way into the magazine of the New York Athletic Club (of which Fred Kafka had made him an honorary member), along with assorted trade periodicals, and he even experimented briefly with the demands of a daily strip, creating a little character called Speedy. His first published cartoon appeared in *Temperance* magazine when he was only sixteen and extolled the virtues of national Prohibition. It was more a professional thrill than a personal vendetta, though, since he's always admitted that Prohibition was a national disaster, and once he got in with athletes and cartoonists, he was no teetotaler.

"It's a miracle anybody's alive, with the stuff we used to drink in the Prohibition era," he exclaims. "We would all chip in for a gallon of grain alcohol, put it in a five-gallon jug, put about two gallons of water to it, add some juniper berries and orange extract, shake the bottle, and the party was ready." But most of them, according to Grim Natwick, "didn't know the difference between wood alcohol and grain alcohol. After one swallow you could light your breath with a match. When skyscrapers flew past you in opposite directions at fifty miles an hour, you knew you had had a drink."

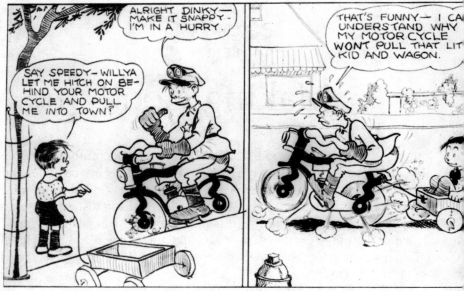

Comic strip in the New York Globe.

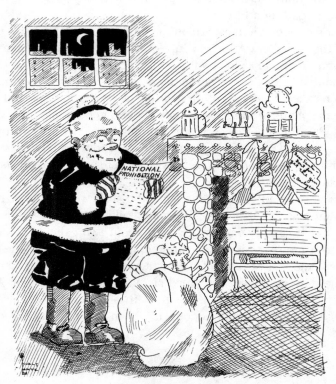

(SANTA CLAUS IN JOHN BARLEYCORN'S HOUSE)
"I guess the best thing to leave Johnny this Christmas is National Prohibition"

(Sketched for TEMPERANCE by Walter Lantz)

Though George Stallings made a safe and reliable source of alcohol, none of the group attempted to compete with his consumption, which grew legendary. One Christmas Eve Walter agreed to help George decorate his tree after Junior Stallings had gone to bed. Drinking and decorating went on past midnight, when it occurred to George that the perfect way to cap off this festivity was to invert the empty scotch bottle and place it on the very top of the ten-foot tree. Walter was foolish enough to agree, but by the time he was in a position to do it, it was clear that Stallings, after emptying the bottle, was in no condition to hold the ladder. Walter found himself brought down in the line of duty and decorated for his bravery all at once.

"Creative artists and actors and so forth, they're a happy-go-lucky bunch of people," says Walter. "They get together a lot, there are always a lot of parties, and the weak ones begin to use liquor as a crutch. They feel that if they can take a drink they can think better, and it doesn't work that way."

The victims of the disease aren't limited to artists, though, and the closest case in point was right there in Walter's own family. His younger brother Al was still getting in trouble every twenty minutes, only now there was no patriarchal grandfather to give him a hard time for it.

First, Al discovered drink. At this point in his flirtation with the bottle,

a cheery, extroverted good humor was all the world saw. He was a born mixer, the life of any party, a spontaneous mimic, and a great self-taught guitarist—and a skilled chef, too, bringing home his own bacon in bulk quantities weekly.

Then he discovered cars. Not the kind that got you from one place to another: Al discovered the kind of car that made heads turn, thawed out cold women, got deferential smiles from hotel doormen, and made parking attendants forget about tips. He went from a Hudson to a Marmon to a Stutz to a Mercer to something called a Blue Boy Paige that was as fancy as its name.

Then he decided to be a racing-car driver. He found a once-in-a-lifetime chance to buy the $11,000 Duesenberg that Ralph Mulford had raced at Indianapolis, for only $3500, and it would have been his on the instant if it weren't for the fact that he didn't *have* that money, and that he couldn't enter any races until he had a mechanic to ride alongside and hand-pump the oil. Al solved both problems by persuading his older brother to take a momentary leave of his senses and join him in the venture. Soon they were practicing on the roads from New Rochelle to White Plains, and driving to Danbury, Syracuse, and Rochester to enter competitions—all without their father's knowledge, natch, since it would have killed him even sooner than it would them. They tried to save money by driving their car to each race rather than shipping it by truck, but the

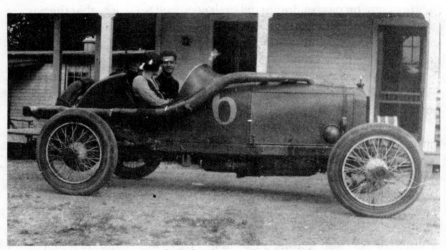

This Duesenburg finished third in an Indianapolis race, driven by Ralph Mulford. It was bought by Walter Lantz, seated in car.

Walter Lantz, Al Lantz, and Clyde Geronimi.

engine was so noisy they nearly got arrested every time they went through a town. Finally, Frank Lantz got wind of his sons' daredevil exploits and blew a gasket. Not wishing to bring any further strain or anxiety to a man in his physical condition, Walter and Al agreed to quit while they were alive.

Walter's most prized memory of his brother involved a stunt that he could only blame himself for putting him up to. When he needed a live-action shot of a bear clambering on the roof of a mountain cabin for one of his films, he talked Al into joining the cameraman and himself for a field trip out to a friend's hunting cabin in the Adirondacks, struggling into a prop bear skin, and cavorting roofward. Al remained as unenthusiastic about initiating an acting career as he was about impersonating a dumb animal, but he went on with the masquerade and started putting on a pretty good bear imitation. But just then, much to the astonishment of everyone, gunshots filled the air. The thought occurred to Al that his bear act was *too* good, and he scrambled off the roof, wasting as little time and as much movement as possible.

Walter in The Hunt.

Al disappeared from sight, but the shots went on. Only then did everyone remember it was the first day of the hunting season. No surprise that shots should fill the air, directed randomly at more authentic woodland creatures and other hunters all over the forest. This satisfied everyone but Al, who, when he was found again, declared that his acting career, brief as it was, had run its course.

Walter proceeded undeterred and refashioned the film so that an animated bear performed the required action. He got the necessary shots of the cabin and of himself running in and out of it, and took his leave of the mountains gracefully.

The decision to make this change was all his. He had had to defer to no one. While Al had been growing into a chef, Walter had become a movie director.

■ ■ ■

It was called Black Monday, but, like everything else, it was entirely fortuitous for Walter Lantz. Hearst's accountants had finally persuaded him that the cost of paying all those animators wasn't justified by the minor publicity value of putting on the screen characters who were known

all over the country anyway. On Monday, July 1, 1918, it was announced, and at the end of the working day on Saturday, July 6, it came to pass: Hearst closed his cartoon studio. A series of complicated and haphazardly chronicled moves followed, in which other studios were licensed (and in some cases financially backed) by the Hearst organization to keep those characters on the screen. So the same happy hooligans, being animated by the same artists, turn up in films produced by John Terry at a studio in Greenwich Village and then by J. R. Bray's studio in the same building.

Bray had apparently taken over the distribution of manufactured cartoons, then the cartoon manufacturing itself, hiring George Stallings to be his chief animator, director, and bottle washer. Throughout the maneuvering, Walter stayed quietly at his drawing board, displaying his talent for being in the right place at the right time, at a time when the right place to be was at George Stallings's side. Stallings was still known as one of the giants of the industry, and as long as he remained in demand, either at the assorted spin-offs of the Hearst studio or, for a short stint, at one of the various Mutt and Jeff studios, life in his shadow was prosperous as all get-out.

When a less benevolent shadow began to loom over Stallings and his reputation started its downhill slide, that ended up working to Walter's advantage, too. Soon Stallings was going out for lunch and not coming back. This sort of thing didn't go over big with the straitlaced Mr. Bray, and it would be up to Walter to go out searching for George—in reality making the rounds of the speakeasies he knew darn well Stallings frequented, rushing him over to the automat for food and coffee, and plopping him back in his chair. Walter remains charitable to this day about Stallings and his habits: "Like a Southern gentleman, he could handle his bourbon. I don't think I ever saw George really drunk, vicious, out of line, or anything. He was really a nice, easygoing guy!" Bray was not so charitable. If Lantz was so dependable when it came to rounding up Stallings, why not put him at Stallings's desk and depend on him to stay there? Stallings was out and Lantz was in.

Walter tried to conceal his astonishment at being handed this prime assignment and assumed a very professional air when he received the news. But the thought occurred to him that the cartoons Stallings had been doing usually consisted of a combination of animation and live action, in a method devised there at the Bray studio and adopted by former employees Max and Dave Fleischer when they set up their own shop and began producing the famous Out of the Inkwell series.

"Who's going to be our actor?" Walter asked Bray.

Bray's answer was succinct: "You."

"How about the director?"

"We can't afford one. You'll have to direct yourself."

"Well, who writes the scripts?"

"You, of course."

Bray was growing tired of giving the same answer to every question, so Walter phrased the next one very carefully: "How do you put makeup on?"

"Go to the movies and see how they do it," he was told.

When Walter asked, "How about a staff?" Bray said, "You can have one inker, one painter, a background artist, and a cameraman who can photograph live action and cartoon animation and develop the three thousand still photos you will need for superimposing the cels. And, oh, yes, you can have an assistant animator."

"Well," Walter says now, "the assistant was an old friend of mine, Clyde Geronimi, who later became one of Walt Disney's top animators and directors."

J. R. Bray was another animation pioneer, but not a man cut from the same cloth as the rest. It wasn't like him to order lunch for an entire rival studio and stick some unsuspecting animator with the tab, as Dick Friel might do over at Mutt and Jeff. J. R. Bray frowned on such high jinks. He frowned at about everything. He came to work at 8:30 every day dressed immaculately in his high celluloid collar, jacket, and tie, he worked very hard, and he left at 5:30. Everybody called him "Mr. Bray." It was years before Walter could bring himself to call him anything else. Finally, in 1967, at the Animation Retrospective at the World's Fair in Montreal, when Lantz was sixty-seven and Bray was eighty-eight, Walter broke the silence. He called him J.R.

Bray was animation's greatest proponent of the mass-production, success-ethic, 98-percent-perspiration spirit of the early twentieth century, at once the Henry Ford, Harold Lloyd, and Thomas Edison of the cartoon business. When Bray later spoke about what got him interested in animated cartoons as early as 1910, he said, "I thought there was good money in it." When asked about McCay and *Gertie the Dinosaur,* he said little about the awe-inspiring artistry involved; his only comment was ". . . Each movement of the diplodocus had a different drawing of the same background. He tried to trace it, you know."

Bray was referring to McCay's laborious method of providing a background for Gertie's antics. J.R. told an interviewer in 1925, "I wanted to

J. R. Bray, founder of Bray Studios.

simplify and perfect the process, so that the cartoons could be supplied as a regular motion-picture feature—as *many* of them as the public might want." Together with Earl Hurd, he formed the Bray-Hurd Process Company and patented such techniques as the painting of animated characters on transparent sheets of celluloid and laying them over separate background drawings or photographs (although Grim Natwick claims, "Everybody in New York ignored the patent, because we'd all used it before he ever copyrighted it"). They replaced the crosshatches-and-pins method of aligning drawings by inventing a standardized system of drawing-board pegs and peg-holed paper that is still used today. Bray, along with Raoul Barré, was among the first to set up an animation studio where teams of artists produced cartoon series on a regular basis, and it was Bray who created many of the time-saving tricks, similar to today's limited animation, that made the idea practicable.

Once his cartoons were a success, Bray branched out into scientific, instructional, and documentary films. It also occurred to him, before it occurred to Disney and others, that his hard work was just filling the pockets of other people unless he managed to negotiate *ownership* of those films, another goal he finally achieved.

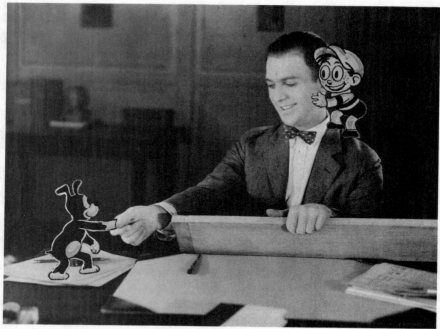

Dinky Doodle and Weakheart, Walter Lantz, Bray Studios, 1922–24.

And he meant for his success to be a value lesson to everybody: "If you have faith in your dream," he declared, "and faith that *you* can make it a reality, don't be afraid to take a chance! As I look back on my own life, it seems to me that whenever I made a real step forward, it was because I had the nerve to take chances." Those words weren't falling on deaf ears.

The film that had coaxed Al Lantz into retirement on the roof of that mountain cabin was released in 1925 as *The Hunt,* and it's rich in the kind of invention that was the charm of the cartoons Walter Lantz made for Bray. In one scene, a flesh-and-blood Walter runs himself through the conventional cartoon routine of popping his head out from behind several individual trees in succession without ever traveling the distance that *separates* those trees; then he takes it one step further and pops several identical heads out from behind all the trees at once. In another scene, he rescues his rifle after it's fallen in the river and tries shooting it at a pelican, only to find fish flying out of its barrel and into the pelican's beak.

Walter rightly points out the crudeness of his acting technique ("I played everything like I'd have a cartoon do it," he admits), and his borrowings from Chaplin, Lloyd, and Keaton just make things worse. In comparison with the brilliance of contemporary Hollywood and German UFA models, there is little to be said for the visual gloss that Lantz's photographer, Harry Squires, was able to get out of the antiquated wooden Moye newsreel camera Bray supplied him with. But these films have a cornucopia of bright ideas, and the crazier the better, molded from his animation experience and fired with the recklessness of youth and the roar of the twenties.

Bray insisted that each picture be completed on time (one was released about every two weeks) and cost no more than $1800. ("I had no idea what the cartoons were costing," Walter admits, "so this figure didn't frighten me.") Each picture met Bray's requirements, and as Walter plugged doggedly on, the pace and quality picked up. The studio recovered from the doldrums it had been in since Paul Terry and the Fleischer brothers had left.

The combination of live action with animation was achieved by a tedious and involved process somewhat more complicated than the one used by the Fleischers, whose live-action backgrounds tended to be static when the animated figures were in motion and vice versa. In the Bray pictures, both could be moving at the same time. Walter explains, "I

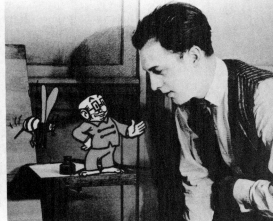

Walter Lantz and Col. Heeza Liar.

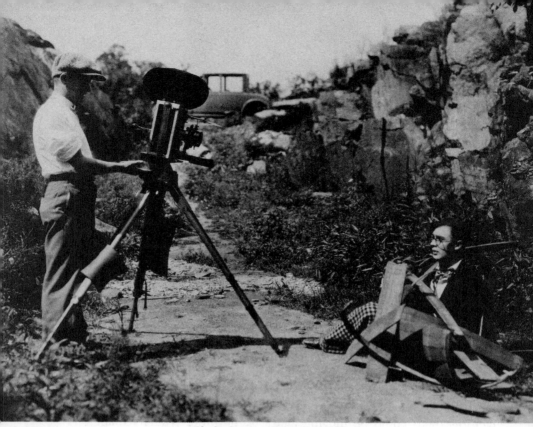

Clyde Geronimi assisting Lantz..

would pick up an imaginary character six or eight inches high and talk to him and put him down, or whatever the action happened to be. Then we would take the negative of this live action and make an eight-by-ten photograph of every other frame—bromides, we called them—three or four thousand of them, and develop fifty at a time so the density would remain the same. The animator would place tissue paper on these photographs and animate the character on my hand to fit my actions. Then we'd take these drawings, ink them on sheets of celluloid, paint the backs of the celluloids, and rephotograph the eight by ten with the cel. That's how we got the combination." This process could be varied to get animation out of live-action figures by gluing cutouts from photographs onto cels of their own, creating effects similar to those of the Monty Python animators fifty years later.

Walter's delirium was coming out of the inkwell rather than the bottle.

Walter Lantz with Dinky Doodle and Weakheart.

His regular stars, the cast of pixies who populated his pixilated reels under names like Dinky Doodle and Weakheart, were like any other animated stars of their age: good, red-blooded, healthy American cartoon characters, ready to distort any prop at hand for the sake of a gag, pen-and-ink figures whose home was the drawing board and whose playgrounds were the conventions of the genre—clearly but minimally delineated individuals whose emotions were recognizable without subtitles and who defined themselves by what they *did* rather than what they *said*. Sketched in a kind of emotional shorthand, they were personalities only as far as they needed to be to get the gags across. The main ingredient was the gags, strung out along piano-wire-thin premises and improvising screwball chords every inch of the way.

The stories and jokes were concocted La Cava-fashion, at informal meetings presided over by Walter and attended by all the capable as-

Walter with Dinky Doodle and Weakheart.

sistants he'd been able to gather, who now included Geronimi, James Culhane, and even, for a spell, brother Michael. Culhane, who later Gaeli-cized his first name to Shamus and went on to do plenty of animating and directing himself, had been a fellow art student with Michael at Harlem's Vocational School for Boys and had become a fellow recruit at the Bray studio on the strength of his drawings, which Michael had trundled home and displayed to Walter over the dinner table. There he was, performing whatever odd job a trained hand could handle, and, in his memory, some of those jobs got pretty odd: "The biggest problem was the paint. You would work all day and finish a pile of cels. You'd get up one morning and it would be blazing hot. I'd run down to the studio, and everything was stuck to the next drawing. Or in the wintertime they'd turn the heat off in the building for Saturday and Sunday, and you'd come in, you'd take some cels, and all the paint would fall off on the table."

Culhane showed more stick-to-itiveness than the paint, but Michael Lantz had no such patience. Michael had originally been intrigued by the art of sculpture, and this fascination grew rather than diminished with each passing day in an animation studio. A very amicable parting took place, in which Walter helped Michael find his way to New York's National Academy of Design, and from there to the great sculptor Lee Lawrie, with whom he worked and studied for ten years. When Lawrie was commissioned to do the statue of Atlas that still graces Rockefeller Center, Michael served as the model. He went on to create many imposing and impressive monuments of his own and to receive many more equally impressive pieces of sculpture as awards.

But as far as Walter was concerned, there were no doubts that he was just where he wanted to be. His films were being turned out on schedule and within budget, and they were going over well with audiences. What more could a producer ask for? Most of them opened at the Capitol, Loew's flagship theater for the New York area, and commanded such hefty rentals there and in other key locations that the cost of making the films could be made back in a single engagement.

And something else was starting to happen. As Walter walked into restaurants or pulled into service stations, people recognized him. He began to realize that not only was he getting more steady work than the average cartoonist, he was getting more steady exposure than most professional actors. He hadn't wanted anything more than to be a success in the cartoon business. Before he knew it, he had become a celebrity.

REEL 5

Hot for Hollywood

When Walter Lantz came to California fifty years ago, the lines of his life, time and place were merging much like the drawings of one of his cartoons. Both he and Hollywood were on the edge of a threshold. . . .

—*Westways,* 1977

IT WAS ON ONE OF the Bray days that Walter was ushered into a room at the Fox Studios' New York office and situated in front of an unlikely looking apparatus. There was a huge disk about a yard across, perforated around the edge like a precision turntable, with pinholes and slits suggesting some sort of visible but impenetrable Morse code. The disk was mounted on an absurdly long shaft sprouting from the side of a Gyro Gearloose contrivance of the kind that must have powered Oz. When this farrago was turned on, the disk rotated like a pie on a spit, and the spots of Morse code formed a stroboscopic spaghetti.

Walter had been instructed to bring his ukulele. Now he was asked to play it. He played. The pie spun. The spaghetti strobed. H. G. Wells missed something good.

Walter would never again see this machine or anything even remotely resembling it. If the experiment in which he took part was a success, the Fox people neglected, in their excitement, to let him know. But his destiny, and the destiny of everybody then involved or about to be involved in the business of making motion pictures, was to be intimately bound up in the workings of that machine and others like it. Its purpose was to record sound and image in synchronization.

The "revolution" that supposedly hit the movie industry like a thunderbolt the night *The Jazz Singer* opened had in fact been percolating for many years. Lee De Forest's sound films of vaudeville acts were on display in selected theaters as early as 1923, and before that, sound prologues and musical interludes had been added to various films as curiosity items. As the 1920s wore on and the novelty of the movies wore

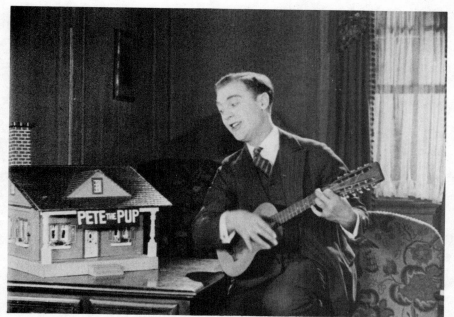

Walter makes one of the first sound tests at the Fox Studios in 1924.

down, it became clear that the days of the silent film were numbered. The famous thunderbolt came in storm clouds that had been visible on the horizon before they arrived.

It was not exactly clear what role the animated cartoon was going to play in all this. A curio offshoot of a curio industry, it was hardly considered topical in the face of a general cinematic move back to theatrical roots, with real people speaking real lines written by real writers and singing real songs backed up by real orchestras. The unreality of the silent melodrama and the silent clown comedy was growing increasingly unfashionable and with it the animated cartoon—the most unreal branch of show business the world had ever seen.

By 1927 the animation business was in a slump. Artists abandoned their light-tables and went back to the newspaper strip field. Rental rates for silent cartoons at the theaters plummeted. "I thought that was the end of animation," Walter admits. "I'd reached the peak of what I could earn."

In the face of a general lack of enthusiasm from Bray, Lantz, and the theater owners, the theatrical animation branch of Bray Studios was

closed. (The educational branch of the enterprise remains open to this day.) Walter's prospects elsewhere in New York seemed dim: Outfits like Terry's and the Fleischers' could offer no positions but the ordinary animator's chair, hardly an attractive post to a man who'd been writing and directing his own pictures for several years and was recognized at service stations.

Across the country there were new developments. While Walter was still working for him, William Randolph Hearst had decided to feature his newfound star Marion Davies in a series of expensive, full-length productions shot in the same building that housed the cartoon studio. Walter found Bob Vignola, a genuine Italian, among Miss Davies's directors, and a flourishing friendship was inevitable. Now Miss Davies was a major celebrity, and Vignola was part of her move to Hollywood and MGM, as well as a prestigious director in his own right. He encouraged Walter to hazard being a small fish and come test the waters in a bigger pond. It was a risky proposition, but not as risky as staying in New York.

Walter and his Locomobile, with the New York Athletic Club emblem on its radiator.

Walter told his father he would be heading west for a visit to Hollywood. Length: Undetermined. Frank Lantz, ever encouraged by any move that bore the scent of fresh vistas, challenge, excitement, and possible riches, didn't bat an eye. All he said was "Go."

"If it hadn't been for Vignola, I wouldn't have come to the Coast," Walter says now. "I had no idea what I was going to do. The day I arrived, Vignola was having a big party for Belle Baker. He had Sophie Tucker there, Gloria Swanson, the Irving Thalbergs, the Buster Keatons. I met the top stars in Hollywood!"

Surrendering yourself to Destiny in Hollywood starts out in an air of fanciful excitement, progresses to a spell of the doldrums, then boils down to the cold, hard residue of reality. The key question rotates from "Which of my options shall I exercise first?" to "What earthly reason would *anyone* have for hiring me?" You soon find out that there are only three good reasons recognized within the borders of Los Angeles:

1. You can do something no one else can do.
2. You can do it for a price no one else would consider.
3. You have influential friends who will overlook the absence of the other two.

It's this last one that really gets things moving, and that's why Walter's first real brush with Hollywood movie-making came in the most unexpected form possible: as lead comic in a series of two-reel comedies.

It seems that J. R. Bray, who'd been producing short comedies along with his other ventures throughout the twenties, saw possibilities in Hollywood's latest arrival and knew that Walter had years of experience and screen exposure and could be counted on to show up every day. Bray's West Coast production staff promptly put Walter to work at Larry Darmoor's studios in the heart of Hollywood.

Although sunlight was still the key source of illumination in the late 1920s, powerful white-hot klieg lights were often used to eliminate shadows and brighten scenes. They proved a blessing to the photographer but a curse to every actor forced to stare, bright-eyed, in their direction, since they had an effect on the optic nerve somewhat akin to tear gas. "All the stars used to suffer from those lights," Walter remembers. "You could hardly see when you'd go home at night; your eyes would be running and burning." The condition was called "klieg eyes," and it sometimes caused permanent damage. This hazard seemed decidedly more than the occasion warranted.

"Gee, I don't like this," Walter told Bray. "I want to go back to animation." But animation at that time was still a dying business centered in New York. The only animator in Hollywood was a young upstart named Walt Disney, who was producing cartoons for release by Carl Laemmle's Universal Pictures. The two Walts met and talked, but Disney was his own writer, director, and producer and didn't need anyone but animators.

The two-reel comedy was obviously a healthier animal and a far more lucrative proposition. To gain a sturdier foothold in its door, Lantz needed Reason Number 1 to come into play, which is just what happened when he met Sam van Ronkel, another producer laboring under the Universal banner, at one of Vignola's parties. Van Ronkel needed an animator's magic touch in some of his short comedies based on the character of Andy Gump, a Halloween configuration derived from the comic pages of the daily paper (and a familiar name to the American audience before being lent to a brand of portable outhouses).

So Walter spent several weeks with the Gump crew, helping them concoct screwball episodes and working out the technical means to get them on film. But it didn't take him long to get restless, cooling his heels at Universal's idea of a fun factory. Comedy was not a top priority at Universal City until the late 1930s, and there was little chance for Walter either to learn much or to advance in a place that wasn't interested in paying top salaries for top talent. An introduction to Leo McCarey, arranged by Van Ronkel, improved the situation.

Where short comedies were concerned, Hal Roach and Mack Sennett ran the town. Leo McCarey, a director and supervisor for the former, was one of the most successful of the younger crop of behind-the-camera comic luminaries: college-educated, witty and charming in conversation, and possessed of a sharp eye for comedy pantomime and the potential for laughter in the rise and fall of human dignity. He and Lantz delighted each other, but McCarey could offer little in the way of assistance. "Walter, I'd love to have you," he told him, "but our staff is filled and I can't pay you anything."

"I don't want the money," Walter countered. "I have money. I'll work for nothing, just so I can sit in and see how you work. I'd like to get some experience on two-reel comedies."

That made all the difference. Hal Roach Studios got something for nothing, and Walter Lantz got his experience.

He found the Roach lot a convivial place to frequent. In spite of the obsessive search for laughs, a homey, relaxed atmosphere prevailed. Hal

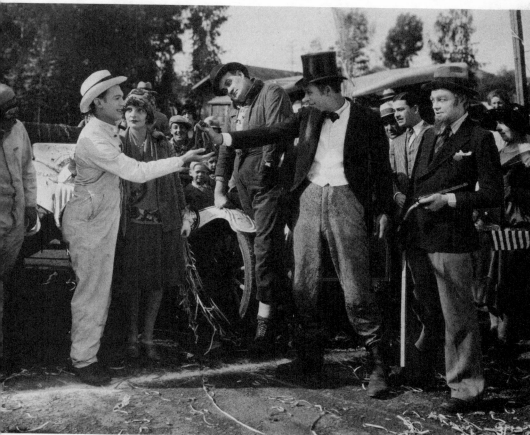

Walter and Peggy Shaw, stars in J. R. Bray's two-reel comedies.

Roach's parents moved into one of the bungalows on the studio grounds; his father served as the paymaster; his mother hung out laundry that flapped in the breeze. Story men might be seen in corners of sets, on piles of old lumber, in and out of everybody's offices, or anywhere their muse seemed to function best. The rigid caste system that stratified the rest of Hollywood failed to take hold on these premises, and everyone felt on the same chummy terms with everyone else. It was a human place to create comedy, and a particularly human kind of comedy came out of it. With the exception of the Chaplin and Keaton classics, the best-loved and most-watched short comedies of the twenties and thirties are the

ones that emanated from Roach's studio: the Our Gang films, the Charlie Chase pictures, Will Rogers's philosophical two-reelers, Edgar Kennedy's slow-burning displays, and of course, the great comedies of Roach's masterpiece, the team of Stan Laurel and Oliver Hardy.

Walter was there when the first Laurel and Hardy silents were being made, the team was just finding its style, and Leo McCarey was assuming the role of guiding hand. He was there when they filmed the prototype of their Academy Award–winning short *The Music Box,* struggling up the steepest set of stairs in southern California with a washing machine before they'd caught on to the comic possibilities of a piano. He was there when future director George Stevens (*Shane, Giant*) was flexing his cinematic muscles, creating gorgeous images as Roach's chief cameraman. He was there when Leo McCarey was stringing together three or four comedy routines on a piece of paper, calling it a script, and shooting a whole film based on nothing more. And he was learning what he wanted to learn.

He recalls, "I didn't know what a gag was until I came to Hollywood— never heard the word. I made hundreds of cartoons back east, but these were birds-and-bees stories, cute little fairy tales. I learned about gags from the two-reel producers and directors and actors, just by watching and listening. The phrase the comedy writers like to use is 'Tell them what you're going to do, do it, and tell them you've done it.' See, three laughs. That's how I learned about 'milking' a gag: Try to get as much as you can out of a simple situation. You have the running gag, where you repeat the same situation all through the picture. You have topping a gag: Just a man walking along and falling in a manhole isn't funny, but if he's walking along and steps on a roller skate and goes up in the air and *misses* the manhole, and then gets up and brushes himself off, and *then* falls in the manhole—that's funny. It's also very important who you pull these gags on: Pulling a physical gag on an old lady isn't funny, but if that same old lady is all dressed up in a beautiful gown and a lorgnette, and gets hit in the face with a pie. . . . That's how we learned to put slapstick comedy in the cartoons."

Walter would sketch a sequence in storyboard form and intrigue his co-workers with the superiority of images over words in matters of visual comedy. Everybody soon caught on to the fact that Lantz was the wizard responsible for those delirious comedy-cartoons coming out of New York, and there he was animating again. In one Laurel and Hardy episode, he danced musical notes out of the horn-speaker of one of those old victrolas

and on to the noses of the sleeping comedians to rouse them from their slumber. In another, titled *Flying Elephants,* a now-famous stretch of his animation follows Oliver Hardy's observation, "Beautiful weather—the elephants are flying south": Sure enough, a shot of the sky above reveals a herd of elephants winging their way southward.

Hal Roach's place was an ideal spot for weathering the looming transition to sound. The Roach humorists may have been masters of the mechanics of gag construction, but they didn't go about it in the mechanical way that their rival Sennett specialized in. The warmth of the Roach humor and the logic of its development were pretty much ignored in the hurly-burly at Sennett's domain in Edendale. Sennett had established himself in 1912, when fast, furious action and vigorous buffoonery were quite enough to provoke merriment in movie houses, and fifteen years later his concept of comedy had hardly advanced a notch. With an acid test like talkies in the wind, the old formulas were going to be hard put to keep audiences amused; Sennett's primitive idea of the human

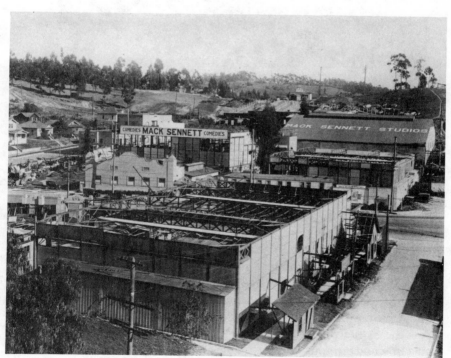

Mack Sennett Studios, Edendale, California.

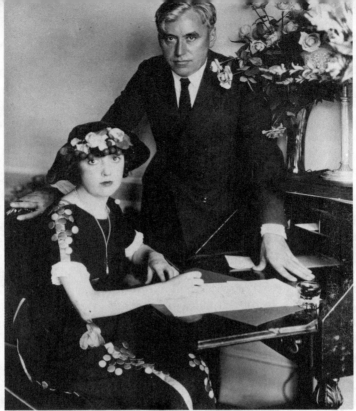

Mack Sennett and Mabel Normand.

comedy would have some rough going, up against the sophistication at Roach's.

The distinction proved to be critical. As it turned out, Walter was at Roach's for only six weeks. Reason Number 1 beckoned again, and the source of the call was the Mack Sennett studio. Walter heard the message by way of a character named Pinto Colvig, later the voice of Disney stars like Goofy, Grumpy, and Sleepy. When Colvig tried to help out Mack Sennett with a shot of a giant cootie that Sennett felt he just couldn't do without, he realized he didn't have the know-how the job required and recommended Walter, who tells the story this way:

"Mack Sennett was doing this feature, a World War I story, where they had soldiers in trenches and they were always scratching, from the cooties in their shirts. Sennett wanted to show this huge cootie going across the battlefield, and when the soldiers saw this they would all drop their guns and run out of the trenches.

"The Old Man asked me if I could do this shot. I said, 'Yeah. Just give me the film of the scared soldiers, and on cue have them throwing up

their rifles and running off into the distance.' Looking at me dubiously, he said okay.

"So they gave me the shot and I animated this cootie, which was just a black dot with six legs walking across the screen. It took me about fifty drawings and one afternoon to make this silly little scene. But I couldn't just do a cootie walking across a screen, it was nothing. I had a captain look at the scene through his binoculars, and I showed the cootie in the binoculars going around the binocular frame—going up one side, sliding down the other.

"Then in their optical department they superimposed this cootie over the shot of the soldiers. By the time I did it and they processed it, it was about a week's work. I ran the film for the gagmen, and they all okayed it. But they said, 'Walter, if I were you, I would not show this to the Old Man now. Why don't you hold it about three weeks? You could draw your salary here, and you wouldn't have to do anything but sit around and listen in on the story department. If he thought you had done what he wanted in such a short time, he wouldn't appreciate it.'

"So after three weeks we had the showing. Everybody went in the projection room, and we watched the Old Man. He had a habit of chewing tobacco. If he kept chewing, you knew he liked it. If he kept spitting into the sandbox he had, you knew he didn't. And he kept chewing. The shot was over in a few seconds, and he howled. Slapping his thigh, he said, 'Lantz, you're in. I'm going to give you a job here.' "

"Here" was Sennett's studio, a dog-eared, lopsided, misbegotten junk-yard that looked like the collision of three ordinary back lots. "The cacophony," said Frank Capra, who worked there just before Walter, "seemed to burst from loudspeakers." The film with Walter's cootie was *The Good-Bye Kiss.* When the Old Man, who directed the picture himself, couldn't get the kind of reaction shot from the star that he had in mind, he resorted to wiring the man's wrists and ankles and giving him a jolt of electricity big enough to make his hair stand on end. Lantz claims, "This gag was used quite often, in the days before method acting."

But as Walter hung out with the story men, and Sennett and the rest of them started dreaming up all the cartoon gags they could to make use of this new resource, he found that not everything that went on at the Edendale madhouse was that shocking, though most of it was about that subtle. "We were amazed at the foresight this old fella had on comedy," he recalls. " 'Cause, after all, he was not an artist, he was not an actor, he was just a blacksmith." More literally, Sennett began as an ironworker, and others have been more outspoken about him. Film historian William

K. Everson has written, "Taste and subtlety were virtual strangers to Sennett. . . ." Screenwriter DeWitt Bodeen, a film historian himself, remarked, "I must say that I have never heard of a man being so disliked by the people who worked for him as Sennett was. He was a common, vulgar man." Sennett ate green onions, lettuce, and radishes for breakfast, then washed them down with whiskey. He chewed unlit cigars and could hit a spittoon at thirteen paces. "Although Sennett," according to Frank Capra, "had no great sense of humor—as most of us commonly know it—his reaction to comedy was an infallible audience barometer. If Sennett laughed, audiences would laugh." Walter agrees: "He made everything very blatant; he believed in telegraphing every gag. If a character was going to use a barrel of dynamite, he'd *label* the barrel 'Dynamite.' If he was going to fall in water, he'd label it 'Water.' He liked to work with dynamite and water."

Long about Christmas, the dreaded pink slips started showing up in the pay envelopes. Standard procedure in that mordant profession called the Dream Factory: Lay everybody off before the holidays, when you couldn't get any work out of them anyway, and bring them back again when things got moving early in the year. Walter looked around and saw the story department, then the various production units, dropping off as the men got their notices. Everyone got the ax but Walter. He began to think, "I must be the fair-haired boy around here." Finally, shortly before Christmas, Walter was summoned to the Old Man's private chamber, brass spittoon and all.

"Lantz, you're a nice kid, and I like the work you've done for us," Sennett said between streams of tobacco juice. "You're new out here, and I didn't want to embarrass you too much, so I kept you to last. I won't need you anymore. The studio is closing down and won't open up again till March."

"Boy, he *did* like you!" said Capra, when he heard that story. "He wouldn't do that for his mother!"

■　■　■

It was the afternoon of New Year's Eve, 1927. Walter Lantz was once again at liberty. Ah, liberty.

He was whiling away the time at Bob Vignola's playing cards with an actor going by the name of George Duryea (later well known to Western fans as Tom Keene), when, on the spur of the moment, he was asked for the use of his Locomobile. Duryea's leading lady from his Australian

Gracie Stafford prepares for her starring role in Abie's Irish Rose.

tour of *Abie's Irish Rose* was coming into the Pasadena train station that night, and he wanted to meet her in style. Walter tossed him the keys, Duryea drove to the station, and Grace Stafford entered Vignola's party and Walter's life.

In ten years of legitimate stage experience, Grace had racked up a pretty imposing list of credits. Her first Broadway experiences had been with major names like the musical impresario Earl Carroll (in his first dramatic effort) and prominent British playwright-actor Ivor Novello. Without much ado, she was hastened into an Australian company for Anne Nichols's monster hit of the 1920s *Abie's Irish Rose*. Grace was set

Grace Stafford, actress.

to be in Australia for six months and was there for two years, not just in Sydney, but in tank towns and outback territories all over the continent and on into New Zealand. When she arrived in Los Angeles, it was not as a young actress with any harebrained notion of pursuing a career in the movies: She had no interest in that at all, and when she was later offered the chance, she went out of her way to avoid it. All she was pursuing when she stepped off that train was George Duryea.

But there was no denying the chemistry that immediately developed between the lively showgirl from New England and the quiet cartoonist from New Rochelle. The mellow atmosphere at Vignola's villa, both familial and streaked with glamour, was the perfect hothouse for the friendship that took root and started blossoming. In the months ahead, the two were to see a lot of each other—and, before long, announce to the world that they were getting married.

To two other people.

■ ■ ■

Cars and cartoons. No reason on earth why this paronomastic combination should ever produce any real results. But produce it did, with the dependability of a good spark plug. In 1928 the deal of Walter Lantz's life was made, and it all started because he knew his way around a camshaft.

Sam van Ronkel had a resplendent automobile, befitting his status as a movie producer. It was so resplendent, in fact, that he was afraid to drive it. His Rolls-Royce was intimidatingly luxurious, and the mysteries of its gear shift eluded him. Rather than master the mechanics, he found it easier, and *more* befitting his status as a movie producer, to have someone drive it for him. Since Walter had nothing better to do, he was elected.

Though Walter didn't play poker, he was treated like one of the boys when he drove Van Ronkel to his Thursday night poker games. Another one of the boys was Carl Laemmle, the dapper, folksy, five-foot-two Jewish immigrant from Laupheim, Germany, who had set up Universal Pictures in 1912 before there *was* such a thing as a major film studio. "He won me in a poker game," Walter would say of Laemmle in later years. Universal's president could lose $25,000 in a single night and react with a shrug. But he seemed to prefer winning, and he noticed he did more of it when Walter was around. "Lantz really is my lucky charm!" Laemmle exclaimed.

While kibitzing at the table where the big game was being played, Walter was actually, in his unpretentious, roughly intuitive style, playing the Hollywood game, deluxe edition, just the way his grandfather would have wanted it: hanging around the front door rather than the back, hobnobbing with nabobs, waiting for Reasons 1, 2, and 3 to line themselves up in a neat little row so he could stand up and cry "Bingo!" "I never pushed myself to make contacts," he insists. "I'm not the type of person who could go out and push myself like that. But I met these wonderful people. . . ."

Laemmle was still distributing a series of cartoons made by Walt Disney based on Laemmle's suggestions, through an arrangement worked out with Charles Mintz, who paid Disney for the cartoons and then sold them to Universal. Suddenly Disney found that Mintz had stolen the character away from him, right along with his top animators, Hugh Harman and Rudy Ising. For a time, Mintz employed Harman, Ising, their fellow Kansas City artist Friz Freleng, and Walter himself in getting the cartoons made. Then Mintz, a man deeply beloved by almost no one, turned around to find Harman and Ising taking the character from under his nose and offering it directly to Universal, who owned it all the time anyway. Finally Laemmle, fed up with all the shuffling around, appropriated the character for himself and got rid of everybody else.

Dismayed, Disney wrote his brother Roy from New York, where he'd gone to fight the battles, "I believe that whatever does happen is *for the best.*" He cooked up a new character that looked remarkably like the one he'd just lost, called him Mortimer Mouse, and offered him to Universal. The reaction was: "Mice?! Who wants mice? Paul Terry's done hundreds of them. Forget it." Later, Disney changed the mouse's name to Mickey, but made sure that, whatever else happened, he owned the character himself.

Laemmle then established what in 1928 was a striking new precedent: Universal Pictures would make its own cartoons right there on its own lot starring its own character. In later years, MGM, Paramount, and Warner Bros. would follow suit. This was all very well, except that Laemmle knew nothing about how animated cartoons were made. He needed somebody who knew animation, knew animators, knew the character, knew comedy, knew how to head up a whole department, and—a key consideration for anyone working for Carl Laemmle—knew how to keep within the strict confines of a budget.

That's when Van Ronkel intervened and reminded Laemmle that the perfect man for the job had been right there noshing with him every

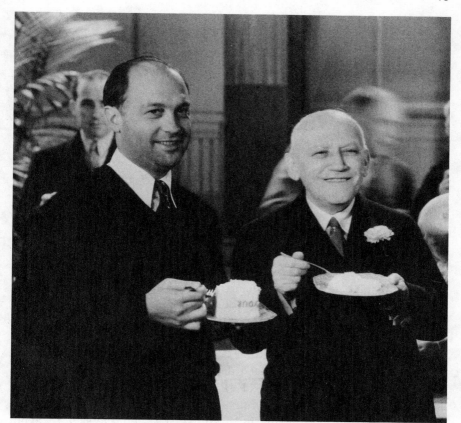

Walter Lantz with Carl Laemmle.

Thursday night. "He's been in the business longer than Disney has," he reminded him, and rattled off a list of Lantz's credentials. To Laemmle, this was all very well and good, but one consideration stood out above the others. "He's been lucky for me in poker," he decided, "he should be lucky for me in producing cartoons."

And that was that. "Just dropped right in my lap," Walter remarks. "That's where it really took off." Walt Disney told writer Pete Martin in 1955, "Universal gave the deal to Walter Lantz, and I was very happy. When Walter got it, we all met together and had a drink in New York, and Walter's been a good friend ever since."

And the name of this established character, which dropped just this way into Lantz's lucky lap out of a clear blue California sky?

Oswald the Lucky Rabbit.

REEL 6

Wild and Woolly

... It is thanks to the progenitors of the animated cartoons that the miraculous eyes occasionally wink and the monotonous mobility forgets itself in fabulous clowning. . . . Let me invite you to a seance with Oswald the Rabbit! . . .
— e. e. cummings, "Miracles and Dreams," 1933

UNIVERSAL PICTURES IS TODAY one of the most firmly entrenched bastions of economic stability in the American Southwest, but it started life in a briar patch of conflict, confusion, and mistrust, as a pack of renegade underdogs banded together to protect themselves from the really big guns of Thomas Edison. Carl Laemmle's Independent Motion Picture Company, or IMP, was corralled by Adam Kessel and Charles Bauman, Mack Sennett's distributors, to join their New York Motion Picture Company in a merger designed to combat Edison's Motion Picture Patents Company. Kessel and Bauman united IMP, Bison 101, Powers, Nestor, Champion, Eclair, Yankee, and Rex into a giant conglomerate that seemed to be the largest movie company in the universe. Laemmle saw a wagon labeled "Universal Piping Company" pass the office window on the day of the merger, and the new firm was called the Universal Film Manufacturing Company. Charles Bauman was named its president and Carl Laemmle—since no one else was trusted with the money—its treasurer. Internal power struggles and vindictive raids followed, fought back with mercenaries, police, and an old Civil War cannon in Santa Monica Canyon. When the dust cleared, Carl Laemmle held the reins, and for over twenty years he stayed in the saddle.

Laemmle was known as "Uncle Carl" to the majority of his employees, and in many cases it was the truth rather than a nickname. He loved employing family members, just as he loved considering everyone within his employ a member of his extended family, just as he loved targeting his pictures to those hordes of small-town families who then comprised

Uncle Carl Laemmle.

Original entrance to Universal Studios.

the bulk of the American population. Under his reign, early underwater photography reached the screen in *20,000 Leagues Under the Sea*, Erich von Stroheim exposed European decadence in *Blind Husbands* and *Foolish Wives*, Lon Chaney snarled into stardom as *The Hunchback of Notre Dame* and *The Phantom of the Opera*, Rudolph Valentino glowered in *A Society Sensation*, Bela Lugosi brooded as *Dracula*, Boris Karloff stumbled in *Frankenstein*, and Lew Ayres fulminated in *All Quiet on the Western Front*. A Jewish Old World gent, Laemmle requested donations yearly for his German hometown, Laupheim, and the Universal family, grateful for the steady employment or for their family connection or for both, didn't fail to comply.

Universal was the first of today's major movie studios, and, though the growth of Paramount and MGM had by 1928 rendered it the most minor of the majors, it was always a potent force in the industry. It was made to order for Walter Lantz, who needed nothing more than a home base to allow him to set up a filmic family of his own. "I had one hundred twenty people working for me," he says of his first Universal years. "I knew everyone by their first name, and they called me Walter."

He made his old crony Bill Nolan a director, with a salary equivalent to his own and responsible for half the department's anticipated output of twenty-six cartoons a year. Nolan and Lantz both went to work recruiting buddies, and a healthy chunk of the New York animation industry headed up a migration west that was to effect a fundamental change in the entire business.

"I signed a seven-year contract," Walter recalls, "but, if you read between the lines, I had a ten-minute contract." He tried to ensure that the contract would last the full term by practicing every survival tactic that popped into his creative skull. One was to keep his name off his office door: "Everybody had so much ego—the directors, the producers, the writers—they wanted a name on the door. But that was the worst thing you could do, because if that name was up there too long, the studio manager would get tired of looking at it, and he'd say, 'Let's get somebody else and change the name.' "

The "office" itself didn't sit still long enough for anyone to get tired of it. Its first location was in some ancient writers' cottages and dressing rooms and a barnlike structure with a rheumatic loft called the Bullpen (appropriately named, since it once housed the publicity department) in an abandoned alley at a remote outpost on the immense lot, generally referred to as Pneumonia Row. As Walter describes it, "It was a horrible

place. I had to hold an umbrella over the drawing board whenever it rained."

All this was purely temporary, as the Universal machine shop went to work building drawing boards and camera stands according to Walter's specifications. The workers did their job in short order, knocking off twenty animators' light-boards in a couple of days the way they'd build Monte Carlo for a Von Stroheim film. Just to get things rolling, the carpenters took a table forty feet long and drilled in a pegboard every five feet, so the animators were touching elbows all the way down their lineup. Soon the staff of animators, assistants, inkers, and painters was comfortably housed in a cavernous old ex-shooting stage that had been converted to an animation studio.

Universal was not, in general, making the conversion to sound with any eagerness, but once the transition was made, it worked wonders for Walter's business: "Sound and music opened an entirely new field for animated cartoons," he points out. "They became in demand again in theaters."

That demand wasn't hurt any by the opening of Walt Disney's *Steamboat Willie* in New York later in 1928. The first Mickey Mouse picture to hit the theaters and start a sensation, *Willie* wasn't the first cartoon with a sound track, but it was the first cartoon to use its sound track *creatively,* and that made all the difference. Lantz explains: "He [Disney] had the idea of animating to a musical beat. The characters' actions were animated to the tempo of the music. It was much easier to watch, and this fascinated audiences because they'd never seen anything like it before. Disney really created that idea, and then we would do the same thing."

The abstraction of a moving drawing was suddenly made vivid and immediate when that drawing was set to music and given sound effects. The cartoon stars of the thirties and forties became bigger celebrities than their silent-screen counterparts, and the animated short subject became a *de rigueur* element of every movie theater's program.

If Oswald was going to talk, he needed a consistent voice, and Walter found one in the pint-sized person of Mickey Rooney, then a star at age nine in the two-reel Mickey McGuire comedies being shot at Larry Darmoor's studios. Lantz made an arrangement with Darmoor and obtained Rooney's services. "Mickey did a terrific job," he remarks. "But he was just a wild kid. We'd sit down and do some dialogue with him, then take a rest, and then we had to run all over the lot to find him."

Mickey Rooney in one of his Mickey McGuire comedies.

Nothing stood still in the cartoons, either. Lantz was determined to be as inventive in his sound films as he'd been in his freewheeling silent pictures, and he encouraged the same kind of madness from his staff. The addition of sound and music just meant that all the wild action would happen to the rhythm of some hot jazz. The result is the creation on film of a world in which just about anything is likely to come to life and dance around. Like the skeleton key who shimmies off the key chain in *The North Woods* and gets Oswald out of his handcuffs. Or the tubes that abandon the radio to protest the bad violin music in *Radio Rhythm*. In another entry, *In The Navy,* Oswald is a sailor told to get busy, so he proceeds to milk the handles of the ship's wheel like a cow's udder, brush the teeth in the mouth of the cannon, and haul up the anchor so it can shake itself off like a puppy.

Walter's personal life was being played out against the same hot jazzy rhythms. Grace Stafford (*née* Boyle) married George Duryea (soon to be Tom Keene, then Richard Powers) before the 1920s were quite over, at the home of writer Evelyn Campbell in Del Mar, near San Diego. There

was no aisle to march down, so the guests simply formed a procession through the living room and stationed Walter, the best man, by the victrola with a cue for starting up "The Wedding March." He picked up on the cue but decided Sophie Tucker's "Red Hot Mama" was more appropriate for kicking off the ceremony.

The wedding party got even hotter after that, with every variety of then-illicit spirits (Prohibition hadn't yet been repealed) contained in every variety of bottle, jug, flask, and flagon. These spirits were just getting raised to the appropriately high pitch when the doorbell rang, heralding the arrival of none other than the city's chief of police and a squadron of officers with the stated intention of staging a raid on the spot. There ensued the usual frantic efforts to hide those selfsame bottles, jugs, flasks, and flagons under sofas, chairs, tables, and cushions. The police did a thorough job, taking everyone's name, blocking all the exits, and altogether putting on an excellent show before revealing that it was a gag set up by one of the wedding guests—Ben Piazza, the casting director at MGM and a man with connections all over the state. The

Masquerade parties were very popular in Hollywood in the 1930s:
Walter is visible in the center of the second row,
Grace is sixth from the left in the back row.

officers proceeded to take off their uniforms, throw away the names, and join the party, and then it got even hotter than before.

Walter's wedding took place a couple of years later, joining him to a member of the Vignola crowd named Doris Hollister, a slim, olive-skinned beauty with dark hair and dark eyes. Doris was a true child of the movies, the daughter of George Hollister, one of Hollywood's best cameramen, and Alice Hollister, a silent-screen actress who'd appeared in many of Vignola's films. Appropriately, the wedding was held at Vignola's palatial layout and grew into one more spectacular party, with the spacious rooms, red-checkered tablecloths, and generous heapings of food that were Walter's Italian birthright.

But before all this splendor took place, a sober note was struck right in the middle of Walter's stag party. He was whooping it up in Toluca Lake with a gang of his friends, when Grace Duryea (*née* Stafford) came to the door with the terrible news that a friend of hers had been hit by a car and just happened to have been thrown precisely onto Walter's front lawn. Walter and his fellow stags soon recognized the friend as Norma Pagano, wife of screenwriter Ernie Pagano. "She was an actress," says Walter, "and she put on one great act." Soon it was obvious that this was Grace's revenge for the phony raid on her wedding day, and the rudest possible way for two women to crash a stag party.

■ ■ ■

On top of the Oswalds, Walter was given extra assignments, like the prologue to Universal's first big musical feature, the Paul Whiteman extravaganza *King of Jazz*. Universal decided to sock audiences not just with sound, not just with the dance-band music of a prominent musician, not just with Technicolor in its rudimentary two-color process that was limited to red and green but still managed to dazzle the 1930 eye, but with two and a half hours of all this, as well as every special effect and optical illusion the studio could muster up. That included animation, and when Walter was asked if he could absorb a half-reel prologue to this magnum opus into his operation's work schedule, he readily agreed and on the spot became the first to make a Technicolor cartoon, beating Disney and his *Flowers and Trees* by two years. It was also the first piece of animation to be accompanied by a major musician, anticipating the Fleischers' use of Cab Calloway, Louis Armstrong, and Ethel Merman. When Lantz looked for a lead vocalist and recruited one of Whiteman's Rhythm Boys for the part, the scene became the cinematic debut of Bing Crosby's voice.

All these firsts posed serious problems when it came time to do the work. There were no color paints then designed to adhere to animation cels, and when the Grumbacher company's standard oil-based paints were applied, it was the old headache again—the color started chipping off before the cels could be photographed. Technicolor, which had then received only limited exposure, was a jealously guarded process, guarded so jealously, in fact, that the company's chief engineer brought the bulky Technicolor camera with him to the studio each morning and locked it in a vault at night.

Paul Whiteman was a gregarious, Falstaffian character, not without a touch of condescension when it came to the business he'd climbed to the top of. Since animation had become an art form set to a musical tempo, the prerecording of Whiteman's music required a precision beat. Following an industry-wide practice, Walter took a roll of blank film and had it punched every twelve frames, producing, when projected, a visual metronome in 2/12 time for Whiteman to follow. But Whiteman wasn't used to following anybody else's beat.

Carl Laemmle with Paul Whiteman.

"I'll go blind looking at that thing," he protested. "We won't finish this score for a week. I've got forty men here, and it's costing a lot of money."

"Well, how are we gonna get the beat?" Walter wondered aloud, fingering a tiny and not particularly conspicuous stopwatch.

"Oh, give it to me," said Whiteman, yanking the stopwatch out of Walter's hand. "I'll give you the rhythm you want."

Walter remembers the whole scene in its argumentative detail: "Darned if he didn't beat this thing out. It came to exactly four minutes at the 2/12 tempo."

The big-name music and the Technicolor added a new dimension to the animated sequence, which got the silly, rousing feature off to a suitably silly and rousing start. Lantz was interested in pursuing the Technicolor connection on a regular basis, but Laemmle felt that thirty-five cents a foot (or $31.50 a minute on release prints) was more than the novelty was worth. Walter did get one lasting resource out of the project, though—Whiteman's arranger, Jimmy Dietrich, who stayed on to score and orchestrate the Lantz cartoons for nearly the rest of the decade, ensuring that the Jazz Age sound was a hallmark of Oswald's adventures as long as he was on the screen.

Laemmle's reaction to Technicolor was characteristic of the front-office attitude toward Walter's work from the beginning. Happily, Universal made no attempt to examine scripts prior to production or to make judgments regarding character, content, or style. While movies were their business, the studio heads drew a blank where animated cartoons were concerned, and as long as the films were coming in okay, it was generally easiest to leave well enough alone. So his employers' ignorance, like most things in his life, worked to Walter Lantz's advantage. As long as Walter delivered a film every other week and kept up the yearly contributions to Laupheim, things went fine: "The studio didn't even know I was on the lot."

Then there was a year when word came through that contributions to Laupheim were being solicited only from Universal's Jewish employees. Walter considered that very nice and thought no more about it. Next thing he knew, he was summoned to Laemmle's office for a personal consultation.

Laemmle was wearing a very long face. "Every year you make the contribution to Laupheim," he intoned. "I was very sorry to see that you didn't contribute this year. I just wondered why it was."

Walter felt like a kid caught spitting on the Sabbath. "I'm sorry," he

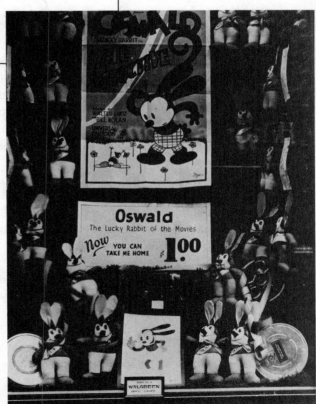

Early Oswald toys.

answered, with the proper show of contrition. "I'll make a contribution if you want, but, if you remember, you mentioned that you were only expecting your Jewish people to contribute."

Laemmle looked startled, as if by an apparent contradiction in terms. "Aren't you a Jew?" he asked.

"Well, no."

Carl Laemmle wasn't one to use profanity, so he said nothing. He just sat and stared. "Well, what *are* you?"

"I'm an Italian."

"You must be kidding."

"No, I'm really an Italian."

Laemmle stared some more. Then he posed the eternal question: "If you're an Italian, how'd you get the name Lantz?"

Walter told the old story, and as he told it he felt it getting older.

"I'll be darned," said Laemmle finally. "Here I pictured you a Jew all this time." He regarded Walter for a while longer. Walter felt the distance between them widen somewhat.

Then Uncle Carl smiled and extended his hand. "Anyway, Lantz, you're a good kid. So will you still make that contribution?"

It was the least he could do.

"We used to have a gag," comments Walter now. "Whoever happened to be passing Laemmle's door after a studio manager left, he'd pick him to be the next manager." After serving briefly under the tenure of Carl Laemmle, Jr., Lantz found himself answering to the next appointee, Henry Henigson. Henigson turned out to be the kind of person who enjoyed setting up meetings with people, then making them wait outside his office for several hours to guarantee they'd squirmed sufficiently before he actually admitted them. Sometimes he made it part of his daily ritual at the studio barber first thing in the morning, sitting in the chair reading *The Hollywood Reporter,* getting his trim, hot towels, shave, massage, manicure, and shampoo, the whole picture topped off by some unlucky subordinate waiting for a glimmer of attention from the potentate. This had the effect of breaking down the other person's morale, and—in case he'd been the one initiating the contact—making him forget what it was he'd wanted to talk about. Once the guy had sat out this trial by perspiration, Henigson let whim dictate whether or not he would go so far as to speak to him.

Walter was summoned to the Master's chambers for just such an experience one morning and told that it was indeed the barbershop that was to be the location for the ordeal. And indeed, it was an hour before

Henigson looked up from his briefing and his toilette to acknowledge the visit.

"Lantz!" he exploded, by way of acknowledgment, "you're using too darn many pencils in your cartoon department! Do you know what pencils *cost*? What do you have to use so many pencils for?"

Walter tried to explain, as if he were *not* speaking to a six-year-old child, that you can't make animated cartoons without drawing pictures, and you can't draw pictures without using pencils. He added that his staff created anywhere from seven thousand to eight thousand drawings to put Oswald through one of his seven-minute paces.

"Well, that's too darn many drawings!" Henigson fumed. "Why can't you make cartoons with two thousand drawings?"

Walter put it as simply as he could: "If we used two thousand drawings, we wouldn't have any action."

Henigson was frustrated by his lack of any real superiority in the situation. "Well, you've got to find a way to cut the cost. Why on earth can't you erase all your old drawings when you're through with them and use the paper over?" he sputtered.

That left Walter to figure out whether he should explain that the money you'd have to pay someone to do this would obliterate any savings you might make much sooner than it would wipe out any drawings, or whether such a suggestion perhaps wasn't worthy of a reply at all. He decided on the latter.

"If you want the type of cartoon we're making, we've got to use a lot of pencils and we've got to use a lot of paper," he announced, and he walked out of the barbershop and into the office of Laemmle, Jr., where he explained the whole thing.

The concluding argument took place between Laemmle, Jr., and Henigson, and the point was made that the cartoon department caused management fewer headaches than the other branches of production.

But the day of reckoning had to come. It was the Depression: Banks were closing, strikes and riots were daily occurrences, and the next revolution threatened to be a lot less peaceful than the one the talkies had ushered in. There was an industry-wide strike in 1931, and Universal's live-action production was closed down for months. Walter, who collected his $175 at the payroll window at the end of the week like everybody else, was summoned to the executive suite and told that he could continue working during the shutdown if he agreed to postpone receiving any salary for an indefinite period, which he did.

Later he returned to his department with his hat on his head and a

grim look on his face. He told his staff he had an important announcement to make and asked them to step out into the corridor. One hundred twenty animators, assistants, inkers, and painters matched his solemnity as they left their drawing boards and filed into the outer hall. Palpable was the tension and gallows was the humor.

Walter sat on the receptionist's desk and spoke: "Well, I was just over talking to Henry Henigson, and things are really bad. He told me that we just had to cut the budget. And I kept saying, 'I don't know where I can cut it any more.' He said, 'You're going to have to make the cuts.' So I just took a cut for everybody." And he took off his hat to reveal a Daddy Warbucks dome with a silly grin under it.

There was a moment's silence, broken by a howl of laughter that, in the words of one witness, went "way beyond how funny the joke was." It was mixed with relief. Everybody went back to work, and nobody took a cut but Walter's head. It seems he'd gone to a Hollywood hair specialist about his incipient baldness and been started on a treatment that involved shaving his scalp as a preliminary move. He had wanted to introduce the new look in the most dramatic way possible.

Walter Lantz as animator on an Oswald cartoon.

Inker traces cel from drawing.

FRANK B. KELLING—
FRED. W. JONES
EDMUND. SHULTZ.
GEO. NICHOLAS
DON DEXTER
LEO SALKIN
Jo D. fGALO.
LOWELL ELLIOTT
JACK DUNHAM
MARVIN W. CONNELL
JANET SCHULTHEIS
SID SUTHERLAND
Curt Abrams
TRAV ABRAMS
JACK CARR
STEVE BOSUSTOW
George MORENO

Karla Schmidt
GENE METELLI
BOB CONNELLY
TEX AVERY—
ESTHER RUTH
MARGE CARRUTH
(DORIS)
TED BENEDICT.
Virginia Walker
Bob Moore
Naomi Keith
LaVonne Harding
JIMMIE DIETRICH

VIRGIL ROSS...
FRED KOPETZ
Virginia Page
ERNEST SMYTHE
—CAL HOWARD—
X Walter Lantz
Victor McLeod
LEE KLINE
George Grandfire
Manuel M. Moreno

Lantz studio crew, circa 1933.

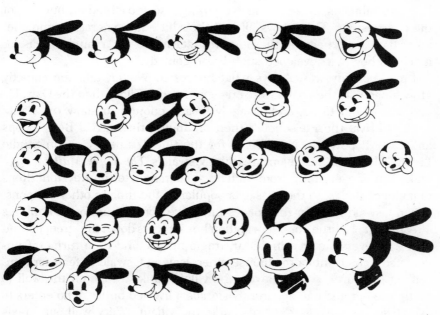

*The original Disney Oswald. Later, Lantz put clothes on him
and made him a white rabbit.*

Clyde Geronimi and Bill Nolan.

The move was really made in self-defense: If he hadn't made a joke about the scalping, everybody else would have, and with a vengeance. "Big, happy party," Walter remembers. "We used to clown, throw spitballs, thumbtacks, erasers, and everything else at each other, but we got the pictures out. These boys all had their little idiosyncrasies, and I let them have their head all the time. If it started to get a laugh, I was for it. That's how we developed such broad comedy."

Broad comedy was always what interested Walter, and the comedy grew broader as the 1930s wore on—crazier and wilder than the Oswalds had started out to be, and savagely insane enough to allow the Lantz studio to rival the Fleischers' (then producing the surreal Betty Boops and early Popeyes in New York) for the title "Zaniest Cartoon Studio Living." Lunatic misadventures like Oswald's *The Hare Mail* of 1931 make fun of everything from archaic melodramas to the Keystone Kops to polite comedies to the air sagas popular at the time to other cartoons. When Oswald runs for the police, a massive horde of uniformed officers streams out of a little one-room station house, tears down the street behind him with everyone wearing dour, tragic masks, and then turns off undetected to pour into a roadhouse diner, leaving Oswald to fend for himself. At his hovel of a hideaway, the villain yanks a rope off the wall to tie up the heroine and apparently signals a liveried butler, who enters to ask, "Did you ring, sir?" "No!" barks the villain. "Very well, sir," nods

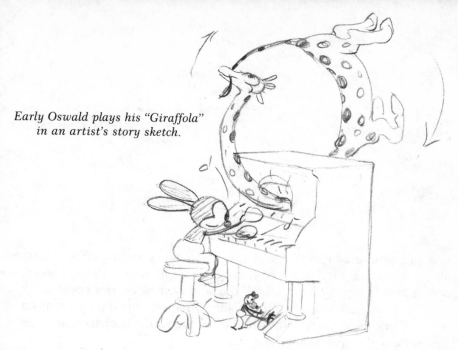

Early Oswald plays his "Giraffola" in an artist's story sketch.

the butler and exits, never to be seen again. In the finale, Oswald is plummeting many miles to the earth when he notices that his parachute happens to be labeled "Do Not Open Until Xmas," so of course he's powerless even to *try* pulling the cord. (The girl saves him by stretching her grandfather's beard into a safety net.)

This is clowning at its most intense, the kind of comic anarchy found in comedy features made at that time, like *Horse Feathers, Million Dollar Legs, International House,* and *Duck Soup*—humor used not just as escape from hard times but as therapy for them. It was cooked up in

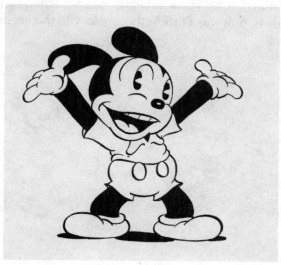

loose, unstructured gatherings of crazy cartoonists goofing off on Friday afternoon after a rough week of getting figures to move on a light-board, determined to top each other with the screwiest ideas they could think of. They found a realm of inspired comedy that combined the surrealism of the silent cartoon with the rhythm of the musical cartoon and the desperation of Depression-era comedy.

The openness of the working methods Walter used to create these effects dazzled the rookies just getting their start in the business. "I've never to this day encountered anything like that," animator Preston Blair says now. "It was a marvelous spirit where everybody participated. It didn't make any difference who you were; he was interested in everybody. As a rank in-betweener, I participated in suggesting gags with all the animators. There was a guy who used to come in there to shine shoes, they'd even ask him!"

La Verne Harding, who started at the Lantz studio at about the same time, had the distinction for years of being the only female animator in the cartoon business. She wasn't the only female with the talent, though.

Walter with Pinto Colvig (standing) and musical director Jimmy Dietrich.

"I knew there were others," she explains, "and if they were given the same chance, they'd be where I was."

"Most producers," Walter says, "didn't believe a woman could draw the exaggeration needed for action, that they could only handle birds and bees and flowers. They were wrong, of course."

According to another animator, Cal Howard, "In those days, it was 'The Rabbit Goes Hunting,' 'The Rabbit Goes Fishing,' 'The Rabbit Goes for a Sail on a Boat,' or he goes on a picnic. Then you do picnic jokes, you do boat jokes or climbing-the-mountain jokes or whatever you could think of. It was an incident, it wasn't a story." Sometimes it was just a locale: one run of consecutive Oswald titles reads like a list of travel posters: *Mexico, Africa, Alaska,* and *Mars,* followed by *China* and *College.*

Contributing to the pooled efforts of the staff for a while was Bill Webber, a Roach and Sennett gagman Lantz had met at Van Ronkel's.

Manuel Moreno, Cal Howard, Vic McLeod, and Lantz.

He would help Walter and Bill Nolan with drawing the storyboard, then the animation assignments would follow—but there was always time to squeeze in more laughs before the whole mélange got imbedded on film. When Texan Fred Avery (soon dubbed "Tex") was given a fairly simple scene to animate in *Chris Columbus, Jr.*, showing Oswald's peg-legged nemesis lighting a cannon and firing it, it had become a comedy routine by the time Tex was through dreaming up things to go wrong for a peg-legged man trying to jam a cannonball into a cannon. "It just went on and on," as Avery described it later. "The drawings kept stacking up! We had no footage limit, and Walter said, 'Heck, yeah, we'll leave it in.' "

Lantz and Nolan always enjoyed Avery's interpolations. It wasn't unusual for Nolan to hand Avery three or four minutes of a picture and say, "Look, Oswald's being chased by a swarm of bees—pick him up on the left and bring him out on the right," and just let him gag it up any way that occurred to him. Sometimes one or two of the other office gagsters would hang around Avery's desk and trade non sequiturs until he had enough ideas to fill the footage. In one of these instances Avery had decided to have a bear stripped naked by this renegade swarm of bees but was stuck for a good reaction. There were the old standbys: the doubletake and screaming exit or the coy blush. But Tex asked the group, "What do you think the audience would *least* expect this bear to do?" The possible answers to that seemed infinite, so nobody said much of anything. Then Tex answered his own question: "How would it be if they chew the fur off this bear, and then he looks right up at the audience and says, 'Well, whaddya know about that?' " It was unexpected enough

to shock the animators into laughter, and it went on to do the same to theater audiences.

Tex Avery's career opened up, growing out of Bill Nolan's increasing disenchantment with the business of animation. More and more, Nolan was passing on to Avery the responsibility for completing his half of the studio's output. Animator Leo Salkin remembers, "Where Lantz was desirous of doing a funny film, Bill just wanted to make it through these things. That was the value of that studio's structure, that a guy like Tex was able to feel his way along and test things and find out whether they worked."

Avery got his first chance at the helm when Nolan simply turned over two of his pictures to him and said, "Do them." *The Quail Hunt* and *The Towne Hall Follies* are the likely suspects in the case, both made just before Tex left for Warner Bros. and both flaunting the kind of dementia he pioneered over there, which was to shake up the entire cartoon industry.

"I remember Lantz calling us in to talk about a new idea for a cartoon," says Salkin, "and at one of those lulls in the conversation he said, 'I saw the dumbest movie the other night at the Chinese Theater, about this giant gorilla, and he's climbing the Empire State Building . . .' And he had everybody just roaring with laughter. But he made it sound so fascinating, we all went to see the movie that night! And then we were debating, Should we try to do a knockoff of it in a cartoon?"

The result was *King Klunk,* another Lantzian foray into bedlam, starting out with the sacrifice of food and one virgin, and a note, "To King Klunk with our compliments." Things are complicated by the discovery of an ancient relic, known to be genuine because it's authenticated by another note, reading "This egg laid 2000 B.C." and signed "Margie." When Klunk is captured and exhibited in New York as "The 6⅞ Wonder of the World," he escapes and beats his chest like a drum, until it up and becomes a drum, so he can use it to bounce back the cannonballs fired at him. As he carries the heroine to the top of a skyscraper, he doesn't seem to notice that he's squeezing the building so hard with his climbing hand that occupants are sailing wholesale out its windows like juice from an orange.

Another movie that intrigued Walter was Universal's *Magnificent Obsession,* and he developed his own obsession with the idea of building a house based on Danny Hall's art deco, post-Bauhaus sets for that picture. Walter asked Hall to design a scaled-down replica of the whole place to

Toluca Lake home built in 1933 by Walter Lantz
was the first art deco house in Los Angeles.

build in Toluca Lake. A contractor agreed to construct the seven thousand square feet for a set fee, and the materials, labor, and lots it would stand on came to $13,000 total.

There was $8000 in the bank, and Walter went to Joseph Rosenberg at the Bank of America, one of the biggest lenders to the motion picture industry, to finance the remaining $5000. Rosenberg studied the plans carefully and assured Walter that such a house could never be built. Walter responded by going back to Hall, asking him to build it, and dragging it into the bank—a scale model, thirty inches by twenty-four inches, with removable roof and partitioned rooms, proving Rosenberg wrong. He got the loan. On the happy day when construction and furnishing were completed, Walter invited a gang from the studio to take a look at its glossy, white and chrome-trimmed interior.

The gang included one Jack Carr, a New York animator who specialized in puns. Carr and the rest of the group spent the noon hour surveying

the elegant layout and, once outside, Walter asked them how they liked it. Carr replied, "Be it ever so humble, there's no plate like chrome."

■ ■ ■

There was a lot of talk at Universal about a controversial director who'd been engaged to do a feature on the lot with Carole Lombard and William Powell. He'd been a successful silent-film maker and was considered a washout with the coming of sound, but had bounced back recently with a succession of unlikely projects that had become solid hits. The director was Gregory La Cava, and his picture was *My Man Godfrey*.

Walter greeted his old boss with Italian fulsomeness and showed him around his new cartoon department, which had been expanded by now and had moved from the old glass-roofed stage to a larger building with real windows. La Cava surveyed it like a baron, watched with pride as one hundred twenty artists sweated diligently over Walter Lantz productions, and chatted with old cronies like Bill Nolan.

Then he turned to Walter and reminded him of an old debt. "I told you you'd make it," he declared. "How about that dinner?"

REEL 7

Confidence

There is nothing to it.
All you gotta do is do it.
—Song in Walter Lantz's
Two Little Lambs, 1935

GRACE STAFFORD'S CAREER was going great guns. Henry Duffy's chain of legit theaters stretching from Los Angeles to San Francisco gave her steady employment, in such distinguished company as Leo Carillo, Eugene O'Brien, and Charlotte Greenwood, for as long as live theater survived on the West Coast. Which wasn't long. But it was followed by radio engagements as the Maxwell House Coffee lady and in various starring roles on "Hollywood Playhouse."

Her flirtation with movie stardom was brief. She got a call from Samuel Goldwyn, who'd seen her in *So This Is London* at Los Angeles's El Capitan Theater and had come to the conclusion that it was time for her screen debut. Goldwyn interviewed Grace in his living room, was the soul of graciousness, and explained that the part he had in mind for her in *Bulldog Drummond* could just be her filmic breakthrough. She remained skeptical of success in the new medium, but Goldwyn assured her that everything would be fine and lined up a screen test for her the following week.

Grace enjoyed the interview, but failed to enjoy the following week. The thought of facing a phalanx of machinery and a crew of technicians instead of an audience filled her with dread that grew worse as the anointed day approached. By the time the fateful morning arrived, she was no more capable of taking the necessary steps to the studio than she was of using that machine called the telephone and telling them she wasn't coming. She figured she wouldn't be missed in the parade of girls being tested. When she was called at noon and told that they'd been sitting around since 10:00 with a soundstage, a set, a crew, and a leading man all reserved for her, she felt worse than before. She explained her

insecurities and bowed out.

Grace didn't feel so bad about the missed opportunity as she did about finking out on the test. "Fear did that," she remembers now. "That's why I preach against fear all the time." Her turnaround came when she met Dr. Ernest Holmes, founder of the Church of Religious Science and promulgator of an early variant of the power of positive thinking. Holmes, yet another of Vignola's friends, had distilled thousands of years of Oriental and Western religions and philosophies into a single system of thought. It seemed to make sense on first acquaintance, and it's been standing Grace in good stead ever since.

Thoughts are things, Holmes taught. Concepts create consequences. "Haven't you seen people who just love to be sick?" Grace remarks, by way of illustration. "They *wait* for something to hit them, and they enjoy it so much. You can think yourself into a terrible depression, and you can think yourself *out* of a terrible depression. That's why psychiatrists make so much money. People need help to get out of it. You can do it yourself, and it's much cheaper." Holmes's idea was to concentrate less on the negative effects of personal distress and more on the positive outcome of sunny attitudes and constructive activities: As he put it, "Bread cast on the waters comes back *toasted*."

For show-business people, Holmes was successful in building up confidence and tearing down conceit, and in making that important distinc-

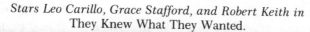

Stars Leo Carillo, Grace Stafford, and Robert Keith in
They Knew What They Wanted.

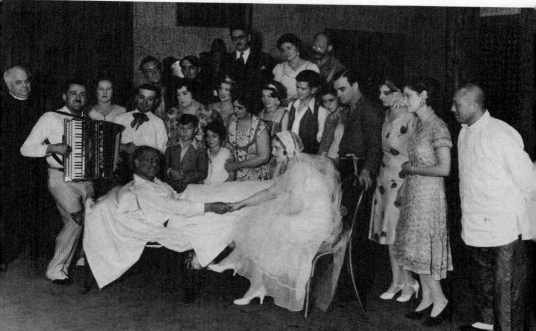

tion clear. Grace soon got Walter and Doris involved in the weekly lectures and periodic dinners. But Holmes's philosophy was not so far removed from the sunny attitude Walter had been using to get through life ever since the days of *Morto ogni notte*.

Confidence, in fact, was the name of one of Walter's Oswald cartoons, released in 1933, in the darkest days of the global Depression. It was the first year of Franklin D. Roosevelt's twelve-year administration, and Roosevelt is the hero of the piece, crooning to Oswald his one-word prescription for all the ills then plaguing the world. The message appealed to Walter long before 1933, and long after. "It was very timely then, and it still applies," he asserts—the words of a man who always knew that economics, like politics, religion, and show business, is basically a confidence game.

Walter has always had confidence, even when things looked worse than impossible, which probably accounts for what looks to everybody else like luck. Having thrown himself back into the cartoon business when it was the darkest and lamest horse in the race, he was gradually finding his confidence vindicated as Walt Disney, Mickey Mouse, sound, music, and Technicolor were joining forces to make the one-reel cartoon the favored son of the entire comedy business. Meanwhile, the two-reel comedy, to which he'd been so earnestly devoting his energies scant seasons ago, was falling on such hard times that it was in danger of dying out altogether. By the mid-thirties, Laurel and Hardy were the only major stars still working in the genre, and when declining revenues forced the concentration of their energy on feature films, there was no one of comparable stature to take their place. Walter asked his friend Frank Capra why this was and was surprised to be told it was *his* fault. "You're the ones who did it," Capra insisted. "All you cartoonists. Put the two-reel comedy right out of business."

Capra still insists: "Those two-reel comedies that I wrote cost more than the features I made at Columbia. They got more money from them at the theater than some of the features. So you know those comedies were important. When the animators came on, the pantomimers died. Who killed Cock Robin? Mickey Mouse." RKO's short-subject producer, Lou Brock, blamed the theaters in 1933: "In a measure," he said, "the exhibitors, by their refusal to pay more money for good two-reelers, have killed the goose that laid the golden egg."

In the wake of all this success, and all this confidence, and with J. R. Bray's words of wisdom still ringing in his ears, Walter decided to stop

Scenes from Night Life of the Bugs, *whose title spoofed
the Universal feature* Night Life of the Gods.

working as a wage slave for Universal and go into business for himself. On the surface, nothing changed. On Friday evening, November 15, 1935, the cartoonists left Universal's cartoon department and went home for the night. On Saturday morning, November 16, they came to work at the same building, sat down at the same light-boards, and resumed work on the same cartoons. But they were now employees of Walter Lantz Productions, a separately owned and operated enterprise with offices on the Universal lot and a contract to deliver pictures to the studio on a regular basis. After twenty years of working hard to help make other people rich, it was time for Walter to take the chance that would put him in business for himself.

But the changing tides that had made animation a successful business proposition had also gone to work to make it a more demanding art. Stories were more carefully structured, characters more fully fleshed out, and

the animation itself more thoughtfully executed than at any previous point in the history of the medium. Making cartoons was no longer a haphazard operation. Walter remained confident, but he began to see that extra time was going to have to be spent on each reel and viewed as a worthwhile investment.

He updated his characters and techniques every year and paid his artists more as he asked more from them. He added a full-time story man, Victor McLeod, to the staff. He changed Oswald from a blob of ink into an all-white rabbit. He added to his cast of characters Elmer the Great Dane and Doxie, a little dachshund whose chief function seems to have been to provide the animators with a good time at the light-board, as he stretched, twisted and glided his way around. A litter of white ducklings named Fee, Fi, Fo, Fum, and Fooey followed, along with their parents, a Mr. and Mrs. Canvas Back Duck. Walter named three monkeys Meany, Miny, and Mo, and they knocked each other around like the Three Stooges. Lantz had nothing less than a barnyard. But his main character was still Oswald the Lucky Rabbit.

The contract with Universal was renewed yearly, with Walter promising to deliver an agreed-upon number of cartoons per year (usually twenty-six) that Universal could distribute with its feature films, in return for which Universal advanced an agreed-upon amount of cash weekly to cover production costs. Once the cartoons recouped their cost, Universal and Lantz shared the profits in a 75/25 split, and Universal kept the rights to the cartoons. As the business grew more expensive and demanding, that weekly advance rose from $2583.33 to $3750. The cartoons steadily improved accordingly. But there was a catch. As the attitude toward animation had changed, so had the attitude toward cartoon characters.

When Meany, Miny, and Mo made their debut in *Monkey Wretches*, they were mischievous little devils who ran so amok in Oswald's pawnshop that, in order to get them off his hands, Oswald was forced to *pay* money to the organ-grinder who had left them in hock. But once the simians were given respectable clothes and their own series, they were forced to become sympathetic characters, and such mischief was beneath them.

The Meany, Miny, and Mo cartoons were budgeted at $8250 apiece, $250 more than the Oswalds, because of the added expense of animating three characters. Even at that, they rarely came in at that price, sometimes overshooting by nearly $1400, while some of the Oswald pictures were

coming in *under* budget. Clearly, these guys were not destined for a long tenure at the Walter Lantz studio.

The problem of delivering higher quality footage at the same breakneck pace was supposed to be alleviated somewhat by renegade Charles Bowers, who was hired, without Walter's knowledge, by Universal's short-subjects manager in New York because he claimed he could provide the story, layouts, and rough backgrounds for all the studio's cartoons for $1000 apiece at the rate of twenty-six a year. Lantz took him at his word, though he expressed doubts that any single person could turn out that much work in that amount of time and still improve the product. He was

MEANY **MINY** **MO**

right. Bowers's new character, The Dumb Cluck, was, like the rest of his creations, simply bizarre.

Walter had better luck with a talented New Yorker he'd recruited from Disney's to create storyboards. Walter describes his discovery, Alex Lovy, as "a very quiet sort of person. You'd never know that Alex could be so funny. He is not demonstrative, but a great draftsman. He's a natural! The guy can draw with both hands!"

"I liked the drawing I was doing, and Walt did too," Lovy remembers. "Then Walt one day asked me if I could direct. I said, 'I'll certainly try.' I did one, I did two, I did the third picture, and it was all right. And I was trying to get up enough nerve to ask Walt for a raise—figured, 'You let me direct, you gotta pay me.' It turned out I didn't have to, because he gave me a raise just before I was about to ask. And he raised me to a hundred dollars a week. Now at this time a hundred bucks a week was easily like a thousand today, and the taxes were nothing. I kept walking down the street saying, 'A hundred dollars a week. Wow!' I'd count, 'ninety-eight, ninety-nine, one hundred dollars, wow!' After I came out of my shock, I thought, What a wonderful gesture on Walt's part, to pay me what he thought I was worth to him. I didn't think I was worth that much to him, but he did."

It was worth almost that much just to watch Lovy draw with both hands at once. To hear him tell it, he can write with both hands at once,

too: "I write from left to right with my right hand, but when I pick up a pencil with my left hand, just as rapidly and without thinking, I can write page after page, but it's mirror writing. I don't have to think of what I'm doing, it just comes out. And then I found that I could do both simultaneously." Lovy was asked if that represented the right and left hemispheres of his brain struggling for dominance. "I don't know," he answered. "All I know is, it sure makes a big hit with girls."

Lovy's greatest facility was for moving cartoon characters around in a dynamic way comparable to the Disney style, evident in his handling of the next little guy Lantz came up with to challenge Oswald's monopoly: Babyface Mouse. Potentially just too goody two-shoes for words, the mouse becomes, in Lovy's hands, an engaging and comically charming creation who bounces all over the frame at the slightest provocation, disarming us with his coyness one minute and surprising us with his boldness the next. In *The Cat and the Bell,* one of his doubletakes so propels him ceilingward that his feet jam his legs clear into his body.

In September 1938, Walter acquired the services of Burt Gillett, another old-timer from the early days in New York, now prominent in the animation business for having directed two of Disney's most famous pictures: *The Three Little Pigs* (famous for being one of the most popular cartoons ever made) and *Lonesome Ghosts* (famous for being the most expensive). Gillett had a sensitivity for balance, beauty in movement, and the way visual grace could be used to enhance a laugh that enabled him to unite the complex aspects of a cartoon into a whole that functioned more organically than was common in the Lantz product. Unfortunately, there was a price to be paid for this kind of alchemy, and Lantz was always wary about paying prices.

As Dick Lundy explains, "Burt Gillett was expensive at Disney's, he was expensive at Lantz's, he was expensive at Pat Sullivan's. He was just expensive." Walter is more specific: "Burt had to do things over and over and over again. He was a trial-and-error person. With other directors, you know you're going to make a picture six hundred feet long, and it won't be six fifty or six twenty-five, because they lay it out on their sheet that way. But Gillett never knew where he was going; he'd wind up with a nine-hundred-foot picture. After he made a few of those, I said, 'Burt, you're going to put me out of business.' "

Lantz and Gillett parted company before they went out of business together, and Walter tried his luck with another major artist, an old veteran of the New York *American* and other aspects of the Hearst empire. "Willy Pogany was one of the great illustrators of our time," Walter de-

clares. "He used to do the beautiful girls on *The American Weekly* and get five thousand dollars a cover. He went through a stage when he was broke, and he worked for me doing backgrounds for three hundred dollars a week."

Broke or not, Pogany's interest in animation extended beyond the paycheck, but none of the studios had taken him seriously. He announced to the press in 1939, "I finally persuaded Walter Lantz that I meant it when I said I believed cartoons were an important segment of the artistic world and destined to become more important. Anyhow, he let me go to work on them."

Pogany's wife, Elaine, wrote a story called "Peterkin Pan," concerning the misadventures of a woodland sprite who mixes up the eggs of all the birds and watches the fun when they hatch to the wrong parents. Lantz produced it as *Scrambled Eggs*. Pogany wasn't used to the speed and efficiency that animation schedules demanded and worked over his backgrounds like they were going to be framed. The cartoon reeks of the kind of lush production value that Hollywood animation studios strived to achieve in the late thirties in the wake of the improvements Disney had been bringing to the art. None of this went unnoticed, as evidenced by

Model chart of Peterkin, by Alex Lovy from Willy Pogany's original.

Peterkin
in Scrambled Eggs.

Tom Thumb, Jr.—
from a Willy Pogany design.

reviews like the one Whitney Bolton wrote for his syndicated column "Hollywood" in October 1939, offering "one of Walter's creations as a threat to the Disney menagerie of charming animal fantasies. The new creature is Peterkin, a red-haired, shaggy-legged baby satyr with pointed ears, the cutest hooves you ever saw and a voice to match . . . If you see Peterkin billed at a theater, run, don't walk, to the nearest box office. If there is an annual prize for the most engaging invention in the art of animated cartoons it belongs, hands down, to Walter's elfin, charming and completely overwhelming Peterkin."

Well, there was no such prize, and there is no evidence that anybody ran to the box office. By 1939, Lantz had created a dozen new characters, experimented with alternatives to cel animation, dabbled in feature-film production, made commissioned films, and kept up his contractual obligation to Universal. And his main character was still Oswald the Lucky Rabbit.

And the brightest moments in his cartoons were still the surviving remnants of the slam-bang surrealism of the old Oswalds, before the Disney charm brought a certain semblance of reality to the proceedings. In *Turkey Dinner,* one of the three monkeys opens the icebox and gets a blizzard, followed by an Eskimo, who asks him, "Is it true what they say about Dixie?" and exits. When the Scotch terrier playing a bagpipe in *The Kiddie Revue* is doused with "Sneeze Powder," he naturally sneezes, but then the bagpipe sneezes, and Oswald has to shoot it like a lame horse. The cute poodle next door spurns the bone Doxie offers her in *Love Sick,* so Doxie keeps digging in the ground until he comes up with a complete dinosaur skeleton.

Walter's pictures were getting better and better, but he was still looking for the star character that would get his new little operation rolling. For publicity he promoted the value of timeliness in the animation field. "In cartoon work," he announced to the world at large, "we've all got to keep up with the new. Two-reel human comedies finished themselves by being constant rehashes of old-fashioned, tried-and-true situations. We lampoon the latest 'ism' in cartoons, or take the latest vogue for a ribbing."

In the middle and late thirties, one of the biggest vogues in the entire Western world was a roly-poly black-and-white bundle of fur called the panda. Pandas are not bears, even though people call them that. They're not raccoons, either, although they may be cousins. Turns out they're just pandas. Until Mrs. Ruth Harkness went into the heart of darkest China to complete the job her husband had died trying to perform and returned to New York City with one of the creatures in December 1936,

Oswald post 1935.

nobody this side of the international date line had even seen one. This first panda was given the Chinese name Su-Lin, which is said to translate as "a little bit of something very cute."

"Cute" is an adjective appropriate to the modesty so characteristic of pandas. Everybody on both sides of the Atlantic was in *love* with this precious creature. Su-Lin has been called the most famous animal of the twentieth century, and she started a panda fad that wasn't over until it included dolls, hats, puppets, postage stamps, wallpaper, tiepins, brooches, cigarette packets, nursery furniture, postcards, songs, poems, and even a cocktail (apple brandy, plum brandy, gin, and orange juice in equal proportions). A one-piece panda bathing suit was designed, with the two big black eyes appearing at strategic points on the female anatomy and the paws nestling down to converge on yet a third.

Biologists have attempted to analyze humans' fascination with pandas, and what they've come up with is that the critters seem larger eyed than they really are, sit up vertically just like we do, have little or no tail just like we do, can manipulate objects with what amounts to a "thumb" (actually a bony extension of the wrist), are round and soft, playful and clumsy, black and white, are found only in dim, dark, deep recesses of the mystic East, are worth large and well-publicized sums of cash, and are, at least to the naked eye, sexless. (Pandas are so shy about exhibiting their urges and their organs that getting them to mate or even reveal their gender is difficult even for experts to this day.) In other words, pandas are just so darn cute you can't stand it, and, cute being the coin of the cartoon realm in the late thirties, they were made to order for animation.

Walter hopped a plane to Chicago to visit Su-Lin and make sketches of him (or her—they never figured it out until after the animal's death).

Walter and Su-Lin at Chicago's Brookfield Zoo.

He timed his arrival to coincide with the Universal newsreel cameraman's so his meeting was recorded for posterity and he got some great footage for his animators to study. He made the mistake, however, of toying with the panda in a two-hundred-dollar cashmere coat. One playful swipe of Su-Lin's paw divested him of an investment. He lost a coat but gained a cartoon character.

Walter called his new creation Andy Panda. A hefty amount of publicity was given the new arrival, and his premiere appearance was named after one of Mickey Rooney's Andy Hardy films and dubbed *Life Begins for Andy Panda*. Alex Lovy, who directed the cartoon, did most of the work in drafting a workable character from photos and movie film.

First chart of Andy Panda, 1938.

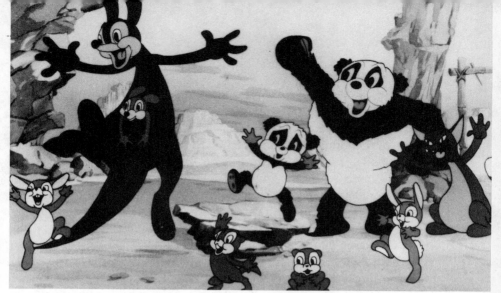

Life Begins for Andy Panda, *1939.*

Andy and his old man trade banter in Boston accents that sound like variations on baby talk in a manner derived from Fanny Brice's radio character Baby Snooks. When Papa Panda warns Andy that if he doesn't stay close to home, he'll be captured and put in a newsreel, the notion prompts Andy to wobble enthusiastically away from home in a rapid-fire, babylike shuffle (with his father tearing after him in a grown-panda version).

Walter hadn't yet grabbed the brass ring, but every year he was getting agonizingly closer. He still needed his star character: The star system prevailed in cartoons just as it did in live action. Andy was an infant with a lifetime of possibilities ahead of him. Perhaps, in time, he could be developed into the blockbuster the studio needed. But suddenly there was grave doubt as to how much time he would actually have.

■ ■ ■

"Walter, we're pulling the plug."

The year was 1940. Those are probably not the exact words, but Walter Lantz doesn't remember the exact words; he just remembers that he didn't like the tone of the conversation then and he doesn't like thinking about it now. The speakers were Nate Blumberg, Matty Fox, and Cliff Work, the men who ran Universal Pictures—or, rather, the men who chaired the committees that ran Universal Pictures—and words like those conjured up visions in Lantz's cartoonist brain of empires crumbling, bags of money winging it out the window, and pandas drying like prunes in the California sun.

Without its founder, Universal was a foundering ship without even a captain to go down with it, being bailed out daily by ex-barbers, ex-aircraft company executives, and ex-exhibitors, everybody but ex-filmmaking pioneers. Carl Laemmle had been ushered out in 1936. Others had been found to take his job, nobody to take his place. The giant hulk of a studio was at the present resting on the slim shoulders of Deanna Durbin, whose profitable pubescence was turning into unprofitable adulthood. J. Cheever Cowdin, chairman of the board (who had the dubious distinction of having a Groucho Marx character named after him in *At the Circus*), had left strict instructions to economize wherever possible, and it was generally agreed by all the real-life decision makers that it would be nice if the

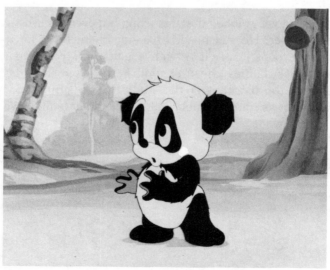

Andy Panda.

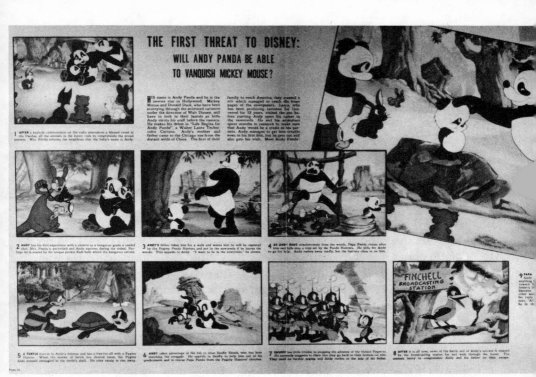

first rats to desert this sinking vessel were creatures of pen and ink.

In point of fact, Universal had no real plug to pull as long as Walter Lantz Productions was an independent entity. But in the working relationship that existed between the parent company and its offspring, there was a sort of umbilical cord that Universal was free to sort of cut: Walter's company still survived on Universal's weekly advance. When Messrs. Cowdin, Blumberg, Fox, and Work saw $3750 a week in expenditures that they could eliminate in a single thrust, they jumped at the opportunity and looked forward to the way it would sound at the next board meeting. What they were telling Lantz in effect was that he was free to make cartoons any way he saw fit, that Universal would be happy to distribute them for him and happier still to split the profits with him, but they didn't really care *where* he got the $3750 every week to pay for it. Talk about cute!

Cutting umbilical cords is a painful experience, but if new life-support systems can be found, it can turn out to be one of life's major moments. Walter went home and calculated that, at $9000 per cartoon, he would need to make three cartoons before the incoming revenue would be sufficient to support the production of more, with an extra $1000 to cover

overhead and taxes, coming to a total of $28,000. From loans on personal life-insurance policies, he secured $6750. He mortgaged his house, now almost a city landmark. He borrowed on his furniture. He even put his car into hock.

Eventually, he put together $14,000. Halfway there. "I went to all my friends in Hollywood," he remembers. Bob Vignola, Ben Piazza, Harold Lloyd . . . Nobody saw the merit in Walter's plan. Lloyd even doubted that cartoons would take the place of two-reel comedies, a terribly shortsighted remark coming from one of the financially shrewdest men in Hollywood, when you consider that the replacement had already occurred.

No matter where Walter went or what he did, he didn't seem to be able to come up with another penny above the $14,000 plateau. He was able to wrangle one major concession from Universal: On January 31, 1940, they surrendered all film and merchandising rights to the characters in his cartoons of the previous four years. Now Walter owned Andy Panda and Oswald Rabbit free and clear. But where was that going to get him if he wasn't making any cartoons?

The last weekly check from the studio had arrived on January 23, 1940. On February 24, the last payroll charge was made to *The Adventures of Tom Thumb, Jr.* The studio was closed. In the face of no encouraging evidence whatever, Walter remained confident. "For a while, there was only one person on the payroll," recalls Bob Miller, the studio's accountant. "That was me. I thought it was pretty nice of them to pay me my twenty-five dollars a week."

Walter's niceness is still his artists' fondest memory when they look back on their years with him. "Lantz is one of the nicest guys you'd want to meet, anywhere, anytime, and my favorite producer," declares La Verne Harding. Airbrush artist Mabel Sjögren points out that "Lantz put up with an awful lot. We took any excuse for a party." Assistant animator Lowell Elliott, who had just been promoted to the story department, is in agreement with many other witnesses when he claims that he never saw Walter even get angry. "He may have *felt* like getting mad," he adds, "but he was always pleasant."

Alex Lovy explains the devotion of the Lantz crew this way: "He's always been interested in the welfare of his employees, not only in their work, but even in their private lives. If they had problems, he'd listen to them, do what he could, quite often financially helping them. One thing I always liked about working for Walter: He would let us do *our* thing. Then he would make his suggestions—which usually were very, very

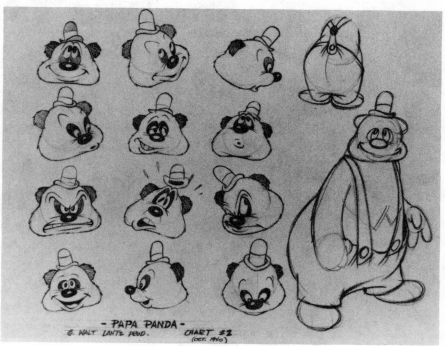

- PAPA PANDA -
© WALT LANTZ PROD. CHART #2
 (OCT. 1940)

Model chart of Papa Panda.

good. And, even if they weren't, we used them anyway; he was the boss. See, Walter was a cartoonist. He understood our problems, and he understood what we were doing. Fred Quimby [MGM], Ed Selzer [Warner Bros.], I can name several others, they didn't understand the artists they employed. It was like piecework: You sold seven dresses a week, or you moved fourteen boxes an hour, and you drew eighty-two drawings an hour. They didn't understand that sometimes you just *can't* draw, you stare into space and think, and you make it up later."

The personal feelings most of the staff had for Walter were responsible for getting the wheels rolling again. As La Verne Harding tells it, "Half a dozen of us would just meet out there and have lunch. Nothing else to do. No jobs anywhere. One time we were talking in the office, and I said, 'Since we all come out here anyway, why don't we just up and make a picture, for fun?' Me, I don't ever think about the dollar part. Walter picked it up right then. He said, 'Well, if you do that, then I could use that as collateral on the next picture, and it would go on and on and on till we're on our feet.' It didn't bother me. 'Sure, fine. What do I know about collateral? But if we get to work, well, great.' So that's what hap-

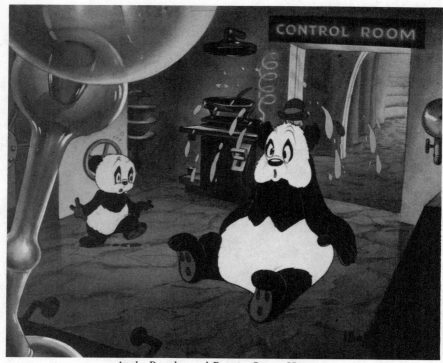

Andy Panda and Pop in Crazy House.

pened. We made the picture, he took it to the bank, got enough money to make another picture, and then we were on salary from then on."

The cartoon they made was an Andy Panda about scrambling for shelter in a storm and taking refuge in an amusement park, and they called it *Crazy House.* All concern for $14,000 went by the boards when Walter took the film to Universal and appealed to their sense of showmanship. They sent him to Irving Trust in New York and agreed to co-sign for a $100,000 loan. He gratefully paid back all those dedicated artists who had put their talents on the line. ("He paid us back over and over again," according to Alex Lovy.) Not only was Walter running his own operation, but he had managed to avoid selling away half of its ownership. Once the profits from the cartoons were sufficient to repay the loan, he would have free and clear title to the films he made and the characters he created.

There was only one problem with *Crazy House:* It wasn't as crazy as the old Oswalds had been. But, with the studio doors open and the wheels of production turning again, there would be world enough and time to redress that imbalance.

PART TWO

WALTER
AND
WOODY

REEL 8

Knock Knock

WALTER LANTZ: I guess you can take the woodpecker out of the woods, but you can't take the woods out of the woodpecker.

WOODY WOODPECKER: What do you mean, Boss?

WALTER: Only that sometimes we forget you really belong back in the trees instead of Hollywood.

WOODY: Oh, I wouldn't say that.

WALTER: No. You're too much of a ham. But I was just thinking how Woody's life has changed since we first got together. He was just a simple backwoods character in those days, and the only time he used his head was when he was drilling holes.

WOODY: Yep, I shore was a real hick.

—From *The Woody Woodpecker Show,* 1957

THE DIVORCE WAS RELATIVELY PAINLESS. Walter and Doris realized they were growing further apart, and they tore asunder their ties. In an unrelated move, Grace and George Duryea did the same thing. It doesn't take much stretch of the imagination to figure out what happened next.

The wedding was painless, too. Walter and Grace took a little trip to Reno, Nevada, and got married in a Methodist church, with two witnesses who happened to be scrubbing the floor at the time, one named Smith and the other named Jones.

On the way back home, Walter suggested they stop and do a little fishing at June Lake in the High Sierra. Grace protested that she'd never fished and she hadn't brought any suitable clothes. Walter pulled up to the lake and opened the trunk to reveal not only fishing rods and boots, but an outboard motor and fishing clothes just her size. Grace was going to start learning what being Mrs. Lantz was like without wasting any time. When she hooked a healthy trout in her first half hour on the water, she shed all reservations about this new life.

From there, the Lantzes went on to Sherwood Lake, a small resort community about thirty miles outside Los Angeles, where Walter owned a cabin just three hundred yards from the water and where they pro-

ceeded to enjoy an idyllic two weeks of rest, recreation, and further fishing.

But the honeymoon trip had a fly in its ointment. Or, more specifically, a woodpecker. Walter remembers it this way: "There were quite a few in the area, but this one particular woodpecker kept pecking on our roof. I thought maybe he was just pecking for enjoyment. He would come about four in the morning, and Gracie would lean over in the bed and knock on the wall, just as a gag, and he'd knock back. We thought it was quite funny, until we had a rainstorm and the roof started to leak. I couldn't figure out why, because it was a new roof—this was practically a new house. So I went up on the ladder and looked, and here these heavy, fireproof asbestos shingles of the roof were full of holes. The roof was wood underneath, but I couldn't figure out why he was pecking holes in the asbestos. And then I noticed the edges of the shingles were tipped up. I put my hand under them, and here were a lot of acorns.

"I asked a warden how come there were holes in the roof, and he said, 'What the woodpeckers do is pick an acorn, shove it under the shingle, and leave it there for about two weeks. And the acorn ferments in the sun and worms start to develop. Then they come back, drill a hole in the roof, lift the acorn out of the hole, and fly away with it.'

"And he'd give this little raucous scream when he'd fly away."

After several days of this pecking and screaming, Grace thought about Ernest Holmes's ideas on turning negative forces into positive ones. "Why don't you make him into a character?" she asked. It had the desired effect. Walter turned his energies from running around the house and cursing the offending bird to making funny drawings of ungainly, cross-eyed woodpeckers. "I decided to take him into partnership," he explains. "If you can't fight 'em, join 'em."

And he went on making drawings, until he was back in the studio again, comparing notes with the regular gang. Alex Lovy, one of the members of that gang, says this was not unusual: "He would come in, 'What do you think of this character? What do you think of that character?' He told us the story of this woodpecker making all this noise, and he thought it would make a good character—a raucous little bird. We went along with it. I made sketches, and he liked them, and that's where we started. The writers, the different directors, and myself, we all contributed something to his personality. What we do, we sort of put in a little reflection of ourselves. I think, 'Well, what would I do?' I liked the Woody Woodpecker nonsense and nuttiness. That reflected me in a way, rather than the cute little pandas."

It also reflected the nuttiness of the new story man the studio had acquired, a veteran of the Warner Bros. cartoon crew and the infamous "Battery D" of World War I—Harry Truman's outfit, the rowdy, reckless bunch of tough Missourians who had a reputation for getting their commanders dishonorably discharged and committed to the psychiatric ward. His name was Joseph Benson Hardaway, but he went by the name of Bugs, and Walter calls his sense of humor "the broadest of any story man I ever had." From the evidence of the films Hardaway wrote for Lantz, he was a man obsessed with hotfoots, Rube Goldberg contraptions of questionable effectiveness, and characters who swallow mustard, assume a beet-red color that rises visibly from toe to head, and rocket to the stratosphere.

In *Recruiting Daze*, the first Lantz cartoon for which Hardaway received story credit, a "dog fight" features two planes doing dog imitations, there are "shock troops" whose job is to blush when they encounter an ad for the Follies, and when an Ed Wynn character lights the fuse of a cannon, the cannon melts. Trade reviews were good, some even enthusiastic.

Heck Allen, who later worked side by side with Hardaway at Lantz's studio, agrees with Walter's description of him: "His humor was very elemental, I'd say almost rustic. He would have made the perfect casting for either Popeye or a World War I combat sergeant."

"What he looked like, more than anything else in the world," says Chuck Jones, another veteran of Warners's, "was one of the characters from *The Front Page*. It was the Hecht and MacArthur syndrome: All the newspapermen wanted to *look* like newspapermen. He always wore a hat, even indoors, usually tilted over his nose. He'd usually have a cigarette dangling out of the corner of his mouth, and when he was thinking, he'd lean back in his swivel chair and put his feet up."

When Hardaway got hold of the idea of a raucous woodpecker causing trouble to Andy Panda and his pop, he saw the chance to do one of those stops-out wacko cartoons, like the early Daffy Ducks and Bugs Bunnys that he and Tex Avery and the rest of the boys had been doing at Warner Bros. (Hardaway was the man who gave Bugs Bunny his name.)

Milt Schaffer, who was soon to join Hardaway in the Lantz story department, remembers those original ground-breaking cartoons. "If you weren't Disney, then wacky would be the way to go," he relates. "I don't think that Bugs Hardaway would make any character that wasn't crazy. That was his shtick."

And Donald and Daffy, the star birds that preceded Woody, were both

somewhat feather-brained. Any character based on any bird would have to emerge from the inkwell visibly hyper or it would have nothing to do with its real-life model. Birds go through life in a constant state of frenzy: With respiration and pulse rates surpassing our ability to count them and temperatures in what we would call the high fever range, they *sleep* in a greater state of agitation than most of us reach at our waking peaks.

And the woodpecker is a particularly odd species of bird in and of itself. It seems to gallop instead of fly, clapping its wings against its sides with a whooshing whistle and bobbing up and down in the air in a peculiar wobbling flight like an ornithological Clem Kadiddlehopper, earning itself the nickname "wooden wings." Woodpeckers have to protect themselves from being screwier than they really are, as one scientist found out when one of the noisy birds interrupted his reveries much as it had disturbed the Lantzes' sleep: It immediately occurred to him that without some form of protection from this constant pneumatic hammering of the head against hard wood, the woodpecker would slam itself senseless at an early age and we'd be up to our armpits in dead woodpeckers. His research into the birds' anatomical structure revealed a flotation of the brain achieved by a spongy bone inside the skull, knowledge that will now be used in the design of future safety helmets for humans.

But there's one aspect of woodpeckers no research has ever been able to decipher. It seems that woodpeckers peck for three reasons: to find food, to build nests, and to call mates. When drumming for the mating call, the woodpecker exerts far less force with the bill than when hammering for any other reason. Yet the sound can be heard for twenty times the distance. There is no scientific explanation for this. But woodpeckers know.

In other words, there is nothing about woodpeckers, or any bird in existence, to suggest a cuddly, lovable, pandalike creation of the kind that abounded in thirties cartoons, and there is no advance publicity or photographic material in the studio files to indicate that anything more was expected of this zany bird than a few laughs in a single picture.

It's often been said of any given star that he or she "burst upon the screen" in his first appearance, when in fact this person strolled, wandered, slouched, or otherwise muddled his way into his debut on the silver screen. Well, let there be no mincing of words when it comes to Woody Woodpecker. He *burst* upon the screen in the opening of *Knock Knock*, popping straight through the roof of Papa Panda's house to confront him head-on with a cheery "Guess who?!" Right from the beginning, Woody is openly hostile, aggressively frenzied, self-consciously, almost

First Woody Woodpecker, 1940.

insistently crazy. This first incarnation of the woodpecker has been called raucous, annoying, obnoxious, overdramatic, repellent. He is nothing short of appalling. He spends the entire picture frustrating the attempts of both Andy and his father to remove him from their roof—not from any visible sense of territorial desire, just out of a crying need to act demented for its own sake.

But the outrageous spark that seems to possess him is nothing less than the comic spirit. One of Woody's first actions is to pluck two shingles from the roof and clatter them in one hand like castanets, dancing to their rhythmic sound. This nonsense is held on the screen just long enough to be perceptible, then is cut away from. (The adaptability of the shingles is the only motivation given for his furious battle in defense of a single unexceptional roof.) Clearly, nuttiness is reigning triumphant in a way that previous Lantz cartoons only hinted at in freak, uncertain whispers. Before the picture is over, Woody will have tipped his scalp to an attractive female, sailed off into the wild blue yonder with Andy's enormous pop clinging desperately to his legs (running the lawnmower with his feet), and twice foiled Andy's attempts to put salt on his tail—once by whipping a stein of beer out of nowhere and blowing the foam

Woody's "Guess who?" in Knock Knock.

into the kid's face, and once more by expanding to twice his usual volume, full of nothing more than outraged dignity, then exhaling it all while playing his beak like a bagpipe. There seems to be a breath of life moving him, but in fact it's a daft sound and fury and a skilled animator's caprice.

"I think color's done a lot to make Woody," Walter has pointed out. "They hit a red that I've never seen anywhere else." No one whose viewing of *Knock Knock* has been limited to the television screen and present-day Eastman color prints can ever experience the full force with which Woody must have hit moviegoers in 1940. Technicolor was *de rigueur* in the animated field by that time, but the woodpecker is a cartoon rainbow. With a blue body, red crest and vest, green tail feathers and eyeballs, and yellow-orange beak and feet, he is a cacophony of colors as well as sounds, and in those carefully imbibed three-strip 35mm prints that Technicolor has since stopped making, the tones throb at you from that possessed screen. Lantz's florid Italian background seems to have come to the fore and endowed Woody with a quality none of his contemporaries could claim. Since animation allows the imagination free reign presumably unfettered by reality, one begins to wonder why other animators had come up with nothing more flamboyant than Donald Duck's blue jacket, Mickey Mouse's red pants, Daffy Duck's black coat, Bugs Bunny's suave gray, and Tom and Jerry's incompatible anise and brown. Compared to the subdued shades of the competition, Woody was a crimson peacock in full strut, a bird of several different colors at once.

With all this hurled at the audience in a heartless avalanche, there wouldn't seem to be much a viewer could hold on to long enough to make

the character memorable. That's where the laugh comes in. When Hardaway and the gang were getting the various embryonic stages of Bugs Bunny into action, they had wanted a goofy laugh to erupt from his larynx, and they turned to Mel Blanc, who was an expert at that sort of thing and had one left over from adolescence. "When I was at Lincoln High School," he explains, "they used to have a tremendous long hallway that had a terrific echo to it. I would say, 'Hello!' and the answer would come back, 'Hellohellohellohello!' One day I wanted to hear the echo, so I tried a crazy laugh, adding a little hacking sound at the end. I ran down the hall to hear the echo—right into the principal! He said, 'What are you laughing and running around like crazy for?' I told him I just wanted to hear the echo. He darn near threw me out of school!"

For the rabbit, the laugh had proved only a distraction, but for Woody it served as a graspable handle in a whirlwind of fuss and feathers (it laughs!) and imbued some character to a nameless embodied force. That laugh stuck to the woodpecker like it never did to the bunny, helping insanity reign supreme in his initial outing and making Disney's wide-eyed coyness take a back seat to pure cross-eyed comic energy.

Woody wasn't the only one who laughed. Test audiences on the West Coast were convulsed, but when Walter shipped the film to New York, he received a letter from Bernie Kreisler, head salesman of the shorts department, that went something like this: "Are you out of your cotton-pickin' mind, Lantz?! Who'd ever go for a woodpecker? We won't be able to *give* him away. He's terrible. He's rambunctious. He's got a crazy laugh.

Knock Knock.

He'll drive 'em right out of the theater before the feature begins! He's boisterous, he's loud, he's ugly."

"Anything you can say about a character, he said it," Walter remembers.

Grace wasn't surprised. "I was on Universal's side when I saw that film," she claims. "Isn't it wild and isn't he ugly? I think Walter drew him that way because that's the way he thought of him up there in the mountains."

But this bird wasn't a pesky outsider anymore; he was one of Walter's children, and Walter fought back protectively. "He's all right with me," he declared to Kreisler. "*You're* not paying for these cartoons. All you're doing is distributing them. It's my nickel, so release him, because I'm taking the chance."

A few preview screenings, and a star was hatched. Exhibitors responded enthusiastically, and Kreisler called Walter a few days later as if nothing had happened and asked for a series of comebacks.

"We didn't start out to make a famous character," Lantz insists. "He just caught on." But when he tries to explain why he caught on, he compares him to every spiteful sprite, from Pan to Harlequin to Charlie Chaplin, that has delighted us since antiquity: "He does things you would like to do, but just don't have the nerve."

The year of Woody's debut, 1940, was the same year that Bugs Bunny's character was cinched in *The Wild Hare* and Tom and Jerry first saw the light of the screen in *Puss Gets the Boot*. And when Rudolf Ising won the Academy Award for Animated Short Subject that year with *The Milky Way*, it was the first time the prize had been wrested from Disney's hands since the inception of the category in 1931. It was a year that Disney never recovered from. Having thrown the weight of his genius into features and having instituted new procedures that benefited the entire industry, he had given his competition just one advantage too many. The new wave of cartoon characters became icons of the forties just as Mickey Mouse, Donald Duck, and Goofy had been icons of the thirties, with a startling aggressive quality the Mouse and the Duck and the Goof never pretended to have: Cocky, wisecracking, and brash to a sometimes frightening degree, these characters were *comedians*, who could initiate wildcat slapstick on the purest whim, who weren't afraid to stoop to the vulgar, but who could just as easily rise to the lyrical on even less notice. Disney had abdicated an important throne.

As Walter reminds us, "These characters had distinctive personalities,

Woody and Pop Panda, 1940.

the same as Charlie Chaplin, Harry Langdon, Harold Lloyd, and Laurel and Hardy, who will be remembered a hundred years from now." While these stars were fading from the screen in the early forties, bright new ones of glittering color and impeccable timing were rising to take their place.

"It was the dying out of one phase and the start of another," Alex Lovy agrees. "We were at the brink of war, and there was a lot of aggression in the world. Maybe that had something to do with it. Simultaneously, all the writers and producers and directors at the various studios felt that we ran out of cute ideas and we ought to try turning the page and coming up with something new."

Woody went on from *Knock Knock* to take his place as one of the stars of the brassy, gaudy, noisy forties, alongside such company as Daffy Duck, Yosemite Sam, Sylvester the Cat, Foghorn Leghorn, Heckle and Jeckle, the Andrews Sisters, Danny Kaye, Martha Raye, Betty Grable, Red Skelton, Abbott and Costello, Olsen and Johnson, the Ritz Brothers, and Jane Russell. Anybody who thought Woody Woodpecker was too raucous for a crowd like that wasn't paying attention.

Ace in the Hole

Woody Woodpecker started out as a supporting player, but he became a star in his second picture, and he's been a nest egg to me ever since.

—Walter Lantz

UNIVERSAL HAD Abbott and Costello and embarked on what some critics have referred to as its "Golden Age" (if such a thing is possible). Now that Walter Lantz had Woody Woodpecker, there is no doubt that he entered his. Not only were the doors open now, the studio had a major star on their hands, a new direction to go in, and an audience hungry for the kind of zaniness it was prepared to turn out. With no shortage of characters, capital, talent, or inspiration, the Lantz operation moved ahead in the early forties with confidence that showed in its cartoons.

"Woody gave us all a shot in the arm," Walter explains. "The first Woody pictures produced didn't have much of a story line, just one basic idea and we gagged the heck out of that. I went for broad comedy and slapstick. I thought that we just had to make broader cartoons to get the laughs that Disney was getting with his Donald Duck. So we exaggerated more. All the takes were exaggerated. In the old days, if a character was going to make a take, he'd just open his eyes wide. Now, we'd take the two eyes out on springs and back in again. Not every character lends himself to that. A guy would get hit in the mouth, and all the teeth would fall out (but in the next scene he had teeth). I never dreamed up those types of ideas. The story men I had at the time thought these were very funny, so I went along with them. That wasn't my *nature*, these kinds of gags."

Lantz's was an "anything goes" studio, and with Hardaway heading up the story department, anything was always going. The cartoons got dizzier and dizzier as they made more and more use of animation's potential for giving life to the senseless. In *Hams That Couldn't Be Cured,* a wolf is seen crocheting a bathtub. In *Cow Cow Boogie,* a cowboy sits

Story sketch for The Screwdriver.

down at a piano that has apparently been allowed to gather some dust since its last use, as well as several chickens, roosters, cows, and a horse complete with rider, all of whom stream out of the insides at the sound of the first note. And when Homer Pigeon parks his horse and buggy in *Swing Your Partner,* he drops anchor—into a mud puddle, where it promptly sinks, followed by the buggy and the horse.

And Andy? As La Verne Harding puts it, "With Woody coming along and making such a hit, who's thinking about Andy Panda?" Andy stayed on, but first he had to show a capability for handling slapstick and wild action. This he did by sprouting to adulthood right in between *Goodbye Mr. Moth* and *Nutty Pine Cabin,* proving himself a sympathetic and believable straight man for a supporting cast of moths, beavers, goats, gophers, and anti-aircraft guns that could provoke the genial guy past his boiling point to a degree worthy of wartime humor.

When Walter made *Goodbye Mr. Moth,* he saw a chance to get even with the head of Universal's short-subjects sales department, and when he needed a signature at the bottom of a letter to Andy's tailor shop, he scribbled in "Bernie Kreisler." He heard about it as soon as the picture was shipped to New York. It had been an innocuous enough letter, asking for a dye job on a pair of pants, but Kreisler was afflicted with a certain measure of vanity and found the item insulting.

"Walter, you take that name off!" he protested. "I'm the head of the shorts department! I have a very important job!"

Walter replied, "Well, Bernie, I'm sorry, I can't take it off. Universal made three hundred fifty prints of it, and we can't just make all new prints."

"That unsold it," he remembers now. "It was going to cost Universal another nickel to make prints. So it's still on there, but, boy, Kreisler didn't like it."

By now, all the Walter Lantz cartoons had reached a level of production value equal to the best of his late thirties output and a level of zaniness rivaling the best and the craziest of the Oswalds, making for an unbeatable combination. But Walter had another invaluable resource in his corner: music.

His taste in musicians was unfailing. Even more than the charming scores provided by Frank Marsales and Jimmy Dietrich in the thirties, Darrell Calker's powerhouse music for the Lantz cartoons of the forties does everything but steal the show from the drawings. With a musical palette ranging from the most violent purple to the purest gold, Calker was never at a loss for the tone that was going to most perfectly complement, bolster, or offset the range of colors on the screen. He could emphasize a gag without undercutting it with overkill, he could highlight the action without racing ahead of it or dragging it down, and he could catch the swing beat of the forties without destroying the timelessness of the visuals.

Calker added another fillip to the sound of the Lantz cartoons by doing a little recruiting on the side. His evenings were spent frequenting the piano bars and jazz clubs all over town. He knew who was in Hollywood and for how long at any given second, and what's more, he knew when they were down on their luck and could be coaxed into a recording studio for spare change. Jazz greats like Jack Teagarden and Meade Lux Lewis provided freestyle scores for entries in a series called Swing Symphonies—often without composing a note. With Lewis, "We sat him at the piano, gave him a tumbler of gin, and said, 'Give us eight minutes of music,' " according to Walter. The last known recording session of renowned pianist Bob Zurke was done for Lantz's *Jungle Jive*. Zurke died a few days later.

"I think I made some of the most interesting musical cartoons ever made," says Walter, who can substantiate the claim with choice pictures like *Cow Cow Boogie*, *The Sliphorn King of Polaroo*, and *Boogie Woogie*

Cow Cow Boogie *sheet music.*

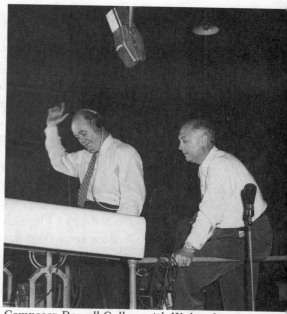

Composer Darrell Calker with Walter Lantz.

Bugle Boy of Company B. "I loved to make musicals, but you can't cheat on musicals. You've got to animate to the beat."

In his first year of totally independent operation, Lantz was able to make thirteen cartoons for an average of less than $9000 apiece (*Knock Knock* was turned in for $8500), but easily the most expensive was the musical *Scrub Me Mama with a Boogie Beat,* with production costs over $10,000. Walter has always had a knack for producing the best work possible for bargain rates (he's even been called a "ledger cartoonist"), and in his second year he was able to bring costs down to an average of $8500 per picture with no depreciation in quality (although the next year his thirteen cartoons cost him $12,000 apiece, with no appreciable improvement). But the wartime response was enthusiastic, especially for his tempestuous red-headed star, and reviews were encouraging, ranging from lukewarm to rave (hitting the highest peaks on Hardaway's loonier exercises, like *Hams That Couldn't Be Cured, Mother Goose on the Loose,* and *Recruiting Daze*). For 1942 the trade periodical *Boxoffice* placed the Lantz cartoons fourth in their annual rating of theatrical short subjects, just behind the Disney and Warner animated shorts and ahead of MGM.

Working capital had ceased to be a problem. Even the originally generous $100,000 seemed to cramp Walter's now expansive style: In 1942, Lantz left Irving Trust and went again to Joseph Rosenberg at the Bank of America, receiving a standing loan with a ceiling of $250,000 and putting up his steadily increasing stockpile of cartoons as collateral. Also in 1942, he was able to move his studio from the crusty old Universal lab building to a newer and more comfortable facility built especially for him right behind the publicity office.

While all this was going on, the war was never far from sight. Every day there were urgent bulletins, casualty lists, food and gas rationing, and the scarcity and attendant skyrocketing price of many of filmmaking's most essential elements, raw film being the most fundamental. Nor were the loss of the European market and the consequent decline in gross receipts far from the attention of the cartoonists as they struggled to make each dollar do the work of three. When Walter and the other artists found that their talents could contribute to the upkeep of morale, they jumped into the breach, and Woody Woodpecker and the rest of the Lantz menagerie were soon populating the walls of mess halls and the noses of B-26s. Woody was the current studio favorite with servicemen and civilians, so he was a natural for the draft, but Walter didn't rest until he had dragged out of retirement every rodent, simian, and insect who'd ever done a walk-on since Oswald the Rabbit discovered the sound track. If they weren't going to star on the silver screen, they were by gosh going to star on their own airplane!

*Andy Panda insignia
for the Air Force.*

*Walter and Woody
in an Air Force mess hall.*

Andy Panda's Victory Garden,
*as animated and as demonstrated
to Air Force personnel.*

Walter delivers Air Force insignia.

Background artist Fred Brunish on camera, as he and Lantz
explain to the Navy what they're doing.

The studio also undertook a series of instructional films for the Navy, using stop-motion animation of actual apparatus, scale models of battleships, and lighting effects in place of traditional Bray-style cel animation, pioneering in the use of a plastic called Lucite when transparent material was needed and glass proved too temperamental. The studio turned out twenty-two films in twenty-eight months, while keeping up the regular output of theatrical cartoons for Universal. Layout artist Fred Brunish performed much of the stop-motion work, behind locked doors next to the story room. Hardaway's assistant Milt Schaffer was amazed that "the studio had a defense priority rating, just on the strength of Fred sitting in that room all locked up doing these things. And we were just making Woodys!"

Walter was asked if the new techniques would replace the standard animation processes, and he answered, "No, I'm afraid not," quite readily. "We still haven't figured out a sure way of shortening our work on making cartoons. It's just a tough grind and we have to keep on plugging. Start cheating on cartoons, and they become jumpy and the cheating shows."

Walter and Grace settled in a comfortable home in Encino, where they prepared to enjoy a woodpecker-free existence. However, "before we were completely settled," Grace remembers, "there was a surprise phone call. It was Walter's brother Al, and the long-distance connection was surprisingly clear. He was calling to say that he, three of his four daughters,

and a buddy had driven to California to visit us! No wonder the connection was so clear—he was in Pasadena, only thirty-five minutes from Los Angeles. Trying not to panic, I explained that we could accommodate only the girls at our house, but Al quickly assured me not to worry: He and his friend were going to Las Vegas and San Francisco. I must say, the idea of entertaining three of Walter's young nieces really excited me. (I can't speak for Walter's reaction.)

"Al and his friend took off after dinner, and we got our young charges settled in. One night, after a week of showing these delightful children the wonders of Hollywood, I asked Norma, the thirteen-year-old, when we could expect to hear from her dad about the return trip to New Jersey. Doris, the youngest, ran crying from the room as Norma explained. 'Daddy told us we were coming to California to live with you and Uncle Walter.'

"As usual, Walter worked things out beautifully without breaking any hearts. He understood why Al had planned this strategy. His wife had died and left him with four daughters to raise. Marie, the oldest, was engaged, but Norma, Stella, and Doris were of school age. And so, when Al returned from his 'vacation,' he agreed with Walter's plan to enroll Stella and Doris in a Catholic convent not far from their father. Norma wanted to stay in public school and live at home with her dad."

■ ■ ■

Walter knew that "It was Woody's wacky characterization that really caught on. It was during the war years: The soldiers and sailors loved this type of humor, and it's probably a good thing we started that way." But with the sweet-tempered people who populated Lantz's place working on a screwball character like Woody Woodpecker, it was inevitable that tension would develop between the nutty gags on the storyboards and the smooth, even-paced animation that was bringing them to life, and that tension was grounding Woody in more ways than one.

"The early Donald Ducks, Mickey Mouses, Oswald Rabbits, Bugs Bunnys, all of them start off looking wild," Walter reminds us. "We weren't totally satisfied with Woody. He was one of the most grotesque-looking characters I had ever seen. As we go along, everybody adds something to the character."

Alex Lovy added a lot. "At first, I had him looking as obnoxious as he sounded," he explains. "Gradually, we started making him a little cuter, a little rounder, with shorter legs, a little shorter beak. It was kind of stupid to have a bird with teeth after a while. What are the teeth for? He has a big bill! Sometimes the painters would paint the teeth and some-

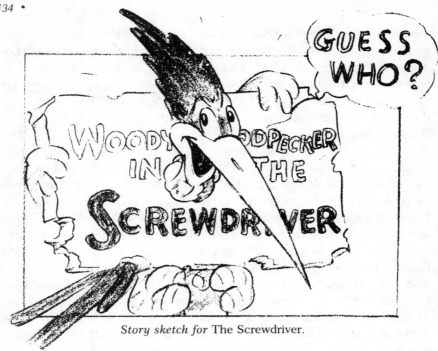

Story sketch for The Screwdriver.

times they wouldn't. So he'd talk, and here's these black and white flashes! So we decided to leave them out entirely."

La Verne Harding affected the new character, too. "She'd get this cuteness into Woody, and before you knew it, we were all doing it," Walter claims. "Well, I had more the feeling of cuteness than goofiness," La Verne says. "I never got too many wild scenes, because my style was more the cute type. I worked better in a personality scene than a wild action thing, like a character going nuts: What do I do with him? Would you take him over here, move his feet up, what? But when he's talking, acting, or whatever, that was a lot easier for me."

But *somebody* was going to have to be able to handle this nutty character when he went nuts. For a while that particular bill was filled by animator Emery Hawkins, whom Grim Natwick called "the only animator I know who can go completely insane in his animation and make it seem rational." Hawkins's feeling was "The only limitation in animation is the person doing it. You can do anything—and why shouldn't you do it? I animate every way: backwards, forwards, upside down, in and out. Every scene needs a different kind of thing. It's awful easy to feel like you're nuts when you're doing it. I don't know when I'm being screwy and just

missing the boat or when it's entertainment. There's no way of judging until somebody looks at it and reacts. I've always been a renegade, to be honest. I've moved about forty-seven different times at different jobs. I'd do little parts and bits of a picture and off I'd go."

Hawkins had worked at the studio before, inking cels when he was eighteen, but he was fired when he changed all the cels because he didn't like the way they were animated. This time his own animation was appreciated so much he was made a director. Along with Bugs Hardaway,

The Screwball.

he directed Oswald Rabbit's farewell appearance, *The Egg Cracker Suite,* and along with Milt Schaffer he made Woody's *Ration Bored.* But neither of these pictures demonstrates the daring, sparkling quality that galvanized his animation.

Back to the drawing board. As far as Woody was concerned, this bird's real trouble was not that even-paced animation was grounding him, but that he hadn't yet learned to soar.

REEL 10

The Boogie Woogie Man

Much I marveled this ungainly
Fowl to hear discourse so plainly,
Though its answer little meaning—
Little relevancy bore; . . .
—Edgar Allan Poe, *The Raven*

INTO THE TOWN of Goose Pimple, Nevada, one night strolls a cyclone.
Some cyclone—it's dwarfed by the shacks on the town's Main Street.
Some town—the signpost on its city limits lists its population as, "0,000."
Goose Pimple is a ghost town, and the mini-cyclone heads for the town's
hotel, edges its way under a tablecloth, and emerges as a ghost. With a
gavel he commences a convention of ghosts that proceeds to take over
the ghost town.

These ghosts turn out to be good spirits, as infectious as the music
they sing. Three of them roll their heads down their arms like they were
hats, bounce them on the floor, and toss them in the air, where they find
perches on a chandelier, and the light inside them creates a pawnbroker's
sign with jack-o'-lantern features. Three others glide headfirst into their
wide-brimmed zoot-suit hats, swoop headfirst out of them again, pedal
them like unicycles across the air, row them like kayaks through it.
Creatures sprout heads, and heads sprout creatures, and objects give
birth to people who weren't there a second ago.

The film is *The Boogie Woogie Man Will Get You If You Don't Watch
Out,* released in 1943, the first of a great series of Walter Lantz cartoons
directed by Shamus Culhane, and probably the best argument ever put
on film for the idea that you don't know what fun is until you're dead.

Since his tenure with Walter in New York, Culhane had worked for
the Fleischers, Ub Iwerks, Leon Schlesinger, and the Disney studio. "In
addition to being a director," Culhane explains, "I've always been a writer,
right from the early days when you had to write your own stories in the
first place *and* design your own characters *and* your own gags and every-

The Boogie Woogie Man Will Get You if You Don't Watch Out.

thing. It was very important to be a gagman in those days, so I've always embellished my stuff."

Culhane shared with Walter a heritage of New York twenties and early thirties animation, when limbs were as detachable as boxcars and no distortion was too bizarre to be tried at least once. *Boogie Woogie Man*'s acrobatics of dismemberment (not all of which are indicated in the story sketches) are an updated, up-tempoed version of the style of the old Fleischer Out of the Inkwell cartoons and Lantz's Oswald episodes, but the new pace made all the difference. When Culhane animated a character, that character *stayed* animated.

His third cartoon for Lantz was *The Greatest Man in Siam,* which, along with its follow-up, *Abou Ben Boogie,* takes place in a Byzantine, rococo, arched and looped rendition of the Middle East, where everything is black and yellow and pink and gold and frankincense and myrrh (and blackest of all is the Black Market, where they gather who deal in licorice and blackberries). Here are palaces, markets, and mosques at odds with themselves, Xanaduvian hallways that seem to stretch to infinity, and terpsichorean, prestidigitationous characters who seem to have just come from there. The Fastest Man in Siam shoots an arrow into the air, and by the time it gets to the other side of the room, he's had time to get there first, grow a tree, pick an apple off it, and put it on his head, directly in the path of the arrow, which splits it into applesauce.

For Culhane's fourth Lantz cartoon, he finally got down to tackling the Woodpecker. The outcome was *The Barber of Seville,* at $16,717, the most expensive production of that year for Lantz. The concept was grand and, once again, musical: Woody would take over Tony Figaro's Seville Barber Shop and give the customers a full treatment to the tune of Ros-

Scenes from The Greatest Man in Siam.

sini's *Barber of Seville* (possibly inspired by Chaplin's shave to Brahms's Hungarian Dance No. 5 in *The Great Dictator*). Mel Blanc was no longer supplying Woody's voice; an exclusive contract with Leon Schlesinger to provide the voice for Bugs, Daffy, Porky, and nearly every other character at the Warner studio made him the first voice artist in animation to receive constant screen credit, but prevented him from working for any other producer. Woody's voice was a sped track anyway, played back at a slightly higher velocity than it was recorded at to produce the comical effect of a significantly higher pitch, as Disney would do later for Chip 'n' Dale and Ross Bagdasarian for Alvin and the Chipmunks. So the matter

Pat Matthews's model sheet for Miss X.

Sample storyboard sketches for The Barber of Seville.

of who provided the voice was academic: Almost any voice, raised to that pitch, produced the same effect. After experimenting with one or two other actors, Walter finally settled on the nearest warm body with an inherent understanding of the character, and that was Bugs Hardaway, who proceeded to do the Woody voice for the rest of the decade. (Except for that maniacal laugh. The piece of film on which Blanc recorded that remained Lantz's property and was the source for every laugh the bird uttered until the fifties.) But Rossini arias called for another kind of larynx altogether.

Normally when Walter did a musical cartoon that demanded a large orchestra, he was able to get the Universal studio ensemble to knock it off in a few minutes at the end of a recording session at no extra charge. Now he asked Joe Gershenson, Universal's musical director, to contact a good opera singer to perform the score at regular speed so it could be sped for Woody. The tenor was found and shipped fresh from San Francisco, and according to Grace Lantz, "He was horrified," when he heard the results. "We paid him to come out and sing it for the cartoon. He didn't know he was going to do it for Woody Woodpecker."

Culhane enjoyed Walter's star character, but had reservations about him. As he describes his feelings, "It was a funny character. The shape and design of it was excellent and that trick voice was very smart. But he was not an actor. I like pantomime, and he's a real action character." The director responded by popping Woody around the frame without regard for animation conventions or the logic of the scene or the position he was in one drawing ago or anything but the rhythm of the music. He starts it gradually in the opening dialogue of *Barber of Seville,* then accelerates it as the picture goes along. "He's the one who showed the animators how to do that," Walter remarks, "because Culhane was a darn good animator."

Whether it's because he's confronted with an Italian customer or because he's in the Seville Barber Shop or because the proprietor's name is Figaro, we'll never know—Woody just launches straight into the "Largo al factotum" from *The Barber of Seville*—no translation, no motivation, no explanation. He suddenly becomes a musical purist and decides he must either serenade his customer or croon a lament for the lost Figaro, and the effect is funny.

The rhythm of the music gave Culhane a certain liberty. "I'm an ex-violinist, among other things, so I know music pretty well," he says. "When it got around to this, I felt just right speeding it up to keep the

picture moving—it should take you on a roller-coaster ride, really give it to you."

And soon it does. As Woody sings, he compounds the nuttiness by spraying his underarms with shaving cream, covering his customer's dome with it like he was a pumpkin pie, and applying it like polish to the man's shoes (and once he really gets going there's no need for him to *stand* on anything while performing these actions; just floating against the background will do). He sharpens the imposing-looking razor on his subject's tie, and there's a gleam in his eye to match the one on the blade as he lunges at the guy, razor hand swinging. As the music picks up tempo and Woody proceeds with his simultaneous parodies of barbers and opera singers, the cuts get faster and faster, and in terms of continuity, less and less logical: They are now *jump cuts,* of the kind Jean-Luc Godard was supposed to have invented in *Breathless* in 1959, but they do have a logic of their own that is not only filmic but musical, and characteristic of the synaptic popping from place to place Woody's been doing since his opening dialogue.

Culhane remembers, "I'd use devices like that to keep things moving. I found myself doing lead sheets according to the music and I couldn't believe what was coming out: twelve-frame cuts, 'Figaro, Figaro, Figaro, Fi-ga-ro'—I realized that if I did the thing once around at normal speed, I could go like crazy when it came back to the 'Figaro, Figaro' part because the audience knew what the action was; they would retain the memory of it and be able to read a shot which they normally would not. It worked fine."

Woody gets too absorbed in his musical desecration to keep track of his victimized customer, and the " 'Figaro, Figaro' part" comes just in time for a frenetic search of the premises—in drawers, behind chairs, under rugs—for the missing character (whose name is probably anything but Figaro, but that's okay, music has taken the place of logic in this picture). The search reaches its peak in one mad shot (brilliantly animated by Pat Matthews) in which Woody splits into three, four, then five images of himself at once, like animated paper dolls, all screaming "Figaro!" It's not clear what he hopes to gain by this, but it makes as much sense as anything that's gone before it, and it's the climax not just of the music and the comic frenzy of the film, but of the idea of Woody's being everywhere at once in accordance with nobody's ethics but his own, which Culhane's been building so perfectly since the picture started.

"If you could have seen the pencil test for *The Barber of Seville*!!!"

says Culhane now, referring to the test photography done on the animators' drawings before the cels are inked and painted. "A lot of people would have asked me to modify it. Walter didn't. He was very easy to work for, for that reason: He didn't bother you. Lantz seems to have made a policy not to interfere with a director's style. I think this was his outstanding attribute as a producer. Sometimes it took a lot of guts."

Walter's noninterference with artists' styles was his own style as a producer. One of the most flamboyant stylists to contribute to the Lantz look was Art Heinemann, a layout artist who designed *The Barber of Seville,* as well as the Moorish confection of *Abou Ben Boogie* and *The Greatest Man in Siam.* Heinemann had the reputation of being one of the greatest artists in the animation business and one of the few individualistic talents working in animation design. Chuck Jones called him "the only character layout man who could actually design characters that were animatable right now, without a director adapting them."

Walter credits Heinemann with the next important step in Woody's development. After laying out *Barber of Seville,* Heinemann decided Woody needed a trim himself and said, "Let's simplify him."

"Let's not change his habits," Walter cautioned, "just change his design, so he looks pleasant."

"Why don't we leave off a lot of the colors we have on him?" the designer offered. "Make his body just blue and white."

Heinemann's new design was more sleek than the old but also more expressive, stressing the angularity of Woody's features without exaggerating it to the point of grotesquerie and bringing into prominence the gritty, sandpaper toughness that had been submerged in the round-eyed, round-headed maternal touch of La Verne Harding. After *The Barber of Seville* Woody was a more pleasing character to watch, with more action and expression in unlikely places, like the topknot and the beak, but also a more obviously savage one. Tougher and more flexible altogether, and a more engaging comic presence.

Layout and design were getting increasing attention in all departments of the studio. La Verne Harding remembers, "I had a scene of a fellow making a cement walk [*The Loose Nut*], and he picked up a little hair and held it up between two fingers. Well, I had the other fingers going in all directions. Jimmy Culhane said, 'Close those fingers, and you'll see the hair.' That's one thing I never forgot: Don't make an interesting drawing of anything that is not a bit important."

Animation drawings based on Art Heinemann's new design.

Even the look of the story sketches improved. This was no small matter: If the first drawings made of an action were good, the layout drawings and animation drawings that followed could only improve upon them. "It was a good starting point, put it that way," as Milt Schaffer, the man responsible for translating Hardaway's screwball ideas into graphic form, describes it. "Man, we laid those out! There was a staging that worked. It's possible to make a drawing that says just one thing. And for this kind of work it should do that. Walter used to come in and look at my boards and say, 'Why do we need a layout guy?' " What Walter says now is "You could almost animate some of these storyboards with stop-action. They're drawn better than you see in the Sunday pages today."

All of which was simply by way of setting the stage so that the animator could perform dynamically, but without dynamic performers at the light-board it would all be down the drain. So the look of the Walter Lantz cartoons took yet another step forward when Grim Natwick entered the

Woody in Culhane's Fair Weather Fiends.

Grim Natwick scene from Smoked Hams.

fray and contributed his striking talents to the studio's output. Natwick had created Betty Boop and become the key animator for Snow White since we last met him. While Culhane, a great admirer of Natwick, felt that his "most important asset as an artist seems to be his sense of delicacy of design," Natwick calls himself "a rough animation guy" and declares, "I like to swing it."

Natwick delighted in the working conditions at Walter's little shop. "It was like a family," he claims. "There was a very free and easy concordance among the animators. If I liked something another animator did, I'd go right over and say, 'How did you do that?' I never felt there was a sense of jealousy among the people who worked at Lantz's—as there *was* over at Disney's."

He also delighted in Walter's main character, and Natwick's wild style ("a little *too* wild," in Dick Lundy's opinion) adapted readily to Woody's demands. "He's more flexible than Mickey Mouse," as Grim describes him. "He's harder to draw than Mickey, but he can do a lot of funny things that Mickey cannot do." That, of course, was part of his charm. As Walter points out, "There's a little of Woody Woodpecker in all of us. We'd like to do certain things, but, gee, we haven't got the nerve. Woody had the nerve."

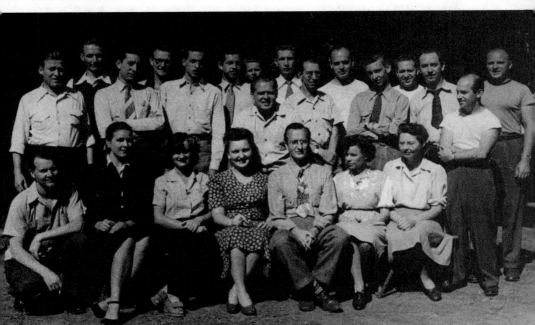

Walter Lantz's wartime staff.

REEL 11

The Poet and Peasant

Disney and his studios, after their promising beginnings, quickly floundered, became facile, and remained mired in bourgeois sentiments. . . . Then . . . Woody Woodpecker, Heckle and Jeckle, Bugs Bunny, Tom and Jerry, the Roadrunner and Tweety Pie arrived to overturn all our habits and break all taboos. . . . The animated cartoon has discovered its own world and explored its complexity. It has revealed, meanwhile, a part of our own life that we did not know existed. Our senses have been enriched.
　　　　　　　　　　　　　　　—Ado Kyrou, *Le Surréalisme au cinéma*

THE POSTWAR SUN was rising on a different world in many respects, not the least of which was the rising cost of making cartoons. With higher standards of production, more costly materials, and trade unionism dictating inflexible minimum wages for everybody in the shop, the pictures made for less than $9000 apiece before the war were running more than double that figure by 1945. Individual cases requiring elaborate action, like *Chew Chew Baby*, exceeded $21,000. In two short years, production costs for the average Lantz cartoon would top $25,000. The only solution was to let that Bank of America loan pile up to the ceiling and to try the usual tack of passing the costs on to the consumer. But between the cartoon producer and his consumer was a middleman called the exhibitor, and his enthusiasm for rising prices was kept well in check.

During Walter's reign as president of the Cartoon Producers Association, which had been formed to help keep the business within reasonable bounds, he and Walt Disney announced that production of one-reel theatrical cartoons would be reduced and possibly cease altogether unless there was some postwar adjustment in rental rates. In August 1946, the trade periodical *Greater Amusements* announced: "Both Disney and Lantz declare production costs of the shorties have reached such proportions it is impossible to make them at a profit under present rental terms, with

Hundreds of different colors are used in an animated cartoon.

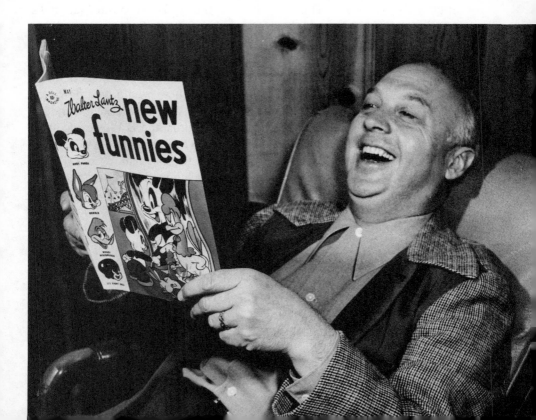

the former backing up his assertion by laying off 450 of his staff making cartoons. . . . It is assumed the exhibitor believes the threats of cartoon producers are nothing more than a well-planned scare campaign to needlessly jack up rentals on the shorties. This corner wouldn't know if the exhibitor is paying too much or too little in cartoon rentals, but it does know from personal observation that certain cartoons can and often do save the box office for features with questionable drawing power. . . . 'Only solution to the problem,' said Lantz, 'is for exhibitors to pay more for their screen brighteners.' . . . He said production costs run from $15,000 to $80,000 for a seven-minute short and pointed out that revenue remains the same despite extra care or quality. There can be no quarrel with cartoon producers for seeking an increase in revenue today over last year's prices, assuming that rentals were in line a year or two years ago." And there was no quarrel. The exhibitors simply refused to pay more for the cartoons.

Walter wasn't the only one on the lot having problems. The prosperous, happy years after World War II were lucrative ones for every studio in Hollywood but Universal. The year 1946 saw a new boom in paid admissions at the box office, but it also saw a new broom sweeping clean in Universal City, with its committee of decision makers overpowered by a merger effected with the small, independent, not particularly successful International Pictures. The new chiefs at the studio were International's spearheads, one of them a lawyer and the other Louis B. Mayer's nephew, a pair of distinguished gentlemen with the undistinguished names of Goetz and Spitz. As art fanciers, connoisseurs, and *bon vivants* about town, they had little affection for the B pictures that had sustained the old regime. They announced that henceforth there would be a new emphasis on quality, significance, British imports, and Technicolor, sending down orders to cancel production on horror films and B Westerns, even those in midstream. As studio executives, however, they failed to see that the studio depended on just those pictures for its income, and if they were eliminated, something equally commercial would have to take their place. The new name for the studio was Universal-International, and a streamlined twirling globe by that name took over as its trademark to do a lot of glistening in Technicolor. Instead of Sherlock Holmes mysteries, there would be *The Egg and I,* inspiring a whole parade of Ma and Pa Kettle movies. Films like *Abbott and Costello Hit the Ice* would be upgraded to *Abbott and Costello Meet the Invisible Man.* Creatures like the Wolfman would be phased out in favor of *The Creature from the Black*

Andy Panda in a nightmare scene from Apple Andy.

The Poet and Peasant.

Scene from The Wacky Weed.

Lagoon. Obviously, it was going to be some time before the concept of quality would sink in at Universal City.

Walter Lantz had survived previous studio shake-ups, and he would survive this one. Culhane had gone to set up shop for himself, but with animator Dick Lundy filling his director's chair, quality and Technicolor would not be in short supply. Lundy had previously spent his entire professional life at the Disney studio, where he not only learned but helped develop the art of animation and became part of that studio's growth into an empire. As an animator, Lundy made a specialty out of the little dances that popped up so often in cartoons like *Steamboat Willie* and the early Silly Symphonies. (In the 1981 exhibition of Disney animation and animators at New York's Whitney Museum of American Art, a special presentation highlighted the analysis of Dick Lundy dances.)

But, as Lundy explains his own work on an animated character, dancing was just the first step: "What I was trying to do was make personality count an awful lot. I would still put in the gags that were there, but try to make this personality so that it worked. If I had to change the gag a little to fit this personality, then I would do it. So it was his personality that was getting the laugh *plus* the gag."

Lundy's keen eye for character and the possibilities for revealing it through expressive personality animation had been instrumental in helping to boost Donald Duck from a supporting player in *The Wise Little Hen* to the main attraction of *The Orphan's Benefit* and finally the star personality of the studio, eclipsing even Mickey Mouse. Lundy was among those responsible for "discovering" Donald ("He was it!" according to Culhane, who adds, "He's got a short fuse like his!"), and he directed some of Donald's more memorable starring vehicles himself. "Lundy didn't have the broad sense of humor that Culhane had," Walter points out. "Lundy had the Disney Mickey Mouse timing. I think he brought a little of the Disney touch when he came with me." What he brought was a propensity for round-eyed, engaging characters, a symmetry in movement and design, and a stringent personality of his own that was dedicated to quality animation as if his life depended on it.

His first directing for Lantz was done during the war to help fulfill the Navy instructional film commitment, and the highlight of this work

Andy gets advice from both sides in Apple Andy.

The stars of Enemy Bacteria.

was the combination live-action drama and animated horror film *Enemy Bacteria,* produced in 1945 and seen subsequently in many medical and health training programs. Walter calls Art Heinemann's design of the cockeyed streptococci and staphylococci who become the film's main characters "brilliant." *Hollywood Reporter* called the finished film a "thrilling triumph for Lantz" and an "astounding display of ingenuity and talent." Grim Natwick says of the experience, "All I remember animating for a while was red and white corpuscles." As these graphic representations of our own mortality ooze along in the plasmic slime, in their deliberately unsettling color scheme of pallid brown, gauzy yellow, and ashen gray, the point that they are enemies of the human body and the U.S. Navy comes home with nauseating force. Lundy and his artists did more than dramatize with hair-raising accuracy what goes on when our systems become inflamed. They demonstrated a rarely exploited potential of the animators' art.

*Air Force supervisor, Lantz, and director Dick Lundy
discuss* Enemy Bacteria.

In *Musical Moments from Chopin*, Lundy shows a side of the Wood-
pecker's character never before revealed, the same side Harpo Marx was
careful to display in every show: the quiet, reflective side that plays soulful
music. *Musical Moments* was the first of the Musical Miniatures, the
series designed to replace the Swing Symphonies, and it demonstrates
not only a new approach to Woody's character, but the quality-oriented
direction the entire studio was taking: instead of jazzy contemporary
music, highbrow classical chords; in place of Art Heinemann's bold de-
sign, a simpler, cleaner, brighter look introduced by Fred Brunish; rather
than cold forties pastel colors, a warmer, sunshine-drenched color scheme;
and replacing the hyperactivity of Shamus Culhane, the holistic approach
of Dick Lundy—an overall attempt to be more aesthetically pleasing with
fewer strokes of the brush.

In a hushed concert hall (or, rather, a hushed barn where a concert
is taking place) Andy Panda is addressing Chopin's *Polonaise* on the
keyboard. The atmosphere of refinement is established solely to be shat-
tered by Woody's entrance; he bobs complacently onto the stage, carrying
a bucket of piano polish (clearly labeled as such purely for the benefit of
the joke, just as conspicuously as Mack Sennett would have labeled it)
and oblivious to everything but his mission, which he proceeds to carry
out with a demeanor pleasantly daffy. Moved, finally, by the music but
unimpressed by the circumstances, he progresses to the polishing of the
keys (perfectly melding his strokes, of course, with Chopin's composi-
tion), making mute appeals to Andy for some affection.

Having absorbed sufficient refinement from his Chopin exposure, Woody
switches politely to his own baby grand, and, in a gesture every etiquette

Woody and Andy Panda in Musical Moments from Chopin.

book should teach, silently spits on his hands so he can play the next selection with his feet. Then with his beak. Then with dancing tail feathers. Then a Woodpecker variation on the Russian cossack kick dance.

Quality brought growth, and growth brought growing pains to the Lantz outfit in the late forties. The studio was lucky to obtain the services of William Garity, the engineer who helped create the Disney multiplane camera and the "Fantasound" stereo system for *Fantasia*. His biggest brainchild at Lantz's was a new sound-track system for greater clarity and fidelity in reproducing the music for *Musical Moments from Chopin*. Garity became Walter's production manager, and his first assignment was to make a new home for the Lantz studio in an old Hollywood building on Seward Street that had once served as a satellite Disney studio for the early work on *Bambi*. Garity supervised the expensive modernization of the building while the artists were at work in it, and from then on oversaw the sound, photography, inking, and painting on every cartoon the studio produced.

Production costs were still rising. Some of the Musical Miniatures were costing over $30,000 to produce—the most expensive pictures Lantz had made. Walter was rapidly turning his cottage industry into a cottage empire, and the whole edifice was based on a single, not particularly stable star.

■ ■ ■

In 1947, Walter looked forward to his meeting with Matty Fox. It was time to renegotiate the seven-year contract he'd made with Universal in 1940. In seven years Walter had gone from a position of weakness to a position of strength. He now had one of the hottest box-office stars in the entire business of cartoonery and turned out soufflés that could hold their own against any of the competition. He was no longer a shoestring producer looking desperately for a release; he was sole owner of a profitable commodity with proven success all over the world. That ought to be grounds for better terms, even from Universal. But success has a way of rolling its own dice.

As Walter tells the tale: "Matty Fox called me into his office. He said, 'Okay, Walter, we'd like to sign up with you again, but we want rights to your pictures in perpetuity.' He wanted commercial rights and licensee rights. Universal would own everything. I said, 'I'm sorry, Matty, I think you're asking for an awful lot. After all, I'm still in debt, and I'll be in debt for a long time. I just can't go for it.' We argued back and forth, back and forth. He said, 'You either do it or else.' That's when my Italian

Woody's image changed by Fred Moore for The Mad Hatter.

blood came up, which it does about once every five years. I said, 'Aw, Matty, I can't take your deal,' and I walked out of his office. I went to see George Bagnall, of United Artists. He said, 'How'd you like to make cartoons for us?' I signed the contract that afternoon. I got a call at midnight from Matty Fox. He said, 'Walter, I guess I've been too hasty. I didn't think you'd walk out on me. I'm ready to negotiate again.' I said, 'No, Matty, I'm sorry. I've made a deal with United Artists.' He said, 'That's a heck of a way to do business.' I said, 'You drove such a tough deal that there's no way I could live with it. So I just quit.' "

Walter made twelve pictures for United Artists in twelve months, and they are among the most charming, delightful, and just plain beautiful cartoons that he, or anybody else, ever made. The simple, clear line that had always characterized the Lantz product was now gaining in expressiveness and acquiring an occasional filigree that added charm without complicating the effect. Hardaway's lunacies, from the most preposterous to the most ingenious, are treated with a deftness of touch in animation that endows them with their own baroque life: as in *The Bandmaster,* when a silly gag about a head-standing lady trapeze artist, who twirls her way from trapeze to trapeze without touching them with anything but her scalp, is transformed into a rare cubistic moment of absurd lyricism that seems to anticipate the entire Eastern European school of animation in a single gasp.

One of the new animators at the studio was Ed Love, a Walt Disney and Tex Avery veteran with an industry-wide reputation for stretching characters to the breaking point without breaking anything but the rules. Another was Fred Moore, a short, stocky, ingenuous Frank McHugh of a fellow, as coordinated on the sandlot as he was at the drawing board, bringing a natural sense of symmetry to every movement he created. La Verne Harding remembers, "He taught me something about getting action in a solid head. You do a character making a take: His head is solid. You stretch it and just get the *effect,* you don't leave it there. Change the shape but still keep it cute. Don't go into any awful-looking thing." Even Ed Love was in awe of him. "Freddie and Fergie [Norm Ferguson] were two of the best animators that Disney ever had," he remarks. "And Disney fired both of them! I never could figure this out, because those two guys made his studio."

The fuller animation in the United Artists cartoons turns the Lantz characters into nonstop spinning tops, gyroscopes of perpetual and unpredictable motion, impressing us with the Disneyesque smoothness of

Andy Panda in The Bandmaster.

their design while surprising us with unexpected hyperboles of movement. Stylization in the gags is balanced by solid animation, and stylization in the animation is balanced by well-defined personalities, until lightness and weight offset each other in the kind of harmony of motley elements that makes awesome skill look effortless.

REEL 12

Wet Blanket Policy

He pecks a few holes in a tree, to see
If a redwood's really red,
And it's nothing to him, on the tiniest whim,
To peck a few holes in your head.
—"Woody Woodpecker," George Tibbles and Ramey Idriss

ONCE THE POWER OF MUSIC was invoked—and, more than that, the power of *popular* music—there was no holding a certain manic woodpecker.

"The Woody Woodpecker song was written in 1947 by two musicians named Tibbles and Idriss who worked in my orchestra," Walter explains. "One played the piano and the other played the guitar. They called me on the phone one day and said they had a song they wanted me to hear. I said, 'Play it to me on the phone.' They did, and I said, 'That sounds very interesting.' They said, 'Do you mind if we try to have it published?' I said, 'No, I think it would be great.' "

Getting it published and getting it recorded, though, were two different things. The foundations of the recording industry were rocked in late 1947 by a certain James Caesar Petrillo, who was head of the American Federation of Musicians and was annoyed that the record business was making millions of dollars for disc jockeys and jukebox companies and considerably less for the musicians in his union. Petrillo announced in October that a nationwide strike of all the recording companies by all the AFM musicians (essentially all the musicians in the country) would go into effect at the stroke of midnight on New Year's Eve and would go on until he felt better about everything. No one knew quite how long this would be, but the last time Petrillo had felt that way had been 1942, and things hadn't returned to normal until 1944. This gave the record companies less than three months to create a stockpile of recorded songs to keep customers and cash registers humming until some unforeseeable future date.

In this frenzied atmosphere Tibbles and Idriss approached Kay Kyser

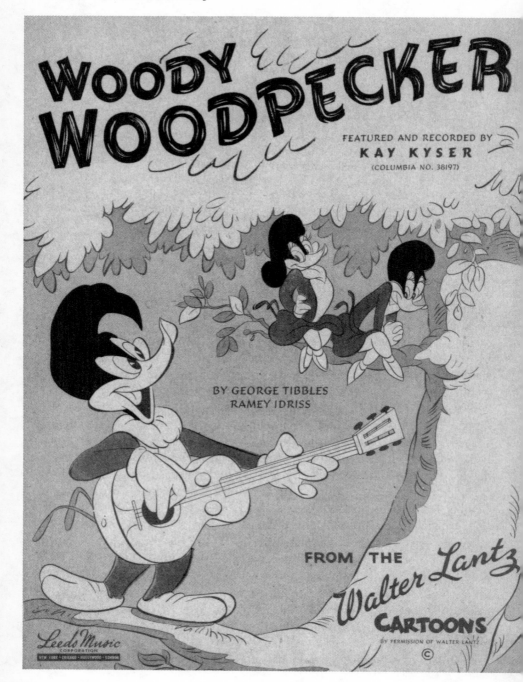

WOODY WOODPECKER

KEY OF F (C−Eb)

BY GEORGE TIBBLES a.s.c.a.p.
RAMEY IDRISS a.s.c.a.p.

(a radio star with his "Kollege of Musical Knowledge") in the middle of an eleventh-hour New Year's Eve recording session and tried to get "Woody Woodpecker" squeezed in before midnight. Kyser, with a long list of numbers to be done in a short space of time, was appreciative of the song but dubious of the clock and said that it would get recorded if every song ahead of it was polished off without a hitch and he found himself with a lot of time on his hands before midnight. Only ten minutes before 1948 and a national moratorium set in, Kyser gave the "Woody Woodpecker" lyrics to Gloria Wood, got Harry Babbitt to do the well-known laugh that provided the key refrain, and brought the song in under the wire.

Of course, the inherent drama in this true-life cliff-hanger had a somewhat anticlimactic resolution when the AFM ban was lifted in a matter of weeks, long before the single was released in May. But by then another kind of drama had taken over: the overnight success story.

> Columbia reported that record orders passed the 250,000 mark within 10 days after release, while Leeds said sheet music sales soared to 155,000 copies, exclusive of rack order sales.
>
> The diskery and Leeds are pitching trade tie-ups, with a deal already completed with Walter Lantz, film cartoon producer, who will use the song as the theme for future *Woody Woodpecker* cartoons. Lantz grabbed vocalists Gloria Wood and Harry Babbitt to do a special film dubbing of the melody . . .
>
> A merchandising tie-up between Lantz and several men's wear makers is also in the works, calling for production of Woody Woodpecker belts and suspenders.
>
> —*Billboard,* June 12, 1948

> Kids were driving their parents crazy with it. Waitresses in jukebox joints were going frantic. The whole U.S. seemed to be gurgling itself silly with the laughing gassiness of a goofy song called *Woody Woodpecker.* Out only four weeks, *Woody* was already tops on *Variety's* list of the nation's most played jukebox tunes.
>
> —*Time,* June 28, 1948

> "I'm going nuts," Walter Lantz said today.
>
> It's almost enough to make a man wish he weren't getting a million dollars' worth of free publicity. But not quite.
>
> "Woody Woodpecker has been laughing for eight years," said Lantz, who produces the Woodpecker cartoons. "But nobody else ever laughed that way until the song came out a month ago. Now I hear it everywhere I go."

So does everybody else.

"People h-h-h-haa-ha at me in the market and the drugstore. When I go for a haircut the barber laughs." (This could be because Lantz has almost no hair.)

"People call me up on the telephone and instead of saying hello they laugh. The caddies on the golf course all hee-haw at the top of my backswing. It's added 15 strokes to my game." . . .

Today it's third on the Hit Parade and, as any weary waitress can tell you, tops on the jukeboxes.

Lantz rushed it into his next Woodpecker cartoon, "Wet Blanket Policy," out in August. Just so you won't forget it, he's going to use it as a theme from now on.

"People will be singing the Woodpecker song," he beamed, "for years and years."

—San Diego *Daily Journal,* June 29, 1948

The whacky, infectious, up-the-scale laugh, which has the whole country imitating it, has made this Lantz cartoon hero one of the top animated stars in the business. Lantz is taking this tremendous popularity in stride, although occasionally he may forget himself, and answer the phone in the style of his creation. From what we hear, Woody himself is also quite calm. "After all," he reportedly said, "I always knew I was good enough to have a song written about me."

—Philadelphia *Exhibitor,* July 7, 1948

It was the only pop song ever written about a cartoon character, and it was one of the biggest hits of the booming postwar tune market, landing on the all-important Hit Parade in the Number 3 slot, then going straight to Number 1 and staying there through most of the summer, finally becoming one of the Parade's longest-running attractions. It was hitmaker Kay Kyser's most successful song in five years. It was announced the Number 1 item on jukeboxes in Ethiopia, and the bedouins of the Arabian desert were reportedly playing it on portable radios on camelback. Suddenly theaters wanted Woodpecker cartoons like they never had before, and United Artists was caught with a scant hundred prints apiece of the three Woodys they'd so far received and no chance to fill the demand. Universal rereleased twenty of their own, previously retired Woodys. If theaters couldn't get the cartoons, the owners played the song at intermission. If that got a good response, they went on playing the song whether they could get the cartoons or not.

Sheet music sales soon hit five thousand a month. Other record companies jumped into the breach, with Capitol, Decca, Mercury, MGM, and Varsity each following with their recording of the piece, until it had sold

close to two million discs. The Ford Motor Company featured the song on billboards for its cars. It turned up in "Alley Oop," "The Berries," and any other comic strip that wanted to show a character singing. It started Woody Woodpecker fan clubs, Woody Woodpecker matinees, and even a Woody Woodpecker haircut that swept the high schools.

It was the first and last tune from a short subject ever to be nominated in the Best Song category at Oscar time, and Gloria Wood was recruited to perform it at the 1948 ceremonies. (It lost the award to "Buttons and Bows.") Harry Babbitt was never similarly redrafted into service, but word got around that he was responsible for the laugh wearing out eardrums all day, and everybody from bartenders to kids in the street to his own Cub Scout pack began yodeling "HaHaHaHAAHa" at him as a way of returning the assault, until Babbitt, like Lantz, began to feel haunted by his own success. A rooster in Hazleton, Pennsylvania, drew crowds with its imitation of the laugh. Clothing and toy manufacturers descended on the studio for the rights to put Woody's likeness on everything from balloons to cream pitchers, and the Revell Company of Hollywood came up with a little red harmonica toy that gave you the right C F A C A melody if you simply blew straight across on it.

The song and its attendant bird turned up in political cartoons on Henry Wallace and General Eisenhower when the rounds of nominations opened for the 1948 campaign. In an informal poll in Rome, Georgia, Woody was nominated for President himself. When Don McNeill of ABC Radio's "Breakfast Club" made a bid for the White House, Woody became the campaign mascot, a variation of the song became its rallying cry, and a million Woody Woodpecker buttons and stickers were scattered over the nation. Estes Kefauver used another variation on the same song in Tennessee and rode to Washington on it as senator.

Sportswriter Harold Conrad made national news when he took a job with J. Arthur Rank in London for the express purpose of getting away from the maniacal cackle coming out of New York record-store loudspeakers—only to discover the song had by then conquered England. A zookeeper in Cleveland got coast-to-coast coverage with the scoop that "HaHaHaHAAHa" isn't even *close* to the sound of a real woodpecker; "Churr-churr-churr" would be much more accurate, he claimed, except, of course, for those woodpeckers who go "Wick-wick-wick."

Then things got nasty. A San Francisco cement worker wrote a note asking that the piece be played at his funeral, before launching a suicide attempt that was sabotaged by police. The tune was broadcast from hel-

Saturday afternoon Woody Woodpecker show.

Road sign showing Woody's birthplace.

icopters in Tacoma, Washington, as part of an attempt by dockworkers to dissuade strikebreaking stevedores. Alabama complained that the song—and, by extension, Woody himself—was an insult to the state's official bird. The Fort Worth *Press* suggested that the local bounty on woodpeckers be applied to any kids caught imitating Woody's laugh in public. Police in Virginia, Minnesota, and Dallas, Texas, reported calls from outraged citizens who happened to live near bars or restaurants with loudspeakers (or just loud patrons) and said that if they heard one more reprise of "Woody Woodpecker" they would not be responsible for their actions. Five hundred Dallas residents signed a petition asking police to ban the song from the city. The song, according to studio publicist Hilda Black, "figured in lawsuits from Schenectady to Cucamonga."

Then things got nastier. The Woody Woodpecker song figured in no lawsuit bigger than the one Mel Blanc initiated when he suspected what casual conversations and informal polls then confirmed: It was that unique laugh that was implanting the song in the consciousness of every American, not its uninspired melody or its doggerel lyrics, and the eccentric noise that nearly got him kicked out of Lincoln High School was now making millions of dollars for everybody but him. It didn't relieve his anxiety to learn that the Woody Woodpecker cartoons on which he'd first vented his larynx were now being sold in stores by Castle Films for anybody who had an 8mm or 16mm projector. From phonographs to radios to jukeboxes to harmonicas, there seemed to be no mechanism devised for the transmission of sound (with the exception of television) that hadn't been overtaken by that defiant giggle. On May 24, 1948, when Blanc attempted to claim authorship for the sound and dramatize the unfairness of the situation to the Lantz company, to Leeds Music, and to Castle Films, he got a response he should have expected. They laughed.

One way for Blanc to get satisfaction was simply to go record his own version of the song, an option available to anyone who paid the fee to Leeds. Blanc's rendition crashed the Hit Parade right behind the Kyser version, soon matching it in sales. And in the middle of July, *Billboard*'s list of the most popular current records was topped off by no less than two variations on the same silly theme, in first and second place (where it was followed, in those session-happy days, by three recordings of "My Happiness" and four of "You Can't Be True, Dear").

But this served only to whet Blanc's appetite. He estimated the loss in "international fame and reputation" he had suffered as a result of

Woody and Wally Walrus in Well Oiled.

others publishing and recording the song at $520,000, and filed suit in a Los Angeles superior court for exactly that amount on July 13, 1948, naming Walter Lantz Productions, Leeds Music Corp., Ramey Idriss, George Tibbles, and Castle Films as defendants. It was noted that a copy of the laugh was attached to the complaint. (It was not explained how.)

Walter was impressed that such a drastic step had been taken. He told *Variety* this had never happened to him since he'd gone into business and it must mean he was getting famous. Tibbles and Idriss were openly delighted at the news and told *Down Beat,* "We're in! This is the real mark of success. A songwriter is never really established until he has a flock of suits tossed at him. . . . It's now pretty safe to say we won't have to go back to scrambling for radio shows this fall and can devote our time wholly to song writing from now on." Of course, the inevitable editorials appeared suggesting that Blanc be awarded, then fined, $520,000 for creating the insidious cacophony and inflicting it on an unsuspecting populace.

Blanc's lawyers took the position that his "unique collocation of sounds"

was an "intellectual composition" that constituted a property exclusively his by right of authorship, according to the laws assigning a "common law copyright" to the author of a given composition until publication. They maintained that the use of the laugh in Woody Woodpecker cartoons did not invalidate this copyright, since the exhibition of a motion picture constituted a "performance" rather than a publication, and they managed to cite three prior cases as precedent for this definition. Judge Daniel N. Stevens did not laugh, but he did manage to interpret two of those previous decisions to mean that theatrical exhibition *was* publication and then declare the third one irrelevant. ("Isn't that a heck of a thing to say?" asks Blanc today.)

Blanc not only performed the laugh of his own free will in *Knock Knock, Woody Woodpecker, The Screwdriver,* and *Pantry Panic,* he had, as the case revealed, made it public as early as "some time in 1934 or thereabouts" on a local radio station in Portland, Oregon. The judge decided that it was pointless to argue whether a performance or a publication had taken place when either one rendered the common law copyright invalid and that the laugh was public domain the instant it was performed in public unless it was specifically protected by a statutory copyright. ("Yeah," says Blanc today. "But who copyrights a laugh?")

This decision was considered to have a long-range effect on all radio and television copyright practices, and it was much debated in legal circles, some attorneys being outspoken in their opinion that it was unjust for Blanc to have lost the case on the grounds that he didn't copyright the laugh. Instead, they argued, he should have lost on the grounds that the laugh was never copyrightable in the first place. When Lantz heard that Blanc and his attorneys were taking the decision to the California Court of Appeals, he contacted the voice actor and made an out-of-court settlement that apparently satisfied both sides. ("Walter's a very wonderful guy," says Blanc.)

■ ■ ■

It's long been believed that the twelve cartoons Walter made for United Artists were budgeted more generously than their Universal forebears. They certainly *look* that way, but the figures don't bear this out. At a total cost of $295,000, the even dozen were made for an average of $25,500, a film, a good $1000 *less* than the average of the season before. The problem, when it arose, was not costs but revenues. There turned out to be a very good reason why United Artists was so happy to have the Walter

Natalie Wood wins a contest for best Woody Woodpecker hairstyle.

Lantz short subjects: They had very few features with half the marquee value of an Andy Panda.

If there was one American movie company in more trouble than Universal in the postwar epoch, it was United Artists. Just when it needed bold, daring moves to reestablish its place in the industry, it was finding petty, insignificant moves difficult. Charlie Chaplin and Mary Pickford, the two surviving founders of the organization and now the two largest stockholders, found no issue too small to disagree over. Some pictures, including Howard Hughes's *The Outlaw* with Jane Russell and Chaplin's own *Monsieur Verdoux*, had generated distasteful controversy in lieu of profits. The movie industry's major financing institutions, Bank of America and Security-First National, made production capital unavailable to United Artists' producers, and the producers refused to deliver their films—with the result that the company almost lost its one unqualified hit of 1948, Howard Hawks's *Red River*. UA President Gradwell Sears wrote a letter to Chaplin and Pickford that minced no words: "Your company is in a most perilous predicament. The company finds itself without credit,

working capital or any guarantee of forthcoming production. Theatre receipts are declining and, in your President's opinion, will continue to do so due to inferior pictures and the competition offered by television. The foreign markets are rapidly depleting and will undoubtedly get worse before they get better." Chaplin and Pickford agreed to sell the company, but of course they couldn't agree on the terms, so the deal fell through.

The Walter Lantz cartoons were nothing to United Artists but baubles to give away to exhibitors to coax them to book features like *The Dead Don't Dream, Just William's Luck, Don't Trust Your Husband,* and *Texas, Brooklyn, and Heaven.* Lantz was supposed to receive percentages of box-office receipts, but the dollar amounts UA attributed to the cartoons were such tiny fragments of the totals generated by the features that they couldn't come close to footing the enormous production bills. The result was that Walter hit the ceiling, that $250,000 maximum he'd agreed on when he transferred from Irving Trust to Bank of America, and, like United Artists, he was fresh out of production capital. But Bank of America's president, Joe Rosenberg, was a friend by now, and bankers were people, and dollar amounts were negotiable where hot properties were concerned. Or so Walter thought.

"They wouldn't do it," he mourns. "No way. I showed them pictures and everything else, but they wouldn't take a chance. Joe said, 'If I were you, I would close down until this loan is reduced. Go to Universal and tell them to reissue your old pictures while you're taking this hiatus. Income will come in, and you'll have capital when you come back.' We had a meeting with Nate Blumberg, and he said, 'That's not a bad idea. You have a lot of impounded money in Europe that we can't get out. Why don't you and Gracie go to Europe, and you can visit all our exchanges, meet the people who have been running your pictures over there, and spend all those marks and lire and francs?' We did that."

This meant heavy layoffs just in time for Christmas. William Garity suggested moving the unpleasant chore into the early weeks of December to ward off heavy holiday spending. Walter knew he'd also be warding off happy holidays, and he didn't like either alternative. But, department by department, the ax had to fall: first the story department, then direction, then the animators, then the assistants, then the background and layout people, then ink and paint. Week by week, the Seward Street studio became a lonelier place. Contractual obligations to United Artists and the erratic cash flow added some fits and starts to this schedule of degeneration.

Ed Love remembers that Walter would "call us in and say, 'Jeez, I'm sorry. I'm having troubles. We're going to close up.' Monday he'd call me: 'Hey, come back to work tomorrow.' So I'd go in, and I'd be there all alone. Then in about a week, Dick Lundy would come in, and slowly the studio would start up, then he'd close it again. And, so help me, Monday he'd call me up and say, 'Come on in, Ed.' This happened about four times."

Finally, *Drooler's Delight* was completed, and the place was empty. Woody Woodpecker had done what Babyface Mouse couldn't, success had done what struggling couldn't, good cartoons had done what mediocre ones couldn't. The Walter Lantz studio was closed.

PART THREE

WALTER, WOODY, AND GRACIE

Watch the Birdie

There was a time when I thought that Walter Lantz might be the godfather of the cartoon industry. It was back in 1953, when Walter called me and said that if I didn't come to work for him, I'd find a woodpecker's head in my bed.

—Michael Maltese

FROM THE NECK TO THE HEEL of the Italian boot, Walter was visiting his ancestral homeland for the first time. Enjoying the royal treatment, being driven from nook to cranny in a limousine with a chauffeur financed by impounded funds, he explored the cultural splendor of Siena, the agrarian rigor of Cosenza. And savored that bizarre sensation of vaguely recognizing everything in sight while seeing it all for the first time.

Italy in 1950 was a mixture of war-torn hemorrhage and Holy Year grace. Ironically, Walter discovered that among the Hershey's bars, Camel cigarettes, and other souvenirs of American occupation, there were no Woody Woodpecker cartoons anywhere in evidence. The venerable motherland was ignoring her own grandchild, the result of years of fascistic restrictions on the flow of imports not yet repealed in the postwar aftermath.

Elsewhere in Europe it had been different. The munificent cash flow from Universal exchanges was equaled at every border by the generosity of customs officials who heard the name Walter Lantz and contented themselves with a fraction of a glance inside their luggage. That way, the cash was able to flow from country to country, spent to the hilt in the appropriate locality, then stuffed away for conversion to dollars in New York. The spending was essential, or the stuffing would exceed the capacity of the pockets. Whether it was the choosing of hotels and restaurants or the selection of entrées on menus, Walter found it a rare treat to be seeking out the least reasonably priced items.

In Italy, the name Walter Lantz was familiar to border guards through films that Woody had nothing to do with—a series of two-minute pro-

motional cartoons for Coca-Cola (which, conversely, were never shown theatrically in the United States). When Walter asked the Italian exchange for $1000 in spending cash, they handed him a suitcase full of money, jammed to the hinges with bills of all colors, denominations, and sizes. With the inflated lire broken down into a hundred different kinds of bills, ranging in size from a foot to two inches long, "You couldn't carry a wallet to handle the money," Walter claims. "There I was going out with my pockets stuffed with money all the time. I may have had only five hundred dollars on me, but I had thousands of lire."

But the firecracker spending spree was suddenly dampened by news of a similar orgy taking place on the other side of the Atlantic. Once again the old familial memories were stirred up, but not in any way that could even vaguely be called pleasant. They were closely related to bad feelings Walter had had just before leaving home, when Gracie had suggested leaving the house in Al's care for the duration of their trip. "Everybody loves Al," she'd argued, when he'd tried to protest. "You're the only one who has any problem with him." "Yeah," Walter had answered, "because I'm always the one getting him out of trouble."

When Walter had helped Al buy a building in New Rochelle and Al had lost it because he didn't pay the taxes on it, it was Walter who had said, "Okay, come on out here." When Al started hitting the bottle again (and it started hitting back), it was Walter who had said okay and financed Al's journey back east. Now that Al's daughters were reaching marrying age, it was Walter who was saying okay and helping them make the transition from boarding school to domestic tranquillity. That was where his mistake was, in saying okay. That's what he'd finally said when Grace pressed the point, and he'd decided to give Al one more chance and ship him out from the east again.

Walter knew something was wrong when he got a call from Al at 3:00 A.M. at the Villa d'Este in Como, Italy, with the urgent news that he'd found a buyer for Walter's car and his house.

"Never mind that," Walter had stammered in the middle of his sleep. "How is everybody? How is Mrs. Kelly? How is Butch?" Mrs. Kelly was the housekeeper. Butch was the dog. They were both fine.

"I can get a thousand dollars for the car!" Al had enthused. Walter's Cadillac was now ten years old.

"No sale."

"I've got a real buy for your house! I can get forty thousand." Walter had paid only $16,000.

"Don't sell the house," Walter had insisted, hoping the edge in his voice was making it across the transatlantic cable. "Just stay where you are." He hadn't yet received the letter from Mrs. Kelly that read, "Mr. Lantz, I'm sorry, but I can't stay here. Your brother is doing things to this house that I just cannot stand."

Evidently it had started the minute Walter and Grace were out the gate: Al had wasted no time in whooping, "Boy, are we going to have a time, Mrs. Kelly! If you think Nero fiddled while Rome burned, you should see what we're going to do!"

After saying okay, Walter had made the mistake of introducing Al to the proprietor of every store in Encino where he had an account and instructing them to cater to his every whim and put it on his tab. First there were flowers sent to Gracie's mother in Worcester every two weeks and signed Walter, Grace, and Al. "This Al must be a fabulous person," she remarked. "He never met me, and he's sent me flowers every couple of weeks." There were long-distance calls to friends all over the country, in the days when you had to go through operators to gain access to a limited number of phone lines. Al's personal style was perfectly suited to winning over people he didn't know, calling them sweetheart like he meant it and getting the priority of his pointless calls boosted beyond endurance. When he'd befriended every phone operator in the greater Encino area, he took to throwing parties for them at the house, where they got the chance to try on any of the furs, shoes, dresses, and negligees that appealed to them.

Unless you happened to be Walter Lantz, it was hard to resist Al's generosity. Butch, Walter's Great Dane, had been carefully trained to stay off all the living room furniture, and he loved Al for getting him sofa-trained again. He also loved going into the studio as Walter's stand-in to amuse Garity, Bob Miller, and the regulars who ran the place through the down time. For Butch, the highlight of Al's stay was probably the party he threw for all of Walter and Grace's intimate friends. Al had gone to several stores until he had found the best and the thickest steaks available. He had sent to Maine for lobsters and had them shipped back live. He proved to all the guests that the lobsters were alive by putting them on the floor and allowing them to mingle socially. The guests thought this was terrifically funny, because by now they had been served some of the finest liquor on the world market. Al prepared the vegetables himself and set a fine table that his previous bosses in the restaurant business would have been proud of. He brought in waiters. Walter's friends later

told him it was one of the grandest parties they'd ever attended. Then, since Walter and Grace weren't there to eat their steaks, Butch got them. Al was irresistible.

But the next phone call Walter got in Italy took things a step too far. It was Bill Garity calling to fill Walter in on the big doings at the Lantz house. Walter suggested Garity get Al a one-way ticket back to New York. Garity followed the suggestion, with the added touch of making sure Al's point of departure was Pasadena, well east of Los Angeles's Union Station, so there was no possibility until he got to Phoenix of his hopping off and taking a cab back. It was up to the Lantzes, when they returned from their travels, to settle the damages, including paying off the various accounts, retraining Butch, and reupholstering the sofa. Walter estimates the total at about $5500, which, he points out, "was a lot of money in those days."

All the same, Walter harbored no grievance. "Al wouldn't have done all these things if he hadn't been drinking," he says. "I did love Al. Everybody liked him. Even the taxi drivers. If he had five dollars and a forty-cent fare, he'd give the taxi driver five dollars. Money meant nothing to him."

Walter thought the episode was over and had recovered from its assorted shocks when he got the urge one evening to sample one of the two hundred or so miniature cordial bottles he'd collected from train trips all over the country and excursions into Canada and Mexico. The collection had originated more than twenty years before and had served more as decoration than as watering hole for most of its existence. But the novelty of imbibing a vintage specimen overcame him, and he uncorked a bottle, raised it to his lips, and made a face that would have given Danny Kaye some competition. He took another bottle off the shelf, uncorked that, and fared no better.

"Gracie, taste one of these," he asked, loath to believe the evidence of his own senses.

Gracie did, and retained her composure. "Walter, this is tea," she replied.

Walter gazed despondently at his expansive collection of travel souvenirs, realizing that every one had been decorked, consumed, refilled with tea, and recorked. Al's misadventures in the Lantz household had found their capper.

■ ■ ■

Walter's European trip wasn't just a vacation. He and Gracie entertained the Universal-International branch manager in each country they visited to help to keep Lantz cartoons at the forefront of attention when matters of publicity and distribution were later decided. Also, while Universal reissued previous pictures and the last receipts from the United Artists contract trickled in, production outlays were nil, and a cash surplus built up that enabled Walter Lantz Productions to eliminate its deficit and operate on its own capital for the rest of its existence.

The building on Seward Street, which had been rented, was purchased outright for $68,000, and Garity's rebuilding efforts were completed for another $120,000. For $28,000, Walter bought the lot across the street, which had eight bungalows on it. He sold the bungalows for ten dollars to a man who came with a truck and hauled them downtown ("I think the termites must have eaten them up before they got to Central Avenue," he remarks), and he had a parking lot for his employees.

By the time Garity was through, Walter had the most up-to-date cartoon studio in town. Animators shared separate rooms with their assistants, and everything was soundproofed with cork floors and acoustic-tiled ceilings. The building was walled with fireproof brick and covered with stucco. The glass in the windows was reinforced by heat-resistant copper screens. The entire place was air-conditioned. Walter's office was papered in beige burlap and paneled with Japanese ash. The directors, the story department, the black-and-white and Technicolor cameras, the background department, the musicians, and the ink and paint people each had a room of their own.

The first job undertaken was a brief Woody Woodpecker sequence in George Pal's feature *Destination Moon*. Walter had been close friends with Pal ever since Pal had left Europe in advance of the war and arrived in Hollywood announcing that his two ambitions in life were to meet Walter Lantz and to continue producing puppet animation. Walter met George and, in return for his admiration, sponsored Mr. and Mrs. Pal's American naturalization, got George into the Cartoon Producers Association, introduced him to people who were able to get his Puppetoon series started at Paramount, and became godfather to his first-born son.

Pal's first foray into feature production, *The Great Rupert*, starring Jimmy Durante, had had a disappointing box-office performance. For his second attempt, he used a script by Robert Heinlein and others, based on Heinlein's novel *Rocket Ship Galileo*. It was a documentarylike approach to science speculation, detailing the first rocket trip to the moon

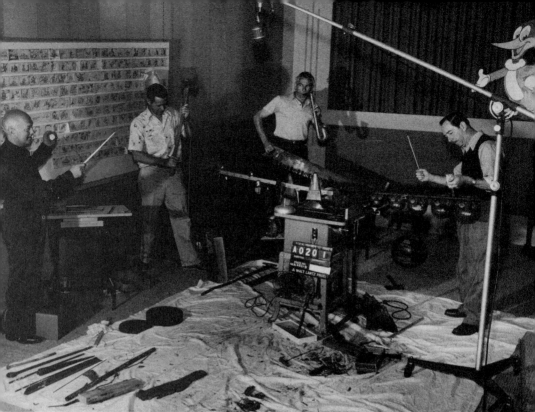

*Walter directs sound effects with Al Glenn, Don Patterson,
and Paul Smith.*

as scientific experts like Heinlein supposed it would occur twenty years
before the actual event. But in 1950 a science fiction film was an odd
duck commercially and travel to the moon was as unreal an idea to the
average viewer as time travel or intergalactic commerce. Pal wanted a
short animated sequence to explain the principles of jet propulsion and,
stunned at the price Walt Disney quoted him, turned to his friend Walter
Lantz for help.

In spite of its educational intent, the little scene Lantz put together is
one of Woody's brighter moments. Pacing around with an umbrella in
one hand, hopping on it and then gesticulating with it, exhibiting all the
dynamism and flexibility he'd developed over the last ten years, Woody
doubts the whole enterprise even as an off-screen narrator explains it to
him. The rocket won't get off the ground, he thinks, because it has no
propellers. "Rockets don't use propellers," he's told, "they have jets." "So
do gas stoves," says Woody, "but they don't fly to the moon." But the

people who wrote the film seem not to have seen the cartoon sequence. The crisis of the final reel is generated by the necessity to jettison a significant tonnage or risk never getting back to earth, yet the cartoon made it very clear that the rocket would have an easier time taking off from the weaker gravity of the moon than it would have getting there.

Destination Moon was released by Eagle-Lion and became their top money-maker of the year, establishing Pal as a successful feature producer. As superstitious as most show people, Pal kept as many of the elements of *Destination Moon* as possible in all his subsequent productions, and that included Woody. From *When Worlds Collide* in 1951 to *The Power* in 1968, he got Woody in every picture somehow. Once in a while a Woodpecker doll or toy is on prominent display, as in *The Time Machine* and *The Power*, and "Sometimes he had to tell me where it was," as Walter confesses. The Lantz luck went to work for somebody besides Lantz. When *Doc Savage* was made in 1975, it was set in the 1930s, before Woody was created, and Grace was given a walk-on role carrying an Andy Panda doll.

But back on the planet Earth there were cartoons to make. Walter renegotiated with Nate Blumberg, who apologized for the headstrong demands his nephew had made and settled equitably with Walter on a new series. The United Artists deal had stipulated that the rights to their twelve cartoons revert to Lantz after their first year of release. Woody was still riding the wave of popularity prompted by his song, and Blumberg indicated that he could use six more cartoons in the next year if they were all Woodys. Walter went to work.

For Woody's voice in the new series and in *Destination Moon,* Walter wanted a little clearer diction than he'd been able to get from Hardaway. Grace is best at telling what happened next: "I'd wanted to do Woody so badly. I'd been doing the voices of crazy characters and all the women, but I wanted to do Woody. I asked Walter about it, and he said, 'Woody's a boy, you can't do Woody.' So I skipped it.

"He was going to audition several voice-over actors, and he had six lined up. But he didn't want to watch them work. He wanted them put on tape, and then he'd listen to them in the studio and select the one he wanted. I got in with his director and said, 'Could I just make a tape, and could you put it in with the others? He may not like it, but let's do it.' So I did the same script. It was put with all the other tapes. When they played them back in the studio, they all went for Number Seven. Well, I was Number Seven."

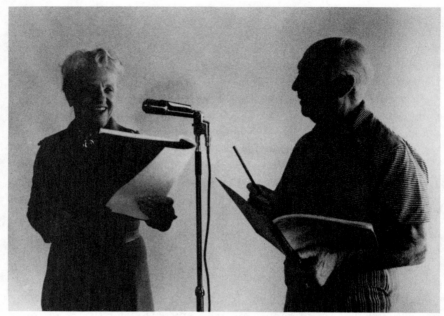

Gracie recording Woody's dialogue.

"When I found out what she had done," claims Walter, "well, you can't print what I said."

So it came to pass: Grace Stafford Lantz became the voice of the bird she'd helped give birth to ten years before, and Walter's cartoons became even more of a family affair than they'd already been. He developed a roster of dependable voice artists—consisting of June Foray, Daws Butler, Dal McKennon, and Paul Frees—and between them and Gracie, there was no character the artists could dream up that couldn't be convincingly voiced. While old hands like Dick Lundy, Fred Moore, and Pat Matthews would not be coming back, and some, like Ed Love and Bugs Hardaway, got out of the animation business altogether, there was a regular supporting cast of characters that Walter could always count on to get the job done. Chief among these were Lowell Elliott, who'd been with the studio since the early thirties as an assistant and was now the studio librarian; Paul Smith, who was animating through most of the forties and was being trained as a director; Les Kline, a familiar face since the thirties; and La Verne Harding, still the sole female animator in the industry. Around a nucleus of people like this, newcomers like Don Patterson, and returning old hands like Alex Lovy and Ray Abrams, Walter developed

the professional family that made him feel most at home when he was at work. And allowed him to function less as godfather than as *padrone*, getting a sense of pride out of his patriarchal supervision of his charges as fully as he did out of the films he was turning out and the profits he was making.

At about the same time, Woody's character underwent the beginnings of a gradual modification. Part of this was Grace's influence. "In the beginning he looked like he'd *really* knock your head off. He was *too* wild," she explains. "Now he's more likable and cuter in the drawing. La Verne modified Woody around the time I took over."

"In 1950 we decided to make Woody shorter and cuter," Walter agrees. "The reason we did that was to make him appear small when he played with human characters. The comic books had a great influence on our changes. They made Woody cuter and more likable, and we thought that was a good characteristic."

Part of the change had to do with a gradual transformation taking place all over the cartoon business as the aggression of the war years settled

Walter with La Verne Harding.

down into the domesticity of the 1950s: Cartoons became less the domain of wild, aggressive comedians and more a home for adorable, wide-eyed types who charmed their way into your heart while they defeated the ogres of the world (who were just as likely to be buffoon pushovers) with an ounce of innocence and a pound of dynamite. Established characters like Bugs Bunny, Tweety Pie, Droopy Dog, and Donald Duck lost some of their fiery temperament. Newcomers, in the manner of Disney's chipmunks Chip 'n' Dale, were small, cute, and, at first glance, helpless: Speedy Gonzales, Casper the Friendly Ghost, and UPA's Gerald McBoing Boing were the new heroes.

The UPA studio itself, set up in 1945, cast a radical change on the look of American cartoons. Influenced by cubist and impressionist painting, its artists created a new image that threw the emphasis on color, abstraction, and design and away from the elaborate, detailed animation of the Disney image. Cartoons everywhere became sleeker, simpler, and saturated with color.

And part of the change in Woody was also due to the inevitable metamorphosis comic characters undergo when they become tremendously popular. Charlie Chaplin, Harpo Marx, and W. C. Fields started life as devilish characters and softened their comic malevolence in the interest of greater audience sympathy. Mickey Mouse became not only less devilish, but more childlike, with larger eyes, a larger head, and expanded forehead. Woody followed roughly the same path over the years, com-

pleting the transition from Walter and Gracie's intruder to Walter and Gracie's child.

Few of these changes were apparent right away, as Walter struggled to get six Woodys together for his first season. The first two, *Puny Express* and *Sleep Happy*, were completed from storyboards left behind by Bugs Hardaway and Heck Allen. Walter rolled up his sleeves and did most of the director's work himself, sometimes animating whole scenes when necessary and managing to keep costs in the $20,000 range. As *Wicket Wacky*, *Slingshot 6⁷/₈*, *The Redwood Sap*, and *Woody Woodpecker Polka* rolled off the assembly line, the increased abstraction, streamlined graphics, and cherubic features became increasingly evident.

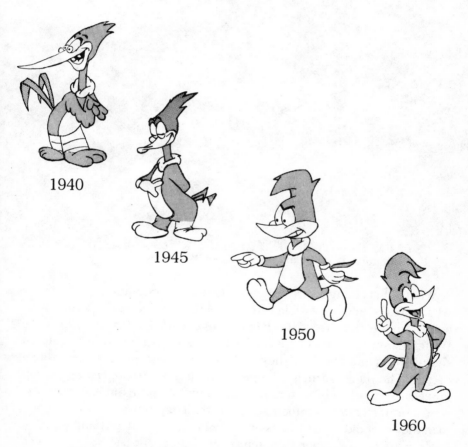

1940

1945

1950

1960

Walter's rendition of the four stages of Woody Woodpecker.

Buzz Buzzard, Wally Walrus, and Woody Woodpecker in Stage Hoax.

What didn't change were the gags, piling up in tumultuous profusion—wild, unlikely, and impossible jokes perfectly suited to Walter's cartoonist temperament. In spite of the more stringent production measures, the Walter Lantz cartoons of the fifties fared even better in the theatrical short-subject market than they had in the previous, more competitive decade. The trade journals *Boxoffice* and *Motion Picture Herald,* which ranked short subjects in terms of profitability and exhibitor response, were putting Lantz's cartoon series in their top ten more consistently than they ever did in the forties, with *Puny Express* in 1951 and *Niagara Fools* in 1957 listed among the top ten individual entries. *Boxoffice* even quoted an Illinois theater owner as saying, "Patrons seem to enjoy the

Woody Woodpecker comedies best of all," and an Arkansas exhibitor as remarking, "*Slingshot 6⅞* had more laughs than any I remember."

Despite all this, Walter's continued warnings to theater owners that the supply of cartoons was limited went largely unheeded. "I would like to make a suggestion to the exhibitors," he told *Boxoffice* in 1951. "In order to give us cartoon producers a well-deserved and long overdue break, how about increasing our revenue just a little? The price of one admission per booking would mean the difference to the cartoon producer between barely breaking even and making a little profit. It wouldn't mean much to the individual house, but multiplied by the number of movie houses around the country would help keep this industry alive."

He sounded the warning again to *Film Daily* in 1956, pointing out that there were only seven animation producers left in the short-subjects business: Disney, MGM, Warner's, UPA, Terrytoons, Paramount, and himself. Within three years, Disney discontinued his short subjects, MGM closed their animation department, and UPA folded, reducing the number to a measly four. Warner's followed suit not long after.

The best Walter could do was take advantage of the shutdowns. When Disney cut back, Walter obtained the services of Homer Brightman, the

Buzz Buzzard.

Homer Brightman sells a story.

man who'd trained Milt Schaffer in the art of making storyboard sketches. Brightman's penchant for acting out his stories in the most explosive way possible became his trademark. Lantz and the rest of his crew sometimes enjoyed Brightman's performance of the story more than the story itself. And sometimes they enjoyed his performance so much it wasn't until later that they realized the story wasn't particularly funny.

Later, Walter got Milt Schaffer himself back for a story or two, including the celebrated *Niagara Fools*. Schaffer also wrote *Bunco Busters*, one of the funniest of Lantz's fifties cartoons, with its deadpan *Dragnet* parody and its tramp steamer in the South Seas depositing miners at the mine fields and Santa Claus at Christmas Island.

Warner's closed down for six months, and Michael Maltese became available. Maltese was one of the cleverest and most imaginative cartoon story men working, having by this time helped originate The Roadrunner

Buzz Buzzard, Woody, and Winnie in Real Gone Woody.

and Coyote series and written such now-famous Chuck Jones pictures as *Duck Amuck, Duck Dodgers in the 24½th Century,* and the Oscar-winning *For Scent-imental Reasons.* He made a bopping teenager out of Woody in *Real Gone Woody,* and fashioned effective cartoons out of conceptions as unlikely as a farm nag falling in love with Pewter the Wonder Horse and corralled into serving as her stunt double, and a flea pursuing his abducted sweetheart by hopping the greyhound on the side of the bus.

"Working for Walter was a delightful experience," Maltese recounted twenty years later. "His studio had something Warner Brothers cartoons never had: a workshop. Complete with power tools, workbench, lots of lumber. Eight months later, I had written eight Woody Woodpeckers and three Chilly Willys, and made four whatnot shelves, three cabinets, one house sign, and a recipe box into which Walter threw his own recipe for linguini with clam sauce, which my wife still makes today."

When MGM retired one production unit, preparatory to shutting down their entire department, Walter took on animators Grant Simmons and Ray Patterson and allowed them to function as a writer-director team for a compelling pair of cartoons called *Broadway Bow Wow's* and *Dig That Dog.* But, more importantly, he took on Simmons and Patterson's old boss: Tex Avery. In the eighteen years since he'd left the Oswald factory,

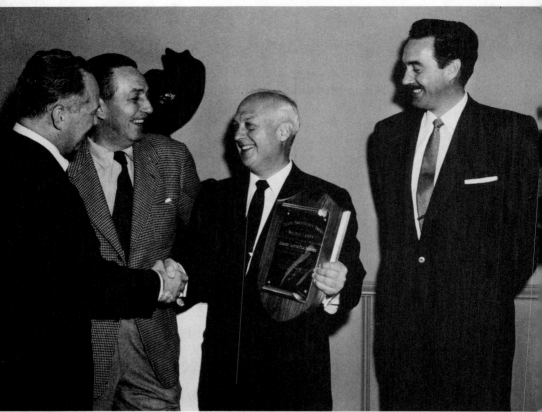

*Walter with George Pal, Walt Disney, and, on right, Steven Bosustow,
at Walter's twenty-fifth anniversary with Universal, 1953.*

Avery had had a major hand in transforming the tone of the American cartoon from the innocence of Donald Duck to the zaniness of Daffy Duck. He'd maintained Walter's penchant for the wild surrealism of twenties animation, even when it had gone out of style in the thirties, and brought it back *into* style in the forties, treating it with a sense of absurdity and a talent for comic timing that was all his own.

Walter had always been a great admirer of Tex's talents and was excited to welcome him back to the fold. He broke a long-standing tradition of settling deals on the basis of a handshake alone and wrote Avery a seven-year contract calling for him to supervise all the animation and the creation of new characters at the studio as well as direct his own series of pictures, in return for which Avery was to receive a percentage of the profits on his cartoons. Tex, after years of working at top-brass-heavy

MGM, appreciated the chance to work in the free and easy atmosphere of the Lantz studio, with no one to answer to but a fellow cartoonist with a similar sense of humor.

"We went a little offbeat with him [Lantz], and he appreciated it," Avery commented later. He dragged out pet gags and story ideas he'd been wanting to use for years. The animators enjoyed the chance to work for him and learn from him. When La Verne Harding handled the yawn of the watchdog in *The Legend of Rockabye Point,* she stretched back the mouth full of teeth about as far as she thought it could go. But when Avery saw the test, he pointed out that in a cartoon the hinge of the jaw didn't have to stop when it was open 180°—there was no reason why it couldn't stretch backward to a 270° angle. "From then on, I remembered," La Verne says: "Just go as far as you can, and then go further." Avery redesigned Walter's penguin Chilly Willy and made him an endearingly glib comic character, a tiny sprite who defeats the behemoths in a style

Tex Avery redesigns Chilly Willy.

at once cute and outrageously funny. He made a pair of Chilly Willys, *Rockabye Point* and *I'm Cold,* and a pair of UPA-style humanoid pictures, *Sh-h-h-h-h* and *The Crazy Mixed-up Pup,* that are among the best cartoons to come out of Lantz's studio and have remained house favorites ever since.

But the situation soon proved far from idyllic. "I think Avery's one of the best directors, creators, story men, layout men, and all-around men in the industry," claims Walter. "But he's such a loner, and such a perfectionist, and he's always worrying that things won't turn out." Walter tried teaming him with Mike Maltese, and, though the two men had worked well together at Warner Bros. in the early 1940s, they were a totally incompatible pair in 1954. Maltese would sketch out a sequence and put it on the board, only to discover two or three days later that all his drawings had been taken down and replaced by Tex's own. "He vacillated. How he suffered!" Maltese commented later. "I complained once to Walter, because I wanted to earn my money there. I complained to Tex, too."

"Another thing that was difficult with Tex was that I wanted him to do Woody Woodpeckers," adds Walter. "He didn't want to do Woody Woodpeckers. Every subject had to be different. Tex gets bored; he doesn't like to stay with one thing too long. That's why I got him to do a couple of Chilly Willys. I said, 'Look, Tex, you've got to be practical; you can't just make a cartoon a one-shot deal. You've got to create characters that people remember, so they have some licensee value. If it weren't for our licensees, we'd be out of business.' "

"Licensee" is the industry term for a cartoon character by-product, of the type that Woody had spawned by the hundreds ever since his infamous song. By now, Walter had Woody Woodpecker games, View-Masters, kerchiefs, masquerade costumes, balloons, comic books, Golden Books, Capitol Records albums, a radio show, and a daily syndicated comic strip that appeared all over the country. The cartoons publicized the merchandise, and the merchandise publicized the cartoons. Licensee income and publicity were part of the reason that Walter was still going, while studios all around him were dropping like flies.

"If Tex Avery had settled on one character and become an independent producer, he'd have been in wonderful shape," Walter insists. "But he is just not geared that way." Heck Allen, Avery's story man for over a decade at MGM, admits this is true: "Tex had no regard for reality whatsoever. He didn't even know how to spell it."

Avery's brilliance was also his undoing. He transferred his worrying from his cartoons to his contract and decided to pull out of the long-range deal and into the quick-buck world of television commercials. Walter claims the move cost Avery a fortune. "He would have been one of the top producers in the business," he says. "But he didn't want to take a chance. He was interested in getting that paycheck every week." As Tex himself put it, "After thirty years of getting a check every week, when I was left out in the cold at Metro, I got a little panicky. You say, 'My gosh, there's no check this week, what are you going to do?' I realized that commercials are the coming thing."

Maltese went back to Warner's shortly after it reopened. "Which is sad," Walter said, "because they [Maltese and Avery] both have a lot of talent in their own way. But if they can't put it together, it doesn't help the producer, does it?"

In the new economics of theatrical cartoons, some kind of regard for reality was essential to survival.

REEL 14

A Peck of Trouble

IN 1955, WALTER HEARD that Al had been sent to a hospital in New Rochelle. He had developed diabetes, and it had gotten serious. Which was more than could be said for Al. While he was laid up, he started tinkering with the hospital television sets, the kind that required a quarter for every half hour of operation. Al didn't always have a quarter and he didn't much care, so he rigged the mechanism so it didn't care either. He let the nurses in on how this was done, and they enjoyed the ruse and became charmed into conspiracy. When the television man came around at the end of the week and found no coins in the machine, Al claimed the set hadn't been on all week and the nurses backed him up. In the act of saving himself some money, he made friends of hospital attendants and roommates alike.

But he'd need to do more than save quarters to pay his staggering medical bills. Once again, it was up to Walter to say okay. He told Al just to mail him the bill and he'd pay it. But somehow, when the bill arrived, it was about double the charge he expected, and the extra fees were attached to a name he'd never seen before. When he called Al about this, he got a cheery and enthusiastic explanation: "This guy is in the bed right next to me. He's a good pal and he's broke, and I thought you'd pick up the tab for him." Walter suggested the pal's tab be sent to the pal's relatives, and that Al stop making so many friends.

But Al's friend-making days were over. He was never to leave the hospital. Shortly before his passing, he assembled his four daughters, who remained devoted to him, and asked if they would comfort him by slipping a bottle of Four Roses under the pillow of his coffin, whether the funeral home approved of such burial rites or not. This they did. To this day, Al remains comforted.

"A great guy," says Walter, remembering his brother with a shake of his head. "I guess I'm the only one who had any problem with him."

Al's four daughters, Norma, Doris, Stella, and Marie, all married and settled comfortably in New Jersey. But Walter found a void in his life

with Al gone. It was filled gradually by the reemergence of an old friend, rather than the introduction of a new one.

Universal called Walter with the idea of putting a cartoon series on NBC to be sponsored by Kellogg's cereals. Norman Gluck, current head of Universal's short-subjects department, released a package of retired theatrical cartoons for television use and asked Walter and Grace to journey to Battle Creek, Michigan, to sign the Kellogg's contract. All the way to Chicago in the air and to Battle Creek on the railroad, the Lantzes were coached by Roy Lang, the account executive for the Burnett Agency who was handling the show for Kellogg's, on the fine points of dealing with cereal people. Battle Creek had been settled generations ago by religious zealots who saw the eating of cereal as an integral part of living the pure life. Their descendants saw the manufacture of grain breakfast food as something more than an occupation. It wouldn't do, Lang said, to make light of their life's work. "Walter and Gracie, you're not in Hollywood," he reminded them. "No wisecracks. The men you're going to meet are very sedate gentlemen. It's always Mister, Miss, or Missus, when you're talking to anybody at Kellogg's."

Grace was not impressed. "Roy," she boasted, "I'll bet you a dime that I will have them calling me Gracie."

Lang was as charmed by the elfin pair as anybody, but he'd spent years dealing with the Kellogg's mentality and knew better. "You've got a deal," he announced.

The train was met by three somber elder statesmen in homburgs and Bonwit Teller coats with velvet collars, approaching the travelers in stately, measured paces. Grace took one look at the procession and blurted, "Well, if it isn't Snap, Crackle, and Pop!" Almost literally, it broke the ice. Three gray, stone faces thawed in the Michigan cold and broke into smiles, laughter, and salutations like "Hiya, Walter!" and "Hiya, Gracie!" And one account executive's face went purple in dismay. Whatever he had expected, he was not ready to be proved wrong in a matter of seconds. Even Walter had to admit to a certain shock. "I thought their hats would pop off," he says, smiling, "three at once, like in a cartoon."

But it's no mystery to Grace where this kind of nonsense came from. "It's Woody," she claims. "I was never like that. I had a lot of dignity as a serious actress. But I've been doing the voice, and the character gets into you. You even start to think like a woodpecker."

"With a head full of nuts and bolts," Walter says, when she starts talking like that, but he agrees that the spirit of Woody had started to follow him everywhere. The notorious woodpecker was no longer a char-

March 7, 1964

Dear Walt Disney,

I watch Woodywood Pecker every week and see you on it. I like it very much and so do my younger sisters. Would you please send me a picture of you and some of the characters. Thank - you very much. Well, I guess I'll go and watch Bugs Bunny.

From one of your t.v. fans,
Wendy

April 6, 1964

Dear Wendy -

Even though Donald Duck, Mickey Mouse, Pluto Ludwig VonDrake and the rest of our characters aren't related to Woody Woodpecker, I'm glad to know you like him because he belongs to my good friend Walter Lantz. And I know Mr. Lantz will appreciate knowing you are a fan of Woody Woodpecker.

I am enclosing the autographed picture of me and a couple of my friends which you asked forand I'm sending your note on to Woody Woodpecker. Perhaps you will get a picture from him, too.

Many thanks for your letter...and all best wishes.

Sincerely,

WALT DISNEY

April 6, 1964

Dear Walter -

As you can see by the enclosed. . . . I get
blamed for everything that happens in
Hollywood!

However, this time it's obvious this little
girl has her Walters crossed -- although
I don't know how the hell Bugs Bunny got in
the act.

All best -

Mr. Walter Lantz
Walter Lantz Productions Inc
861 Seward
Hollywood, California

WD:tw

Walter Lantz
PRODUCTIONS, INC.

8 APRIL 1964

DEAR WENDY:

WALT DISNEY, A PERSONAL FRIEND OF MINE,
SENT ME YOUR LETTER REQUESTING A PHOTO
OF WOODY.

IT'S NICE TO KNOW THAT YOU LIKE WOODY
WOODPECKER AND YOU ARE ENJOYING OUR TELEVIS-
ION SHOW.

SINCERELY,

Walter Lantz

acter he encountered only in the studio or only on the radio; he had become an insidious presence, creeping into every facet of Walter's waking, and some of his sleeping, hours. Not that Walter minded. After fifty years of Al, he was getting used to it.

■ ■ ■

With each theatrical cartoon fighting recalcitrant exhibitors for the right to earn back its production cost, and with *The Woody Woodpecker Show* soon earning the highest Nielsen ratings of any program in daytime television (higher also than 60 percent of the prime-time shows), it wasn't hard to see which way the winds were blowing on Seward Street. "Believe me, TV has given us a new lease on life," Walter told a reporter, "even though we still make cartoons for movies. A couple of years ago I was ready to chuck the whole thing and go into retirement. But that little home theater box has kept Woody alive and pecking."

As layoffs at the Disney studio continued apace, director and sometime painter Jack Hannah entered the job market, and through the ministrations of mutual friend Clyde Geronimi, found his way to Walter Lantz. Since Walter himself was dabbling increasingly in the fine arts, the two spent a lot of time trading insights, with Hannah sometimes laying an animation cel over one of Lantz's paintings to demonstrate suggested alterations without having to make them permanent.

When Sid Marcus came to the studio as a director in the mid-sixties, Lantz was reaching about as far back into animation history as it was possible to go. Marcus was, like Walter, a New York silent cartoon veteran, erstwhile cohort of people like Charles Bowers, George Stallings, and Burt Gillett, and had animated for Lantz on the Universal lot in the 1930s. In spite of his fifty-year history, he was able to infuse the action in his pictures with a hip, contemporary looseness that looked avant-garde and funny at the same time, particularly in *Pesty Guest, Half-Baked Alaska*, and—one of Walter's personal favorites of all his cartoons—*Three Little Woodpeckers*.

After his directorial stint was over, Marcus continued to submit stories to the studio on a free-lance basis right up until it closed. The funniest of the Marcus-directed pictures—and probably the funniest theatrical cartoons being made in the sixties and early seventies—were written by another free-lancer, and another prodigal son returned, the prodigious Cal Howard. Since the thirties, Howard had been involved with other cartoon studios, a few radio shows, and that infamous new medium,

television. Burned out by so much success, he had come home to his original métier, and for ten years he sold Walter storyboards he'd drawn up at home. So from decade to decade, from boom economy to bust economy, from the Chaplin craze to Beatlemania, the impossible held forth in the cartoons of Walter Lantz and survived the ins and outs of cartoon fashions.

As Woody's character achieved its progressive takeover of Grace's personality, she began to gain an intuitive understanding of the character and was able to contribute Woody material in story sessions. The fact that Walter's biggest star was voiced by Walter's wife was a well-kept secret for many years. Grace felt it would only be a disillusioning expe-

Gracie recording Woody's voice.

rience for Woody's faithful fans to learn that the vocalizing was done not only by a woman, not only by a woman of middle age who was still aging, but by *the producer's wife,* and she wouldn't allow her voice credit to appear on the cartoons.

But on a late-fifties return trip to Europe, as Walter and Grace were descending in one of those European open, grilled elevators in the George V Hotel, Walter suggested that Grace just do the bird's laugh, as long as they were in a cage. It was good for a smirk all around. But it's hard to keep a secret in a European elevator, and when they got to the lobby, there was a general hubbub that sounded vaguely like a recurrent refrain of "Pick your pocket, pick your pocket." People were repeating the word "Piko," Woody's *nom de plume* in France, and those who could speak English were remarking, "We heard Woody Woodpecker." Walter and Grace feigned innocence, agreeing that Woody Woodpecker had been in the elevator but seemed to have flown the coop. It didn't get them off the hook. They were pressured into explanations and encores, and giggles and grins greeted every outburst of that old standby laugh. When the Lantzes left that lobby, they left them laughing.

"There were adults, as well as bellboys, enjoying that laugh," Walter ventured to Grace, as soon as he got the chance. "That ought to show you that people like the idea of you doing Woody's voice."

The two gave interviews in Paris and then Italy and Germany, and everywhere they went, the revelation added a new spark to their story. Walter's point was made. The credit went on the films, and the laugh erupted at every possible opportunity. "The ham in her came out," Walter comments. "From then on, I couldn't make her name big enough on the screen."

■　■　■

The helicopter skirted low over the Southeast Asian jungle, shaving the treetops in its search for the ground.

"Why so low?" wondered Walter and Grace, the chopper's only passengers.

"We're getting near the DMZ," the pilot responded. "They're liable to be taking potshots at us. I better stay below the radar range."

It was 1969, and the Lantzes had volunteered for a USO tour of every hospital in the United States Pacific command. Besides Vietnam, this took in Guam, Okinawa, Korea, the Philippines, Japan, and a number of

*Walter and Gracie depart from Anchorage, Alaska,
for the USO Hospital Handshake Tour.*

Walter and Gracie on USO tour, Okinawa, 1969.

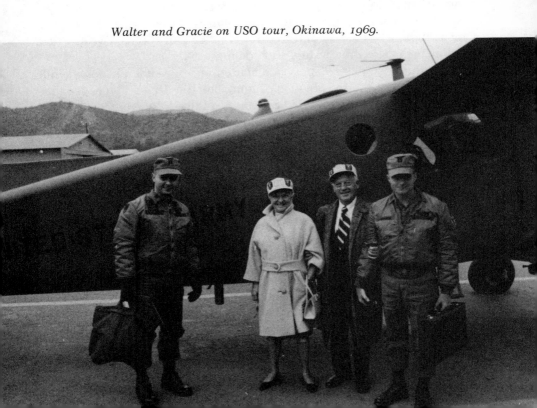

other scattered outposts. They sat at the bedsides of men who hadn't seen an American without a uniform for months.

Walter drew Woody over and over, sometimes upside down on a chest cast for the exclusive amusement of its occupant. Grace bolstered the drawings with the old laugh, her favorite calling card and by now a bearer of fond childhood memories for men afflicted with jungle fever. Sometimes Woody's voice was done over long-distance phone for kids at home, sometimes into tape recorders for instant replay, and once, by special request, for a 3:00 A.M. wakeup call, crowing, "Everybody off your bedpans!" They started at 9:00 every morning and went until 10:00 every night. They flew 30,000 miles and visited twenty-seven hospitals in thirty-one days. They shook thousands of hands, Walter drew thousands of Woodpeckers, and Gracie did thousands of laughs.

They met with staff children, showed them cartoons, and made drawings for them of Woody, Andy, Chilly Willy, or whomever they requested. They met the wounded and the maimed. A veteran with one arm and no legs presented them with a handsome belt he'd strung together himself from loops of leather.

"How did you do that?" they asked.

He answered, "With one hand and my teeth."

"I feel sorry for people who haven't had this experience," Walter commented later. In spite of the pain and misery he and Gracie encountered, watching so many smiles brighten up so many faces turned out to be an inspiration, and they volunteered for another tour the next year. Bread was being cast on the waters and coming back toasted.

But the next year's experience started off on a different foot. While undergoing the routine physical examination the Armed Forces required before starting, Grace was told there was a lump in one breast. A biopsy confirmed everybody's worst fear. The breast would have to be removed.

Walter and Grace sat despondently in the doctor's office and stared at each other. This sort of thing was enough to put a strain on Ed Boyle's idea that everything can be a joy. But it didn't alter Ernest Holmes's philosophy that bad news could be underplayed until it started looking good.

"When do you want to do it, Doctor?" Grace spoke up. "Tomorrow?"

Walter brightened immediately. "Yeah, Gracie, that's a good idea," he responded. "Let's take care of this thing as soon as possible."

She submitted to surgery near Thanksgiving without wasting any time, but the worst wasn't over yet. In operating on the first breast, it became

Walter drawing Woody for a patient in a veterans' hospital.

apparent that the remaining one would have to be removed too. Grace zeroed in on the day after Christmas. There was no sense in dragging it out.

"It's amazing how Gracie took this," Walter exclaims. "We had a small dinner the day before Christmas, just a few friends. She didn't make any mention that she was going into the hospital. She was just carrying on as usual. She doesn't try to hide the fact that she had this. In fact, she likes to talk about it. I know of many instances where she has heard of a woman who was depressed because she was going to have a mastectomy, and, whether Gracie knows her or not, she'll get on the phone and talk to her."

"The most damage is done from fear," Grace says. "I've had good luck visiting a few women in the hospital who were frightened, because if they see someone who's just been through it, this optimism helps. It leads them into a little more positive thought. I say, 'If you'll just accept it, we go from here now. . . .' "

Accepting it, that was the key. There had been that Las Vegas excursion years ago, when Walter returned from the golf links to find a stack of messages from Bill Garity: "Call the office." "Call home." "Call the office." . . . Walter called. Garity didn't waste any words. "I've got some sad news for you," he announced right away. "There's a big fire in Bel Air. It's still burning. Your home was one of the first to go."

The words, emerging from the tiny earpiece of the telephone, seemed to come from some other dimension. The news was too stunning to be absorbed. "You mean there's nothing left?" Walter stammered, trying to get a fix on reality again. "All my paintings and. . . ." There were more than fifty of his oil paintings he was readying for an exhibition, and somehow that was his first thought. Garity assured him that the paintings were at the forefront of their attention when he and his assistant Al Glenn had heard about the fire and raced up to the house to see if anything was salvageable. One look at that inferno, one blast of that heat, and it was obvious that the limit of what was salvageable stopped at their own lives. Destruction had occurred long before they arrived, and the important thing was to leave ahead of the flames.

Walter and Grace switched on the nearest radio and picked up the Las Vegas broadcast of the tragedy. "The first two homes to go in the Bel Air fire," the announcer intoned, "belonged to Walter Lantz and George Pal." Now it was official, whether it had sunk in or not.

What could you say, besides *Morto ogni notte*? "Gracie, there's nothing

Fire destroyed the Lantz Bel Air home in 1962.

we can do," Walter offered. "Let's go have a good Italian dinner and a bottle of champagne and drive home." Which they did. When mourning won't get you anywhere, it's time to celebrate.

The studio, too, served up its share of grief, and not grieving about it was threatening to become a full-time job. When the Lantzes make personal appearances as they did on the USO tour, a question that's asked with disturbing regularity is why the cartoons that are made for television today aren't as good as the ones that were made for theaters years ago. Walter inevitably has to dampen the frolicsome spirit of the festivities to explain that even the realm of cartoon fantasy is afflicted with a bad case of economic reality. Year after year, he's had to watch production costs rise while revenues dwindle.

When it was no longer possible to make cartoons for $20,000, Walter made them for $30,000, then $40,000. Nothing climbed faster than labor costs for the talented animators and the skilled cel inkers and painters. "These people, in my opinion, are worth every penny of it and even more," Lantz asserts. "But if we could only get the money back at the box office. . . . A loaf of bread has gone up from a nickel to a dollar, and a theater ticker has gone up from thirty-five cents to six dollars, but the exhibitor still wants the cartoon today for the same price he was paying sixty years ago."

After 1957, profits from the TV show financed the theatrical cartoons, giving Walter sorely needed operating capital, helping to keep him afloat while others foundered and allowing the theatricals to look forward to a profitable retirement. When Walter had split from Universal in 1935 and established financial independence in 1940, he was bucking the industry trend. Between 1935 and 1945, Harman-Ising Productions became the MGM Cartoon Department, Paramount Pictures swallowed up the Fleischer studio, and Leon Schlesinger sold out to Warner Bros. Theatrical cartoons had become the domain of major studios rather than small, independent operations. When the budget squeeze hit the majors, it was easiest for them simply to discontinue cartoons and concentrate on the big money in feature films. If Walter Lantz Productions discontinued cartoons, it would go out of business.

So Walter kept finding ways to keep the wheels turning. "I produced cartoons at a lower budget than the major studios," he explains, "because our overhead was much lower. I knew every phase of the business; I watched things very closely. Every time I took a walk through the studio, I could save fifty dollars. And I had a wonderful staff. They turned out

A rare gathering of pioneer animators finds Walter Lantz at Expo '67 in Montreal with, on left, Dave Fleischer (Popeye) and Paul Terry (Terrytoons) and, on right, John R. Bray (Col. Heeza Liar) and Otto Messmer (Felix the Cat).

more work than they usually did at the big studios. We cooperated with each other very closely. We tried to produce pictures that were in one locale. By doing that, we didn't have to make so many backgrounds. You can save a lot by writing the score using eight men instead of sixteen men. I cut down on the number of drawings: I got my animators together and said, 'I can't afford to animate the way we used to, and we can't go into limited animation, so let's get in between.' We hit a happy medium where we could afford to make pictures. I started cutting down on the footage: I was the first producer to make the five-hundred-foot picture;

we all used to make them seven hundred or eight hundred feet. I'd say to the story man, 'Cal, this is a wonderful routine, but I'll show you how to cut two thousand dollars off it by simplifying it.' I used to tell the girl in ink and paint, 'Donna, only four colors on this character. Never mind putting a little shading under the sleeve. It isn't going to make the scene any funnier. Paint the collar the same color as the shirt.' "

In the old days, a cartoon could recoup its investment in its first year of release. In 1977, Walter Lantz Productions had not yet fully recouped the production costs of its 1960 cartoons. The business became so treacherous there were soon only three of the old studios left: Besides Lantz Productions, Terrytoons and Paramount's Famous Studios remained in operation in the late sixties, and both were in New York. New animation shops were small, sporadic in output, and dependent for survival on television production (which Walter never wished to resort to). MGM distributed new cartoons made by Chuck Jones's Tower 12 studio, Warner Bros. put out pictures produced by Filmation and the Warner's spinoff studio DePatie-Freleng, and United Artists released DePatie-Freleng's Pink Panther cartoons. As animation limped into the seventies, Lantz bucked another trend and survived as the last of the old-timers.

In 1972 Walter closed his doors for the last time. It no longer made any sense to fight the battles. "I won't live long enough to get my money back," he remarked. A farewell luncheon was held at the Lakeside Golf Club to commemorate the event, and some of the studio staffers who attended were veterans of forty years' service for their *padrone*. It was the end of an era in the history of the American film. Forty years after Lou Brock's finger of accusation was pointed at the exhibitor for the demise of the two-reel comedy, his words proved prophetic for the one-reel cartoon that had supplanted it: theater owners had managed to kill another golden goose.

"We didn't stop producing cartoons because their popularity died out," Walter insists. "It was because we could not afford to make them. It's too bad that we all had to discontinue that wonderful medium. Even now, when I go to the theater and see a cartoon, it's a reissued cartoon that was made years ago, and the audience applauds when the title comes on. They applaud my cartoons, they applaud Disney's, Warner Brothers', or MGM's. The audience still loves cartoons."

The censors, too, had done their part to put the final nails in the coffin of the art. In the thirties and forties, outhouse jokes and sexual innuendo were the biggest targets of Hollywood's Hays Office. Walter told an interviewer in 1971, "You see women on the screen today with their breasts hanging out, and we couldn't even show the udders on a cow!" Minority groups complained about racial caricatures to the point where Walter found it easiest to stick to animal characters: the woodpeckers, penguins, and buzzards never objected. In the early seventies, PTA groups lobbied in Washington for further cuts in cartoon slapstick "violence," resulting in the elimination by NBC of any scenes involving the firing of a gun or the connection of a mallet with a head.

Though Walter's pictures individually received less condemnation than comparable series like The Roadrunner and Tom and Jerry, he still finds the thinking at work shortsighted and misinformed. "These silly rules really cramped our style," he protests. "I never showed a character being hurt badly or bleeding, or killed. The situations feature danger and suspense, but the violence is exaggerated to the degree that it's silly, and children laugh instead of feeling afraid. You do that by adding one wild, unreal visual gag after another. All children rebel, at times, because they're always under an adult's thumb and need some moments of freedom. To them, Woody, is a character with real blood in his veins. The youngsters know that they're not going to peck down a bunch of telephone

Showing a cow's udders during milking: what the Hays Office wouldn't allow our youth to see.

THOU SHALT NOT MR. WOODPECKER

THOU SHALT NOT—kiss a gal. Censors will permit Woody to kiss another bird or animal, but not a human being.

poles like Woody, but they *do* find him a good outlet for their own aggressions."

Walter was considerably happier when the network contract expired recently and his cartoons were put into syndication, sold to independent stations on a market-by-market basis. The individual stations have no guidelines as severe as those of the networks, and the cartoons are now shown exactly as they first appeared in theaters.

Is there any pernicious effect to be had in the exposure of children to explosive slapstick comedy? There has been much controversy over and little resolution to the question, but Walter's voice is joined by many, both within the industry and without, who find the cure more objectionable than the presumed sickness. Among the most strenuous objections is one voiced by writer and animation enthusiast Franklin Rosemont, who points out, "A special study should be made sometime of the particularly disgusting variety of hypocrite who, having no objection to nuclear weapons or to imperialist oppression, reserves his self-righteous

Woody's air-conditioned house.

wrath for cartoonists and others whose imaginary violence never hurt anyone but is supposed to be such a 'bad influence' on children. . . . They are against violence only when it is liberating . . . not because it is violent, but because its violence is in the service of freedom and the marvelous."

Woody at his most ferocious is a creature of the aggressive, irreverent id, and there's a lot of evidence that physical action of the type he indulges in acts more as a safety valve for violent tendencies than as an incitement to genuine destruction. The id will find its outlet somewhere, and if it's not in vicarious form through catharsis, then it will be in other forms— the kind Walter and Grace observed firsthand in Southeast Asia.

While the Lantzes were there, they visited a general's quarters one afternoon and found his kids watching the openly violent animated action-adventure shows that other producers have made for TV.

"Why," Walter wondered, "were they being allowed to watch *this*? Do they want them to grow up and start another war?"

When Grace caught sight of a red telephone in the quarters and was told it was a hot line to the White House, she seriously considered picking it up and crowing to Washington in Woody's voice, "HaHaHaHAAHa— how come our kids aren't watching good cartoons, instead of junk?" But she resisted the idea. It was one of those times when Woody would have had the nerve.

REEL 15

International Woodpecker

DAWN HITS the Sierra peaks surrounding Silver Lake with a smoldering red glow long before it gets around to brightening the sky or shedding light on the cozy cabins ringing the water. The red-crested peaks tower over tranquil shores and sleepy denizens as a call to action sooner than any action is really visible.

Among the first movement you'll spot on a summer's morning is Walter

One of Walter's Happy Art paintings.

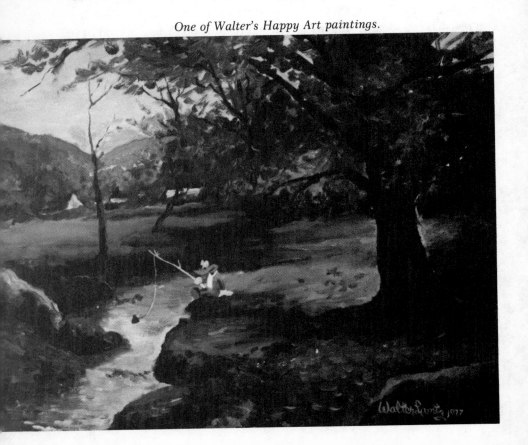

The Lantz home at Silver Lake in the High Sierra.

Lantz, the inhabitant of one of those lakeside cottages, boarding his little skiff with rod and reel and venturing out on the still waters. If you happen to be lucky enough to be in the boat with him, he'll quietly and patiently demonstrate for you the proper method of baiting the hook and dropping the line.

Walter's quiet and patience at six in the morning create a special mood. At other hours of the day, his excitement and eagerness to please sometimes get the best of him, crowding his syllables on top of one another and occasionally confusing their order. But in the dawn quiet of his restful mountain retreat, as he shares with you the sequential steps of a process he's come to know quite intimately, peace reigns. One step follows another, cause produces effect, and all's right with the world.

That's probably the source of that mysterious link between cars and cartoons. The workings of each is an intimate process that can bring

satisfaction, not only in the mastering, but in the performance for others and in the bond it can create between people who share its knowledge. And it's people, as Walter's good friend and neighbor on the lake Frank Capra will tell you, that made Walter what he really is. "His true character comes out when he's with people," Capra explains. "He and his wife are garrulous, and they make friends quickly with anybody—anybody!"

Grace continues to serve as Walter's inspiration and the handiest way for him to mix business with pleasure. For interviews and publicity junkets, she makes the ideal second banana and boon companion (as well as, she persistently points out, "the best write-off he ever had"). She'll cover the world with him just as she covered the eastern seaboard with her father. She'll puncture whatever dignity he manages to assume and draw more crowds with Woody's laugh than he could ever do with a pencil. "They don't want to know how to draw Woody Woodpecker," Walter remarks. "They want to know who the voice is and hear her do it. I like to tell people I've got a gray-haired Woodpecker in the family."

It's a good thing they both believe that anything worth observing is worth laughing at, or one of them would have obliterated the other by now. Grace has a habit of moving so quickly and so energetically that her feet get ahead of her eyes and she tumbles into pratfalls every time Walter's back is turned. This strange custom first came to his attention as they were changing planes at the Toronto airport en route to the Animation Retrospective at Expo '67 in Montreal. She had herself decked out in a new suit and a grand new hat and stood in line with everybody else while Walter strolled to the window to observe the activity on the field. Another passenger carefully deposited his briefcase on the floor behind Grace. One false move and she was flat on her back on the floor with her magnificent hat over her face and the crowd was roaring with laughter. Walter turned to see what the hilarity was about and discovered his wife making a spectacle of herself. "Gracie, what the heck are you doing on the floor?" he asked, sending the crowd into further hysterics.

Years later, swabbing the deck of the good ship *Woody Woodpecker* while it was docked in the marina, Grace went straight with the mop into the water and, in over her head without any swimming ability at hand, she underwent a complicated series of maneuvers to reach the surface, find the ladder, and avoid being smashed in the narrow corridor between the boat and its dock. Walter emerged from the galley to find Gracie soaking wet and grasping the dock's ladder for dear life. "What the heck are you doing in the water with your clothes on?" he wanted to know.

Walter at eighty-four and Gracie at eighty,
still going strong with Woody.

"It's a line with him," Gracie sighs. It was up to the occupants of neighboring crafts to comfort her by telling her, "Now you're one of us. We've *all* fallen off the deck."

But there are no surprises here in the fishing boat, as the morning light bounces from the sky to the lake and Walter trails his catch on a line behind him, chugging along at a steady pace with his baited hook still in the water. Sometimes he starts the day with a row around the lake, rod propped in the rear of the boat, dragging the bait behind it, and there's fish for breakfast.

In the Silver Lake area, the Little League baseball field in the nearby town of Lee Vining was cleared and consecrated partly through Walter's efforts, and its bleachers were a personal gift to the team. The diamond was finally dubbed Walter Lantz Field, proclaimed by a billboard with a painting of Woody at the entrance. Walter drew the billboard, and, when

Walter's Little League field at Lee Vining, California.

Tom Selleck (standing, fifth from right) was a member of the Sherman Oaks Woody Woodpecker Little League baseball team.

he didn't like any of the prices he was quoted for painting it, he got up on a ladder and painted it himself. The season hasn't begun until he's on hand to throw out the first ball.

Though he has made no secret of his USO tour in Southeast Asia, Walter declines to trade on the publicity value of the work he's done and the talents he's contributed to Red Cross blood drives, fire-prevention campaigns, Little League ball clubs, soapbox derbies, museums, universities, public television stations, and local arts festivals. The Walter Lantz Youth Award was given to promising sculptors annually for several

Walter and Michael: The Lantz artists work in tandem.

years by the National Sculpture Society (of which his brother Michael was president).

Walter has also served as judge and advisor to the Los Angeles Special Olympics for the last few years, encouraging paraplegics and the wheelchair-bound to test their limits. The Lantzes' attitude toward the amount of time they spend with the suffering was summed up by Grace when she told *Military Life* magazine, "You look into people's eyes and you don't think of or see their wounds. They are glad to see you; you just love them for what they have done." The Lantzes never pretended they were healing the sick—just taking the minds of the sick off their sickness, which has its own therapeutic value.

In the early 1970s the Lantzes became active in the Armed Services' Hospital Entertainment Liaison Program for veterans, restricting their hospital touring to the American Southwest, but extending their veterans'

Michael Lantz's famous equestrian statues in Washington, D.C.

experience as far back as World War I. Grace remembers being introduced to a ninety-year-old veteran in a wheelchair whose ears were no longer in peak form. He was told that he was meeting the voice of Woody Woodpecker and answered, "Huh?"

"I'm the voice of Woody Woodpecker!" Grace yelled.

A broad smile and a slow nod encompassed the old soldier's face. "So you're Mel Blanc," he beamed.

When they met General Omar Bradley, Grace soon got herself on kissing terms with him, piping up, in Woody's voice, "I've never kissed a general before."

Bradley piped back, "And I've never kissed a woodpecker before."

Walter claims that he was always able to avoid taking things too seriously, even when he was commandeering a department of one hundred twenty people or struggling to keep his independent outfit afloat. "You

Walter entertains the Special Olympics' handicapped children each year in Los Angeles.

can really help yourself by not letting stress get inside you," he says. "The people who let stress get to them are the ones who worry so much about the little things. When you're busy and interested in what you're doing, it just seems to pour out naturally, you don't think of stress. It's not ego, either, it's just that you love what you're doing and feel good about it." Capra agrees, and chimes in, "Lucky is the man who has work that he loves."

It's possible that all the talk of Walter's luck boils down to nothing more than that: He's always loved the work he's done, and it's been returning interest, rather than exacting a price. Walter Lantz Productions hasn't made a film in over ten years, but it continues to keep Walter busy and to produce a substantial income from television and licensing. Woody and his minions are seen on little boxes all over the world, claiming new audiences with every generation.

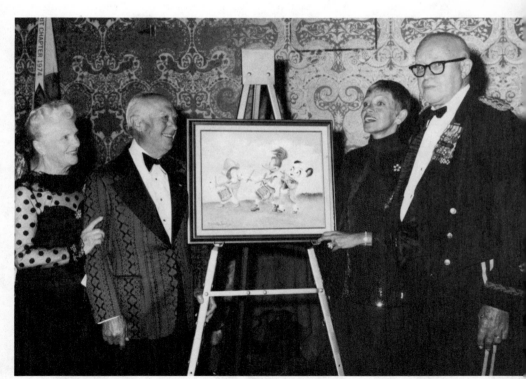

Walter presents a bicentennial painting to General Omar N. Bradley and his wife, Kitty, Army Ball, 1976.

The licensing business, too, is international in scope. As Walter has explained, it's kept him going for years. It's a sweet deal for both the studio and the manufacturer of a product: The studio gets an income for doing little more than approving the product, supplying artwork, and keeping its eye on the quality control; and the maker of a toy or game, by using an established character, saves the million dollars it could take to establish an image in the public's mind. In the early 1930s, when Ed Wadewitz of Western Publishing first approached Walter with the idea of being the sole publisher of his characters' comic books, the licensee merchandising was a minor offshoot of the burgeoning major industry of animation. At their peak, the Western comic books (distributed by Dell) were good for 1,400,000 copies every month. Today, MCA-Universal manages Lantz's licensee dealings in the United States, Canada, South America, Europe, Africa, the Middle East, and Japan. Japan, in fact, puts Woody on everything from kimonos to T-shirts to erasers to kites, and Woody has his own theme park there. In the Spanish-speaking countries,

Woody comic books are distributed in over a hundred countries.

Woody's park in Japan.

where he is called El Pajaro Loco (or just "The Crazy Bird"), and in Sweden, where his name is Hacke Hackspett, the proliferation of storybooks, comic magazines, coloring books, and other paraphernalia is astonishing. In the early 1980s, an El Pajaro Loco commercial was produced for a Mexican popcorn called Palomitas. The food company hoped identification with Woody would help boost sales of its lowest-selling item, which was also the lowest-selling brand of popcorn in Mexico. The day after the ad hit the airwaves, the racks were cleared of Palomitas all over the country. The manufacturers were in no way prepared for the demand they had instantly created, and couldn't even gear up production sufficiently to meet it. Today, licensing is the major business, and animation only its crippled subsidiary.

But Walter's bread was coming back toasted ("with butter on it," he likes to add). The whole of Silver Lake looks buttered as the golden sunlight starts peeking over the mountain rim and reflecting off the unruffled surface of the water, while Walter reflects on the haywire course of events that earned him his sanguine mountain refuge. With nothing

but pencil, paper, film, and imagination, he whipped up a fortune.

As if the success of his studio weren't enough, Walter found a whole new avenue of opportunity in a completely unexpected direction. When production of new cartoons ceased in 1972, he had thoughts of turning more of his attention to painting. Most of what he'd learned about painting since his days in Art Students League had come from background artists like Willy Pogany, Ed Kiechle, and Fred Brunish, and fellow painter Jack Hannah. Then he had discovered the famous landscape artist Robert Wood living right there in Bishop, just a few miles from his Silver Lake cabin, and he explored the art of landscapes and seascapes while working side by side with Wood on Thursday afternoons.

For a long time, the thought of selling paintings was a stranger to him. He claims, "I painted for myself and my friends, and the ones I didn't like I threw away." Then a junk dealer with a nose for oils showed up from Rochester, Pennsylvania, wanting to see some of Walter Lantz's paintings and possibly add a few to his private collection. He selected twelve that appealed to him and asked Walter to name a price. Lantz suggested $3000. Marino wrote a check for $5000 and told him it was robbery. "You're underselling yourself," he assured him.

So Walter had a show at the Los Angeles MacKenzie Gallery. To get it, he had to agree to pay for the champagne cocktail party, a month's rent on the hall, and the brochures that would be sent out. This he did, and the crowd that showed up was largely personal friends. But the instant the gallery doors opened, two of the pieces were already marked "Sold." Walter couldn't find out to whom; MacKenzie just attributed the sales to an "anonymous buyer." The show turned out to be a sellout, collecting $37,000 for thirty-three paintings. And the anonymous buyer turned out to be Grace, scared to death the show would be a bomb and determined to see to it that something was bought.

Walter had more shows. Then he met Joyce Grimes, who ran a gallery in the Hyatt Regency Hotel in downtown Los Angeles, and she was enthusiastic about getting more of his work exhibited. The asking prices crawled upward. At Joyce's suggestion, Walter stuck Woody in a couple of the paintings and found that they were snatched up before anything else in the show. She asked for more just to hang in the gallery, and they were sold as quickly as they were displayed. Prices continued to climb.

Bernie Schanz, a representative from a gallery in Honolulu, asked if he could have one or two of the Woodys for his place. They sold. Schanz became manager of Honolulu's Center Gallery, and Bill Mett, owner of

Robert Wood.

the gallery, asked Walter for as many Woody Woodpecker creations as he could whip up.

Walter decided if his artwork was going to become a steady line, it should have a name; he registered "Happy Art" as a trademark. Now Woody cavorts in beach scenes, desert scenes, cloudscapes, and parodies of famous works of art, much as Dinky Doodle pranced sketchily around the familiar objects of the everyday world as if he belonged there. Some of the Happy Art works are made into oilgraphs: photographed, mounted on plywood, and touched up in oil, then varnished and sold in a limited run. From time to time, one of the pieces is made into a collector's plate, and another limited run is sold out.

For a retired cartoon producer, Walter keeps himself awfully busy.

Woody appears in a Happy Art painting of Mount Rushmore.

When he's not putting Woody onto another canvas or oilgraph or plate or phone or ceramic sculpture, he's off to one city or another to celebrate the national distribution of one of the preexisting placements or to commemorate seventy years of placing Woody and his friends on movie screens and magazine racks all over the world. "A few weeks ago they had a banquet honoring me as the 'Dean of Animated Cartoons,' which made me feel like I was a hundred and eight," he'll remark, referring to the phrase that journalists and publicity writers have tagged him with. The banquet was given for him, along with an award for animation excellence

called the Annie, by the International Animated Film Society in Holly-wood. Walter has also been honored by retrospectives at Filmex (Los Angeles's local film festival), New York's Museum of Modern Art, and the Animated Film Festival at Zagreb in Yugoslavia. He was named a "national giant of accomplishment" by the American Academy of Achievement and was bestowed its Golden Plate Award, an honor granted to leaders in diverse areas of science and industry. His career was read into the *Congressional Record* by California Representative Thomas Rees. And the Academy of Motion Picture Arts and Sciences gave him Hollywood's most cherished prize, the one that had eluded him year after year in the Animated Short Subject category: an Oscar for Special Achievement,

Walter's Happy Art.

Walter's Happy Art collector plates.

Woody's new telephone.

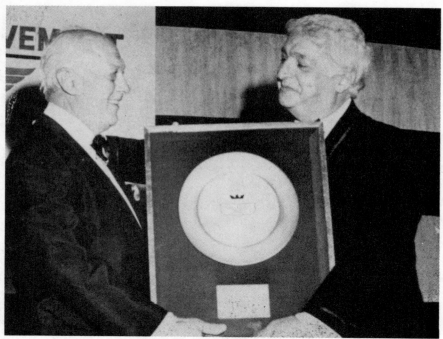

Walter receives the Golden Plate Award,
presented by his brother Michael.

awarded on the same night similar honors were given to Laurence Olivier
and King Vidor. Robin Williams presented the trophy "for doing strange
and wonderful things with a laughing bird" and asked, "Is it true what
the *National Enquirer* said about him and Betty Boop?" In another Walter
Lantz first, Woody ran on stage and accepted, thanking Walter "who's
been drawing me, and a very nice paycheck too, for over thirty-five years."
Woody was superimposed through the miracle of video technology and
extended-family member Virgil Ross did the honors at the light-board.

Walter maintains a quizzical attitude toward all this gilt-edged prestige,
never failing to point out that as he left the Dorothy Chandler Pavilion
on Oscar night, surrounded by well-wishers and backslappers, clutching
the statuette, "afraid someone would grab it and run"—he got his pocket
picked instead. He knows what happens in the comedy business to the
pompous and the proud, and, lest he forget himself, Gracie/Woody is
generally on hand to keep his feet on the ground, as in the case of his
recent pronouncement on *Hour Magazine:* "I feel I'm doing something

*Robin Williams presents the Oscar for Special Achievement
to Walter Lantz in 1979.
Courtesy of the Academy of Motion Picture Arts and Sciences.*

that everybody enjoys, and that's what I'll be doing till I push up daisies, and I hope that's twenty years from now." His companion wasted no time in chirping, "I don't see how you're going to do that, you just bought a crypt."

He's used to such remarks by now, and can respond in kind. The most serious medical crisis he's encountered came with a bleeding ulcer caused by medication for a touch of arthritis. When he collapsed from loss of blood, an ambulance took him to Good Samaritan Hospital, where two paramedics carried him in on a stretcher and one of them asked, "Mr.

Lantz, could you draw me a picture of Woody Woodpecker and autograph it, because I don't know if I'm going to see you again."

"Don't write me off, Buster," Lantz answered back. "I'm going to be around a lot longer than you are." Then he gave him the drawing.

It's hard to bet against Walter being around. He's done that successfully for over eight decades, until it's become one of many claims to fame. He's one of only a handful of surviving film industry veterans from as far back as 1916, and the only one representing the art of animation. His nearly uninterrupted fifty-years-plus association with Universal is a Hollywood record. Universal vice-president Tom Wertheimer calls it "the longest-running contract in the history of the entertainment industry."

No matter how far Walter Lantz's longevity may extend, Woody Woodpecker's is bound to extend further. Walter and Gracie have never had children, but between their nieces, nephews, and millions of fans worldwide, they claim to be satisfied. The child that occupies most of their attention and has affected their lives most profoundly is that ubiquitous red-crested fowl. My Son the Woodpecker. Easier to see a family resemblance to the irresponsibly charming Al Lantz than to his stabilizing brother, but when Walter claims there's a little Woody in all of us, he's probably speaking for himself as well. There's also a touch of Grace in him, a little of Bugs Hardaway, a smattering of Shamus Culhane, a trace of Art Heinemann, a snatch of Alex Lovy, a hint of La Verne Harding, a sprinkle of Dick Lundy, and a whisper of Paul Smith, but the direct lineage is clear. Woody is a living emblem of Walter's unceasing astonishment at the lunatic world his drawing talents shoved him into.

No cartoon character living has so earnest and tireless a protective father. In other cases, the creators and the people who supervise current use have parted company and the energy has petered out. With Woody, the old original forebear is still in there pitching, and he has no intention of quitting.

Woody floats annually now over people's heads in the form of a seventy-five-foot balloon (designed by prominent sculptor Michael Lantz) in the Macy's Thanksgiving Day Parade. Fifty years of his history and his creator's animation art reside in the University of California at Los Angeles's Theater Arts Library. His birthplace at Universal City is memorialized with its own exhibit, replete with photographs, a model of the Sherwood Lake cottage with a mechanized woodpecker, and an ongoing film exhibition. He has joined the video revolution, starring in his own cassettes marketed in assorted languages all over Europe and America. He is the

The Woody Woodpecker exhibit on the Universal City tour.

Woody sculpture in the Smithsonian.

only cartoon character to be honored by a permanent display in the Smithsonian Institution in Washington, D.C., consisting of a print of *Knock Knock* and artwork and music from that film. The display is only a few

Walter and Gracie at the Smithsonian.

blocks from Michael Lantz's 1938 equestrian statues outside the Federal Trade Commission Building. Walter couldn't resist commenting, "I always thought Woody should be in an institution. Lucky for him it was the Smithsonian."

Walter thinks all this over as he strings another fish on the line and freshens the bait on his hook. The atmosphere at Silver Lake recalls the tranquil Sherwood Lake atmosphere splintered so rudely by that aboriginal woodpecker over forty years ago. There's a sound now rolling across the water and reverberating off the mountainsides. It's the drumming of woodpeckers. While he listens, Walter comments on the fact that Woody's cassettes are now available on the latest form of entertainment technology, the laser disk. As we move into the future, we can trust that wood-

November 16, 1982

Dear Walter and Gracie:

Nancy and I are delighted to join the Smithsonian Institution in paying tribute to your outstanding artistic accomplishments with this special retrospective of your work.

Through many years your creative story lines, distinctive animation, and quality voice-over narration have helped to make Woody Woodpecker and your other characters international goodwill ambassadors for our nation. The great imagination and quality of your work have earned you the adoration of youngsters and adults throughout the world.

You have also demonstrated deep concern for the well-being of your fellow citizens through such contributions as your USO tours during the Vietnam conflict. You are both fine "entertainers" who epitomize the best in the American spirit.

All Americans join us in congratulating you on this well-deserved tribute and on your lifetime of bringing joy to hearts of children everywhere.

Sincerely,

Ronald Reagan

President Reagan's letter presented to Walter and Gracie at the Smithsonian.

Walter with the Golden Book, Annie, Oscar, and other trophies.

peckers will follow us, and Woody will be leading them. The Lantz road from the chaos of Castle Garden to the lasers lighting up Woody's image all over the globe was wild and unmapped, and is sometimes more fun to think back on than it was to travel. But it helps to know that Walter's contribution to the future includes one of American folklore's most enduring characters. That makes up for a lot of the battles and heartaches along the way.

The peaks no longer beckon with their blaze of crimson. By the time Walter Lantz decides it's time to gather up his catch and head on home, there's a golden sheen over everything.

Walter Lantz's Acknowledgments

I wish to express my thanks to the people, past and present, who were responsible for the success of Woody Woodpecker, Andy Panda, Chilly Willy, and all of my other cartoon characters.

Carl Laemmle and Universal Pictures, MCA; Gregory La Cava, W. R. Hearst, Cosmopolitan Studio; J. R. Bray, Bray Studios.

Directors: George Stallings, Alex Lovy, Tex Avery, Jack Hannah, Manuel Moreno, Bill Nolan, Shamus Culhane, Paul Smith, Don Patterson, Burt Gillett, Clyde Geronimi, Dick Lundy, Sid Marcus, and Emery Hawkins.

Writers: Victor McLeod, Milt Schaffer, Cal Howard, Tedd Pierce, Dick Kinney, Norman Blackburn, Jack Cosgriff, Mike Maltese, Bill Danch, Dale Hale, Dalton Sandifer, Bugs Hardaway, Heck Allen, Homer Brightman, Al Bertino, and Lowell Elliott.

Background Artists: Fred Brunish, Ray Jacobs, Ray Huffine, Ed Kiechle, Nino Carbe, Art Landy, Tony Rivera, Willy Pogany, Art Heinemann, and Philip DeGuard.

Voice Artists: Grace Stafford, Daws Butler, Mel Blanc, Paul Frees, Dal McKennon, and June Foray.

Musical Directors: James Dietrich, Clarence Wheeler, Darrell Calker, Walter Greene, Frank Churchill, Eugene Poddany.

Animators: Grim Natwick, Lester Kline, Ralph Somerville, Hicks Lokey, Virgil Ross, Rudy Zamora, Art Davis, Ray Patterson, Ed Love, La Verne Harding, Joe Voght, Frank Tipper, Gil Turner, Fred Moore, Ed Benedict, Bob Bentley, Don Patterson, Virgil Partch, Al Coe, Ray Abrams, Cecil Surry, George Grandpré, Pat Matthews, Hank Ketcham, Chuck Couch, Steve Bosustow, and Fred Kopietz.

Archivists: Paul Maher, Walter Lantz Productions, Inc.; Audrey Malkin, UCLA; and Marc Wanamaker, Bison Archives.

Walter Lantz on his fishing boat with author Joe Adamson,
Woody Woodpecker, and his close friend Frank Capra.

Cameramen: Mickey Batchelder and Bill Brazner.
Film Editors: Fred Smith and Norm Suffern.
The Ladies who inked and painted the cels.

My special thanks to Robert Miller, Al Glenn, Irv Handelsman, Hal
Ridenour, O. B. Johnston, Sen Tabata, and Jerry Hartman.
Gracie and I wish to thank President Ronald Reagan and his wife,
Nancy, for their excellent letter of congratulations.
My thanks to Frank Capra for his introduction to this book.

Walter Lantz
Hollywood, California
March 1985

Joe Adamson's
Acknowledgments

I owe my deepest debt to a man I never knew: the late Mr. Jerry Franken, who began this book and finished a series of interviews, an outline, and six roughed-out chapters before he left us, laying a solid foundation that made it possible for me to erect the eventual superstructure.

I also owe more than words can say to those with firsthand accounts of an aspect or two of the Walter Lantz story, for their time and generosity in sharing those accounts with me: Mel Blanc, Chuck Jones, Frank Capra, Grim Natwick, Milt Schaffer, Dick and Mabel Sjögren Lundy, Leo Salkin, Alex Lovy, Cal Howard, Heck Allen, Ed Love, Lowell Elliott, Shamus Culhane, and the dear departed La Verne Harding, Hugh Harman, Bob Clampett, Tex Avery, and Michael Maltese.

For their assistance in assimilating and verifying information and in securing films for screening, David Colker, Marc Wanamaker, Gordon Kent, Jerry Beck, Franklin Rosemont, Leonard Maltin, John Semper, Mark Evanier, Alain Silver, Sam Gill, Franklin Prince, and, most especially, Suzanne Stone and Mark Kausler deserve special thanks. For their help in preparing and packaging the manuscript, Lindsay Doran, Kenn Honeychurch, Linda Delayen, Mary Richardson, and my agent, Timothy Seldes, are worthy of more than my humble gratitude.

For their comments on the developing manuscript, I am indebted to two talented Pisceans, James Morrow and Rebecca Parr, a couple of writers as red-headed, high-spirited, and thin-skinned as the bird that serves as one of the subjects of this book.

In Walter Lantz's organization, I am grateful to Paul Maher, Al Glenn, Doris Luciano, Ruth Aasen, and Bob Miller for their help in making available to me the vast quantities of studio records, illustrations, and films stored therein.

And above all else, I must offer a deep bow in the direction of Walter

and Gracie Lantz, whose extravagance in bestowing reminiscences, mementos, suggestions, attention, assistance, hospitality, love, and laughter has made them the honorary collaborators in this project, rather than the taciturn subjects this author has come to expect.

Joe Adamson
Santa Monica, California
March 1985

Selected Bibliography

Balio, Tino. *United Artists*. Madison: University of Wisconsin Press, 1976.

Black, Hilda. "Facts About the Woody Woodpecker Song." Undated Publicity Release. Los Angeles: Walter Lantz Productions, Inc.

"Blanc Wants Last 'Woodpecker' Laugh." *Daily Variety*, July 14, 1948.

Bolton, Whitney. "Hollywood" column. October 22, 1939.

Canemaker, John. *The Animated Raggedy Ann and Andy*. Indianapolis, N.Y.: Bobbs-Merrill Co., Inc., 1977.

"The Cackle, Too, Is Inflated." *Santa Rosa Republican*, July 15, 1948.

Capra, Frank. *The Name Above the Title*. New York: Macmillan Company, 1971.

"Cement Mixer's Suicide Attempt Goes Putti-Putti." *San Francisco Chronicle*, July 28, 1948.

Clary, Patricia. United Press Features Column. June 29, 1948; March 7, 1949; May 9, 1949.

Crafton, Donald. *Before Mickey*. Cambridge: MIT Press, 1982.

Everson, William K. *The American Silent Film*. New York: Oxford University Press, 1978.

"Gem," "Writers Overjoyed by 'Woody' Suit." *Down Beat*, August 25, 1948.

Gould, Stephen Jay. *The Panda's Thumb*. New York and London: W. W. Norton and Co., 1980.

Handsaker, Gene. Associate Press Syndicated Column. March 20, 1951; May 23, 1967; Undated.

Harding, Allan. "They All Thought Him Crazy, But They Don't Think So Now." *American Magazine*, January, 1925.

Hendrick, Kimmis. "Woody Woodpecker's Creators—at Home." *The Christian Science Monitor*, December 27, 1968.

Hickman, Gail Morgan. *The Films of George Pal*. South Brunswick and New York: A. S. Barnes and Co., 1977.

"It Doesn't Make Sense." *Time*, June 28, 1948.

James, Ed. "Will Petrillo Unseat the Jockeys?" *American Magazine*, December, 1947.

Lantz, Walter. "Upped Cartoon Rental by Single Admission a Producer's Need." *Boxoffice*, December 22, 1951.

"Laugh Suit Lost by Radio Comedian." *Los Angeles Times*, October 4, 1949.

"Leeds, Columbia in Combo Drive to Push 'Woody'." *Billboard*, June 12, 1948.

Maltin, Leonard. *Of Mice and Magic*. New York: McGraw-Hill Book Co., 1980.

"Man of the Month." *The Exhibitor*, July 7, 1948.

Morris, Ramona and Desmond. *Men and Pandas*. New York: McGraw-Hill Book Co., 1966.

Mortensen, T. E. "The Old Man's Corner." *Greater Amusements*, August 16, 1946.

Othman, Frederick C. "Artist Goes In for Cartoons." United Press Story. October 21, 1939.

Pelegrine, Louis. "Extinction Threatens Cartoon Biz—Lantz." *The Film Daily,* October 29, 1956.

Reynolds, Quintin. "Give Me Real People." *Collier's,* March 26, 1938.

Rosemont, Franklin. "Homage to Tex Avery." *Cultural Correspondence* 10–11, (Fall 1979).

Scheuer, Philip K. "Mickey Mouse Charged with Death of 'Live' Comedians," *Los Angeles Times,* November 27, 1933.

Stevens, Daniel N. "Rules Woody Woodpecker Laugh Was Private Property, But Rights Lost." *The Los Angeles Daily Journal,* October 6, 1949.

Wales, Clark. "Out of the Inkwell." *Boston Globe,* March 28, 1937.

"Woodpecker Song Ups Lantz Sales." *The Hollywood Reporter,* July 12, 1948.

"Woody Woodpecker's Song Sour, Court Told." *Akron Beacon-Journal,* November 17, 1949.

Index